History in Depth

Collections of documents come in all shapes and sizes.
Many attempt to cover a very broad period; in consequence
they rely heavily on illustrative material which is thought to
be typical. In practice, this means a patchwork of often
isolated snippets, with material torn out of context. Single
documents or even fragments of documents have to bear the
whole weight of a period, a problem, a theme. Students
derive from such collections a mistaken impression of the
nature of history, of the character of historical research, and
very often, a false impression of the subject of study.

HISTORY IN DEPTH is based on the belief that historical
perception demands immediacy and depth. Working to the
principle that true breadth in history can be achieved only by
examining a concrete problem in depth, each volume in the
series is devoted to either a particular event or crisis of
considerable significance, such as the Peasants' Revolt of
1381 or the British General Strike of 1926; or to a trend or
movement running through a coherent period of time, such
as West African Nationalism from the middle of the
nineteenth century or the concept of Das Volk in the
German lands; or to a particular area of experience, such as
the Victorian underworld or Elizabethan Puritanism.

No artificial uniformity is imposed on the format of the
volumes; each is shaped by the dictates of its subject. But
there are certain basic elements common to all. The core of
each book is a major collection of original material,
translated into English where necessary, with editorial
decisions on modernised punctuation and spelling governed
by the nature of the subject. Each editor provides an
introduction geared to the particular demands of his volume;
each volume carries a full working bibliography, interpretive
notes and an index.

This is a new approach to the teaching of history which
has been evolved in response to a demand from practising
teachers throughout the Commonwealth. The general editor
has selected the subjects and the volume editors with care,
so that each book stands in its own right, and has something
of the quality of a monograph.

History in Depth

General Editor: G. A. Williams

Henry S. Wilson: Origins of West African Nationalism
R. B. Dobson: The Peasants' Revolt of 1381
J. R. Pole: The Revolution in America, 1754-1788
D. S. Chambers: Patrons and Artists in the Italian Renaissance

In Preparation
R. Martin: The General Strike
R. C. Mettam: State and Society of Louis XIV
B. Harrison: Robert Lowery: Portraits of a Radical
Hans Koch: Das Volk
Raphael Samuel: The Victorian Underworld
H. C. Porter: Puritanism in Tudor England
Dorothy Thompson: The Early Chartists
Lionel Butler: The Fourth Crusade
W. H. Hargreaves-Mawdsley:
Spain under the Bourbons, 1700-1833

Other books by D. S. Chambers:
Cardinal Bainbridge in the Court of Rome
Faculty Office Registers, 1534-1549

Patrons and Artists in the Italian Renaissance

D. S. CHAMBERS

MACMILLAN

© Editorial matter, translation and selection
D. S. Chambers 1970

First published 1970 by
MACMILLAN AND CO LTD
London and Basingstoke
Associated companies in New York Toronto
Dublin Melbourne Johannesburg and Madras

SBN (boards) 333 09391 7
(paper) 333 11139 7

Printed in Great Britain by
ROBERT MACLEHOSE AND CO LTD
The University Press, Glasgow

This book is dedicated to my Mother

and in fond memory of my Father,

who died before he could

see it finished

Contents

x

Part IV: Princely and Private Patronage

List of Illustrations

Cover: Portrait medals of Ludovico III Gonzaga, Marquis of Mantua, by Bartolommeo Melioli *c.* 1475, and of Leon Battista Alberti by Matteo de' Pasti *c.* 1446-50
(By courtesy of the Trustees of the British Museum)

xviii

General Editor's Preface

Historical perception demands immediacy and depth. These qualities are lost in attempts at broad general survey; for the reader of history depth is the only true breadth. Each volume in this series, therefore, explores an important historical problem in depth. There is no artificial uniformity; each volume is shaped by the problem it tackles. The past bears its own witness; the core of each volume is a major collection of original material (translated into English where necessary) as alive, as direct and as full as possible. The reader should feel the texture of the past. The volume editor provides interpretative notes and introduction and a full working bibliography. The volume will stand in its own right as a 'relived experience' and will also serve as a point of entry into a wider area of historical discourse. In taking possession of a particular historical world, the reader will move more freely in a wider universe of historical experience.

*

In this volume, Dr David Chambers explores the world of patrons and artists in Renaissance Italy. 'Clio, then, was the inventress of historical studies pertaining to fame and olden times,' wrote Guarino of Verona to Duke Leonello d'Este in 1447, 'so let her be holding a trumpet in one hand and a book in the other; her garment is of various hues and covered in many ways with figures.' In the new, trenchant, human translations of this striking volume, one of the most potent societies of European history is recaptured in immediacy, depth and colour.

The great doors of the Baptistery at Florence and the cupola of its cathedral stand as decisive early achievements of the Renaissance. Among the earliest documents here, from the 1420s are the Wool Guild's appointment of Brunelleschi

to the latter, Ghiberti's accounts for his work on the third pair of Baptistery doors, the often petulant correspondence of Jacopo della Quercia, rejected at Florence, as he sets about the Great Door of San Petronio in Bologna. The collection closes, around 1520, with Grosso della Rovere pressing Michelangelo on the Julius Tomb and Sebastiano del Piombo reassuring him: 'My dearest comrade . . . you will always have me boiled and roasted.'

This is not primarily an essay in the history of art, although it adds a dimension to that history. It is, rather, a study of the process by which works of art were produced during one of the most formative phases of European experience. The purpose is to deploy as wide a range of surviving records as possible — letters, contracts, extracts from books of payments, memoranda — to illustrate the patronage and working practice of artists. The patrons are, inevitably, the focus: the Church, displayed at work on San Petronio in Bologna, in contracts for paintings for religious houses, in the massive patronage of the Papal Court; the Guilds, debating over and contracting for cathedral and the Or' San Michele statuary in Florence, the great halls in Venice and Perugia; the Cities, in an agony of competitive emulation, wrestling with each other and with artists often as refractory as their materials. Particularly rich is the material relating to the patronage of princes and private individuals, the 'protean Medici', the Gonzaga, the Sforza, the long series of letters of that incomparable huntress Isabella d'Este; particularly rewarding are the documents on the artist's working life — fashions and styles, copying and restoration, apprenticeship, subcontracting, litigation, payment.

Dr Chambers supplies essential editorial guidance but this volume, unique in its scope and depth, allows the reader to make his own judgements and assessments on the multiple problems so amply documented — the complexity of styles and influences, the persistence of 'gothic', the relevance of philosophy and theory, the dominance of the secular, the emergence of the artist from the artisanry, the exigencies of technique and costs, the interplay of patrons, prices and piety, the ambiguities of commercialisation. This superbly craftsmanlike study enables the reader to be his own historical craftsman, to re-experience the human reality of

creative work in a particular society; for in this reconstruction of the most crucial of societies, it is the perennially human which registers — Benozzo Gozzoli assuring Piero de Medici that he can cover up unwanted seraphs with 'two little clouds', or Sebastiano assuring Michelangelo that the latest works by the Prince of the Synagogue Raphael were like 'figures passed through smoke'.

Raphael himself in 1514 in a heated and graceless letter to his uncle, full of huge boasts, huge fees and huge prospective dowries, exploded — 'And don't moan about my not writing; I who have a brush in my hand all day long.' Not the least of Dr Chambers' achievements is to have made human an age of giants.

<div align="right">GWYN A. WILLIAMS</div>

Preface

I am very grateful for the generous help I have received in preparing this book. Acknowledgements are made in the appropriate places to Professor E. H. Gombrich and Professor Cecil Grayson for kind permission to include their translations of two letters. I have benefited greatly from the advice of Miss Ann J. Kettle, Professor Lionel Butler, Professor John Steer, Mr John Larner and Dr Jonathan Riley-Smith, all of whom have given time and thought to reading and criticising the text. I am also grateful to Dr C. H. Clough and Miss Susan Connell for advice on particular problems, and to a succession of students in the University of St Andrews who enlivened a seminar on 'the Italian Renaissance'. Of these I owe special thanks to Mr Gerhard Benecke, Mr John Law and Mr David McLees, who suggested additional material for the collection. 'Opus fieri fecerunt'.

Introduction

This book is not another rapturous approach to 'Italian Renaissance Art'. It is concerned with the less imaginative parts of the process by which so many different works, of both great and minor art, came into being in fifteenth- and early sixteenth-century Italy. Its purpose is to display as wide a range as possible of documentary records which illustrate the patronage and working practice of artists during this period, including letters, contracts, extracts from books of payments and other memoranda, all long familiar to art historians, but excluding literary sources: humanist writings about the arts, or artists' own writings about themselves and their art.[1] This sort of material, which art historians from Vasari[2] onwards have valued, raises and sometimes answers important questions beyond the domain of pure aesthetic pleasure; it surely deserves to be more widely known to students, however poor a substitute translations may be for the original texts.[3]

[1] Previous anthologies in English have not concentrated upon this period alone, nor upon such a restricted range of material. E. G. Holt, 'The Literary Sources of Art History' (Princeton, 1947), reprinted under the less appropriate title 'A Documentary History of Art', 2 vols (New York, 1957), is confined to strictly 'literary' texts for the Italian Renaissance, apart form a contract to Perugino in 1495, some letters of Michelangelo, and the well-known letter of Leonardo da Vinci to Ludovico Sforza, boasting principally of his skill as a military engineer (which is almost 'literary' since there is no certainty it was ever sent). R. Friedenthal, 'Letters of the Great Artists from Ghiberti to Gainsborough' (London, 1963) includes translations of some of the letters which appear in the present collection, but the scope of this work is rather different.

[2] Giorgio Vasari (1511-74), 'Le vite de' più eccellenti Pittori Scultori e Architettori' (Florence, 1550, 2nd ed., 1568). The standard edition remains that of G. Milanesi, 'Le Opere di Giorgio Vasari', 7 vols (Florence, 1878-82); an English translation is available in Everyman's Library, also one by G. de Vere, 10 vols (London, 1912-15).

[3] A carefully edited collection of original texts is still badly needed. J. Gaye, 'Carteggio inedito d'artisti dei secoli xiv. xv. xvi', 3 vols

The expression 'Italian Renaissance' occurs in the title of the book not only because it is vaguely evocative, but also because it has some descriptive value for the period in art history lasting from the heyday of Ghiberti, Donatello, and Brunelleschi to the death of Raphael in 1520: when, in terms of the style, content, aspiration, and intellectual valuation of Italian art, and the growing reverence for artists, 'rebirth of antiquity' has most meaning. But any attempt to restrict the material to documents which only referred to the purer radiance of 'the Renaissance' would have been absurd and misleading. Many artists were eclectics, acutely concerned to develop their own individual styles, 'consumed with rivalry with one another', as a contemporary observed.[1] The collection therefore includes documents which stress continuity as much as change, the 'international gothic' and traditional taste as well as the work of the 'avant-garde' with its stricter disciplines.

The terms 'patron' and 'artist' are to be understood by their simplest meaning. Patrons are those persons responsible, individually or collectively, for commissioning and paying for works produced by artists. Thus patronage in its wider sense, the social function of protecting and advancing a client party's interests, may only apply in certain cases, where princes and other persons of influence are concerned. 'Artists' are understood as the designers and producers of works of an acceptable or superior standard in the various techniques of painting, sculpture, and architecture: the three main categories to which Vasari reduced a great diversity. Thus the word is used here both in its traditional sense of

(Florence, 1839-40), a rare work, full of inaccuracies, is still indispensable. Northern art has been better served than Italian, with the useful collection of original texts edited by H. Huth, 'Künstler und Werkstatt der Spatgotik' (Augsburg, 1923; reprinted Darmstadt, 1967).

[1] Angelo Decembrio attributed this remark to Marquis Leonello d'Este of Ferrara (d. 1450) in his dialogue 'De Politia Litteraria'. As a discerning patron, Leonello is alleged to have had little taste for 'the folly of these northern people . . . popular absurdities pandering to the extrvagance of princes and the stupidity of the crowd': M. Baxandall, 'A Dialogue on art from the Court of Leonello d'Este', 'Journal of the Warburg and Courtauld Institutes', xxvi (1963) 314, 316-17. That 'chivalric' and 'classic' tastes were not neccessarily opposites is, however, pointed out by C. Mitchell, 'A Fifteenth Century Plutarch' (London, 1961) pp. 6-7.

artisan or skilled craftsman, rising from the rigorous and restrictive background of workshop training and guild ('arte') membership, and in its exalted sense of the omniscient, divinely inspired creator, which Alberti, and later Vasari, did so much to foster. Conceivably, the same person might be both a patron and an artist,[1] but in general the distinction is obvious enough.

In arrangement the material has been governed more by the species patron than the species artist. Instead of being classified under different arts, individual artists, workshop traditions, regions of Italy, chronology, or according to types of document and subject-matter, it is presented under a number of headings which indicate different types of patron. The final section includes some material illustrating aspects of the working experience of artists without reference to any particular type of patronage. Beneath these main headings the items are arranged separately or in groups according to their particular content and significance. Fine distinctions between types of patron sometimes cause rather similar commissions to be placed far apart. It is not always with strict accuracy that 'Guild Patronage', 'Clerical Patronage' and 'Princely Patronage' are distinguished from 'Civic Patronage'. For instance, the section entitled 'Guild Patronage' illustrates the governmental or civic responsibility which the guilds of Florence assumed for the care and decoration of certain ecclesiastical buildings; the Wool Guild declared that the statue they commissioned from Ghiberti at Or' San Michele was 'for the honour of the city' (no. 23). At Bologna, however, where the government was clerically dominated, the church of San Petronio was the administrative responsibility of the papal legate; the documents about Jacopo della Quercia's commission therefore appear under the heading 'Clerical Patronage'. Meanwhile at Prato the commission for the outside pulpit and the building of the church of S. Maria delle Carceri could not be classified clearly except as examples of 'Civic Patronage'. Private donors who commissioned works to be placed in churches present another difficulty; where the commission was to be

[1] e.g. Lorenzo de' Medici in submitting a design for the Cathedral facade at Florence; or one could describe as 'sub-patrons' artists who subcontracted part of their work to others.

supervised by a clerical body the documents are classified as 'Clerical Patronage'. Finally the point must be made that the same persons acted in overlapping roles, participating in the corporate patronage of guilds or civic institutions, and also acting individually as princely and private patrons: the Medici[1] were protean in this respect, their role eludes definition as it did generally in Florentine life.

What special problems do all these documents substantially or partially illustrate? The answer depends of course on what one is looking for, and this introduction would defeat the purpose of the book if it set out to make a complete analysis. They reveal, for instance, patrons' requirements and preferences, and their evaluation of individual artists. They also reveal the artists' point of view, sometimes raising a suggestive note about the vocabulary they used. What, for instance, did Vivarini and Cossa mean when praising themselves as artists who studied (nos. 41, 103), or Neri di Bicci understand by the terms ancient and modern (nos. 110, 111)? Some light is thrown upon the question of where artists derived their esoteric details and programmes of 'stories', even if contracts are often frustrating in their reference to instructions and drawings which do not survive.[2] Certain artists might be quite cavalier in their disregard for specific instruction; others perhaps preferred working to an exact programme (e.g. Pasti in no. 48). Finally, problems of a social and economic nature can also be explored through the documents: the status of the artist and the terms by which he was bound; secularisation and commercialisation; art's relationship to the society for which it was produced.[2]

[1] On the subject of Medicean patronage, see E. H. Gombrich, 'The Early Medici as Patrons of Art', in 'Italian Renaissance Studies', ed. E. F. Jacob (London, 1960), reprinted in Gombrich, 'Norm and Form: Studies in the Art of the Renaissance' (London, 1966).

[2] Accompanying drawings rarely survive with the other documents. A sketch accompanies Fra Filippo Lippi's letter to Giovanni de' Medici in 1457 about a presentation painting for the King of Naples; see I. B. Supino, 'Fra Filippo Lippi (Florence, 1902) p. 89. The contract concerning alterations to the Cathedral of Chioggia by Giacomo di Lazzaro, 1 July 1468, also includes a drawing, reproduced in P. Paoletti, 'L'architettura e la scultura del Rinascimento in Venezia' (Venice, 1893) i 53, fig. 68. (Miss Susan Connell kindly drew my attention to this.)

[3] For such broader analysis and its dangers, see the Bibliographical Notes.

It will be clear from the inclusion of material relating to the more artisan artists as well as to the élite, that no special emphasis is being placed upon the rise of the artist to a new social status. The possibility of such an ascent had been there before Ghiberti became involved with Niccolò Niccoli and others of the humanist circle in Florence;[1] rhetorical acclamation for individual artists had already been growing in the Trecento.[2] Those who had the right social background, acquired some humanist values and useful introductions might well obtain more than an artisan status; the paths of Brunelleschi, Alberti, Baldovinetti or Raphael were obviously smoother than those of Masaccio or Neri di Bicci. On the other hand not all artists necessarily sought to become rich and ascend the social ladder; a moral decision may have been involved, or else they may not have looked upon their careers in this light at all. Though Mantegna aspired to rise, buying himself a title from the Emperor Frederick III and endowing his daughters with generous dowries,[3] Donatello (according to Vespasiano) refused Cosimo de' Medici's offer of smart clothes[4] and (according to Vasari) kept his money in a basket which was frequently rifled.[5] There are many figures of whom it would be hard to say whether they arrived socially or even aspired to do so. Cossa's letter to Duke Borso d'Este of Ferrara (no. 103) might be interpreted as the protest of a frustrated social climber; but it might equally be that of a master craftsman complaining that his hire was nor worthy of his specially skilled labour. Nor is there a valid social criterion to distinguish artists subjected to the contract system from those who were free from its supposed servitude. Resident court artists may have done without contracts; those who worked independently for princely or private patrons were likely to make formal agreements. Isabella d'Este approached

[1] See E. H. Gombrich, 'From the Revival of Letters to the Reform of the Arts, Niccolò Niccoli and Filippo Brunelleschi', 'Essays in the History of Art presented to Rudolf Wittkower' (London, 1967) i 71-82.

[2] J. Larner, 'The Artist and the Intellectuals in Fourteenth Century Italy', 'History', liv (1969) 13-30.

[3] P. Kristeller, 'Andrea Mantegna' (London, 1901) pp. 202-3.

[4] Vespasiano da Bisticci, 'Vite di uomini Illustri del secolo xv', ed. P. d'Ancona and E. Aeschlimann (Milan, 1951) pp. 418-19; the incident is mentioned by Gombrich, in 'Italian Renaissance Studies', pp. 298-302.

[5] Vasari, 'Opere', ii 420.

eminent painters by personal letter and the services of her influential friends and agents, but it appears that once she had received a firm promise it was clinched by a contract: the very detailed contract with Perugino illustrates this (no. 76). Contracts did not in fact subject the artist to any social indignity; they were drawn up for many other sorts of professional service, and were desirable for the security of both parties. Probably they were of more advantage to the artist than to the patron. This is illustrated not only by cases where special perquisites, such as food and fuel, were included in the contract (e.g. nos. 9, 15) or where the price was subject to valuation by a well-disposed fellow artist (nos. 121, 123, 126), but more generally by the manner in which so many artists seem to have broken their contracts with impunity: even Fra Angelico did so (no. 118). On the other hand it was not unknown for artists to take legal action against their patrons, and two successful cases are quoted (nos. 124, 127). Stern injunctions often appear in the contracts: the artist must do all the work by his own hand, undertake no other commissions, or finish within a given time. Such clauses were hard to enforce and may have been more expressive of hope than serious expectation. Penalty clauses about lateness might threaten a reduced fee or even a fine (e.g. nos. 11, 27) but more evidence is needed to show whether they were put into execution. Meanwhile, there was small consolation for the patron in the artist's pledging of his goods and chattels. If the patron was determined to have a work by his chosen artist, and the latter delayed, the wiser course was to wait patiently or to draw up a new contract (e.g. no. 32 n.); at the most he might try to bring pressure to bear, either through a persevering correspondence or by an appeal to those of stronger influence and authority (e.g. no. 125). In conclusion, artists seem to have been freer agents than might be supposed, though it would be safer not to draw too many inferences about their status from these examples. Each personality and achievement was individual: there is not much to be gained by trying to impose sociological judgements. But the reader may judge for himself from the documents.

Although the selection begins with the clergy as patrons, by far the greater part of the material concerns the various

branches of lay patronage. The balance may or may not be fairly weighted; the patronage of churchmen, above all the munificent prelates of the court of Rome, has not been ignored, but the range of documents is very much conditioned by their availability. If the laity predominate, it certainly does not follow that art became predominantly secular. Religious subjects might be interpreted in terms of classical and mathematical composition or social observation, churches built on centralised plans and with the Roman orders of architecture and decorative detail, but this did not reduce their devotional meaning or function.[1] Moreover, the religious art commissioned by lay patrons was indistinguishable from that commissioned by the clergy. The records kept between 1454 and 1472 by Neri di Bicci, a minor but well-patronised Florentine painter, do not confirm, for instance, that the Florentine bourgeois patrons preferred the subject of the Epiphany before all others because the offering of wealth expressed their own predicament. Neri di Bicci painted over fifty versions of the Madonna and Child with attendant saints; his next most sought after subjects were Annunciations, Coronations, and Assumptions of the Madonna.[2] Conversely, secular art, such as portraiture and allegorical themes, was commisssioned by clergy as well as by laymen. It is a vain task to try and assess the degree of secularity in a patron's motives. Isabella d'Este, in the pursuit of allegorical paintings based on pagan myth, told Giovanni Bellini that she would be equally glad to have a scene of the Nativity (no. 67) and asked Leonardo da Vinci for a painting of Christ as a boy (no. 88). She clearly possessed enough conventional piety and maternal tenderness to want such pictures for their own sake, as well as a collector's urge to accept any work so long as it was by the most reputable painters. But if the genres of neo-pagan allegory and 'poesia' and the individual portrait were innovatory, many secular

[1] R. Wittkower, 'Architectural Principles in the Age of Humanism', 3rd ed. (London, 1962) pp. 3-32.

[2] Vasari, 'Opere' ii 71-9. Extracts from Neri's 'Ricordanze' are given by Milanesi, ibid., pp. 69-90, and ff. 1-28v of the original text (Uffizi Gallery Library, Florence, MS. ii) were edited by G. Poggi in 'Il Vasari' (Arezzo, 1927-31) i, iii, iv; a complete edition has yet to be made.

subjects for art are found long before this period; representations of famous men and military heroes, allegories of government and justice, battle scenes and hunting scenes, and the general adornment of public places and palaces. It would be difficult to calculate whether there was progressively more of all this from 1400 to 1520; so much art was on the borders of secular and religious, and so much has been lost.

Two main questions arise about art as a form of commerce. Were the prices which artists could command standardised or arbitrary, rising or falling over the period? Did something recognisable as an art market develop?

A study of prices presents various difficulties. The sum quoted in a contract, for instance, is no proof of payment, of which separate record does not always exist. Prices might also be quoted in a number of different denominations.[1] In most cases they are reckoned in gold coinage, Florentine 'large florins of gold in gold', or equivalent Venetian and Papal ducats, which was clearly a considerably advantage and security to the artist, though in Florence, as well as the 'large florins' first struck in 1433, coins of inferior gold content, called florins under seal ('de sugello') because they circulated in little sealed bags of leather, survived until 1471 (e.g. nos. 7, 121). However payments are also quoted in the local silver coinage ('moneta di piccioli') which existed in 'denari' and various larger units of 'denari': 'grossi', 'quattrini', 'carleni', 'bolognini' etc., the names differing from place to place. Amounts of these are usually expressed in 'lire' and 'soldi' (12 'denari' = 1 'soldo'; 20 'soldi' = 1 'lira') which were money of account, corresponding to no minted coin. Some of the documents show that artists were paid partly in gold and partly in silver (e.g. no. 6); the rates of exchange between the two systems varied from day to day and money-changer to money-changer, and the documents illustrate this variability. In 1252, when the first gold florin was struck, it corresponded in value to the 'lira' of 240 silver 'denari'; Cipolla has shown how the silver coin steadily depreciated in its relative value so that by 1500 the gold florin was equivalent to 7 'lire' in silver.[2] The rate of 6 'lire' to the florin in the Ghirlandaio

[1] R. de Roover, 'The Rise and Decline of the Medici Bank' 1397-1494 (New York, 1966) pp. 32-3 is followed here.

[2] C. M. Cipolla, 'Studi di storia della moneta' (Pavia, 1948) i 81-5.

contract of 1485 (no. 107) corresponds closely enough with Cipolla's specimen rate of 6 'lire', 3 'soldi' for that year, though the rate quoted by Neri di Bicci of 4 'lire' to the florin in 1456-67 is more generous to silver than Cipolla's rate of over 5 'lire' for the same period.

Prices quoted in gold provide a constant basis for comparison, but how were these prices assessed?[1] Materials, time involved in a work, and the costs of assistant labour determined much. Sometimes the patron paid for specified items separately; sometimes the artist was paid an inclusive fee and met all expenses. The production of bronze sculpture greatly exceeded marble in cost, though the latter could be expensive where a work of vast size was demanded: the most obvious example being Michelangelo's projects for the tomb of Pope Julius II.[2] Prices for paintings varied considerably, and in any analysis of prices one has to remember that the combination of a patron with large resources and a much sought after artist might lead to inflated prices being paid. Fra Angelico was offered 190 florins for the Linaiuoli altarpiece in 1433 (no. 119) and Perugino was to be paid no less than 500 florins for an altarpiece he did for the Benedictines of San Pietro, Perugia.[3] Sebastiano del Piombo's fee of 1000 ducats for his 'Raising of Lazarus' in 1518 seems enormous (no. 18) even though this was a large canvas; it illustrates the high prices available in Rome. At Neri di Bicci's level in the mid-fifteenth century, the artist's fee or honorarium for his 'mastery' might be only a third of the total price paid when costs were deducted (nos. 5, 6). 150 ducats was a top price for a small painting; in 1501 Isabella d'Este managed to

[1] For an analysis of prices and a table see H. Lerner-Lehmkuhl, 'Zur Struktur und Geschichte des Florentinischen Kunstmarktes' (Wattenscheid, 1936), and M. Wackernagel, 'Der Lebensraum des Kunstlers in der Florentinischen Renaissance'. (Leipzig, 1938) is very useful though sources are not cited fully.

[2] Michelangelo was meant to receive 16,500 florins under the successive contracts of 1513 and 1516, in spite of the modifications to his first and most elaborate scheme for which he had been offered 10,000. See C. de Tolnay, 'Michelangelo IV: The Tomb of Julius II' (Princeton, 1954) pp. 32, 48. Lerner-Lehmkuhl gives some examples from the early fifteenth century showing that the cost of marble was about one-third of the total price ('Struktur und Geschichte', p. 43).

[3] F. Canuti, 'Il Perugino' (Siena, 1931) ii 176-7; Holt, 'A Documentary History of Art', i 268-70.

reduce Bellini's fee from 150 to 100 ducats (no. 64) but in 1506 Mantegna was demanding from one of his private clients an increase beyond 150 ducats (no. 72). For frescoes, some high prices were offered towards the end of the period. Ghirlandaio was to have 100 florins for each of ten frescoes in Florence in 1485 (no. 107) but this was less than the Sistine Chapel price of 250 ducats apiece (no. 11) which would be equivalent to the price of 1200 ducats which Raphael stated he was offered for the Stanze della Segnatura and dell'Incendio (no 16). The highest prices quoted for fresco painting are Michelangelo's, though they depend on his own word some years later that he was offered 3000 florins for his part in decorating the Hall of the Great Council in Florence, and the same for the Sistine Chapel ceiling.[2] Even for so brilliant a work as the Battle of Cascina scene this sounds unusually high, though more understandable for the Sistine Chapel ceiling with the infinitely greater labour and invention it involved.

This brief survey suggests first, that prices on the whole rose,[2] at least for paintings, though a number of exceptionally high prices need not signify a general increase on this scale;[3] and second, that artists were rather well paid, in terms of money values and fees for other services. In 1431

[1] E. Ramsden, 'The Letters of Michelangelo' (London, 1963) i no. 157, pp. 148-9 (January 1524).

[2] Cf. Wackernagel, 'Lebensraum des Künstlers', pp. 347-8. However, information about paintings in the late fourteenth century confirms the danger of generalisation, and the need to take the reputation of the artist, material costs and the size of the work into consideration. In 1373 the maximum price for a picture, 'the most beautiful obtainable', was stated by Francesco Datini to be 6½ florins, and 5 florins as the maximum price for a painting of the Madonna required by customers who sought 'good figures' and 'fine work'. See R. Brun, 'Notes sur le commerce des objets d'art en France et principalement à Avignon', 'Bibliothèque de l'école des chartes,' xcv (1934) 342-3. On the other hand, in October 1383 Agnolo Gaddi suggested to Datini the minimum price for painting 3 braccia high was 25 florins, and a Franciscan friar requiring an altarpeice for his convent at Bonifacio in Corsica was prepared to pay 85 florins in 1395. See R. Piattoli, 'Un mercante del Trecento e gli artisti del tempo suo', 'Rivista d'arte'. xi (1929) 238-9, 245; this article, continued in vol. xii (1930), contains much further information about prices taken from the Datini archives at Prato.

[3] Compare the modest payment agreed for a work by Perugino in 1521 (no. 9).

xxxii

Carlo Marsuppini was one of the highest-paid lecturers in the Florentine Studio with an annual salary of 140 florins;[1] at about the same period, 350 florins was a good basic income for a lawyer.[2] Thus Mantegna's salary of 180 ducats (excluding other perquisites) as Ludovico Gonzaga's court painter seems very adequate; his indignation when the Marquis was not always able to pay it may have been because he supposed he might have been still better off on a free-lance basis (nos. 59-60). The upward trend in prices must, however, be considered together with the likelihood of an increase in material costs, and with the caution that though spectacular commissions could be had from the most affluent patrons — from the Roman court, from Venice, or from the French invaders — there was certain depressive factors in the early sixteenth century. It seems improbable that the invasions of Italy, the collapse of many governments and princely dynasties and the increases in taxation helped to create a boom period for artists, a disproportion between supply and demand in favour of the suppliers. Pintoricchio, writing in 1507, seems to have suggested that the good times were over (no. 122).

Was art a good investment for patrons? As an investment to gain social prestige, spiritual enrichment and lasting fame it may have been; but it is difficult to see it in the modern sense of a safe way of investing capital during a period of economic contraction.[3] Partly this is owing to the immobility, the impossibility of reselling so much of the art; partly to the lack of evidence that value appreciated. The inventories of the Medici collection drawn up after the death of Lorenzo the Magnificent show that small paintings by Giotto and Fra Angelico, for instance, might be valued at only 5 florins (no. 54). On the other hand antique objects, cameos, figurines, marble busts, or jewels, gold and silverware were worth hundreds or even thousands of florins, as the high

[1] L. Martines, 'The Social World of the Florentine Humanists' (London, 1963) p. 259. Lerner-Lehmkuhl, 'Struktur und Geschichte', p. 50, gives a rather more optimistic estimate for university teachers.
[2] L. Martines, 'Lawyers and Statecraft in Renaissance Florence' (Princeton, 1968) pp. 103-5.
[3] See R. S. Lopez, 'Hard times and investment in culture', in 'The Renaissance: A Symposium' (New York, 1952).

valuations show: they were a genuine investment. Even so, one may too easily discount the aesthetic motive in collecting them; Cardinal Pietro Barbo (Pope Paul II) and Piero de' Medici were not mere speculators gloating upon their hoards,[1] and artists themselves such as Ghiberti and Mantegna were also collectors. All this is not to deny that art in its more portable forms was to some extent 'commercialised' by the early sixteenth century; but that was not a wholly new phenomenon. The old-fashioned workshop painter Neri di Bicci dealt in other workshops' paintings, had his agents outside Florence, and kept a small stock of ready-made works for sale.[2] This was probably no innovation. Moreover it is not a very long step from the patron's or merchant's agents who made contact on their behalf with artists to the middle man or art dealer who was not himself an artist. The first of these is said to have been the Florentine Giovanni della Palla, who exported Florentine works to France in the second decade of the sixteenth century;[3] but the business associates of Francesco Datini of Prato were ordering and exporting Florentine paintings for sale at Avignon a century and a half earlier.[4]

These introductory remarks have been offered as a preliminary sketch rather than a 'finished painting with adornments'; the intention is to present certain problems through select documents, not to argue a thesis based on exhaustive research. Nor, of course, can this collection pretend to be a critical edition of source material. Caution is required, since most of the translations are made from printed texts. The rendering in English may be open to criticism: constructions, idioms, and technical vocabulary in the original Italian or

[1] R. Weiss, 'Un umanista venziano: Papa Paolo II' (Venice, 1959) p. 26; Filarete's 'Treatise on Architecture', trans. J. R. Spencer (New Haven, Conn., and London, 1965) p. 320.
[2] Vasari, 'Opere', ii 85-6.
[3] Wackernagel, 'Lebensraum des Künstlers', pp. 288-9.
[4] See the articles by Piattoli and Brun cited on p. xxxii, n. 2. A letter from Boninsegna di Matteo, Datini's principal business associate at Avignon, laid down in March 1387 the rule for agents to follow in Florence, of buying when a painter needed money, so as to get the lowest price: Brun, p. 343, quoted by R. S. Lopez and I. W. Raymond, 'Medieval Trade in the Mediterranean World' (New York, 1955) pp. 114-5.

Latin are often archaic and perplexing. An attempt has been made to preserve style, but also in some cases to reduce the prolixity and repetitive jargon of the notaries who drew up contracts. For certain words no clear equivalent could be found, and it seemed better to leave them untranslated. For instance, the word *storia*, meaning the subject or scene represented in an individual composition or a narrative cycle, remains as 'story'. The word *operaio* (Latin equivalent *operarius*), meaning a person holding administrative responsibility for the patronage of a guild, fraternity, or works office of a church, has not been translated: the possibilities are all clumsy or misleading. Where appropriate, the word *arte* has been translated as 'guild', but the Venetian *Scuola*, a species of philanthropic institution unconnected with any particular trade, has neither been rendered as 'school' nor 'guild' but left as it is. Where the Italian gives several synonyms the single English equivalent has been used, e.g. 'pulpit' for *perbio, pergamo, pulpito*. *Una Nostra Donna* has been re-Italianised as 'a Madonna', and names of saints have been retained in the Italian where a particular church is involved (e.g. Santa Maria Novella, not 'New St Mary's'). In general the Italian versions of names have been used, rather than Latin, English or Italian dialect forms, so have special terms such as *braccio* (a measure of 23 inches in Florence, though measures varied in different localities) and *gesso* (a technical preparation of plaster of Paris). Honorific titles like *prudens vir, circumspectus, spectabilis* etc., have had to be translated, although it is difficult to find an English equivalent; *dominus* is translated as lord, though this need not of course imply nobility; the various forms of messer, *missier, ser* etc. have been kept in the original. Dates of years have sometimes had to be altered to conform with the modern practice of counting the new year from 1 January (e.g. the year began in Florence and some other parts of Italy on 25 March or the Feast of the Incarnation; in Venice it began on 1 March).

PART I

Clerical Patronage

The Great Door of San Petronio, Bologna

1 Contract of Jacopo della Quercia with the Papal Legate, Louis d'Aleman, 28 March 1425

Jacopo della Quercia had entered unsuccessfully the competition for the second pair of doors to the Baptistery of Florence in 1401, the event often taken as decisive in the history of Renaissance sculpture. The winner, Ghiberti, was already engaged on another pair by 1425; but Jacopo was no less celebrated in his native city of Siena, where he had completed his stone fountain, the 'Fonte Gaia', and where Louis d'Aleman probably met him in 1422. The San Petronio commission gave him a chance to show his skill again in another rival city to Florence: San Petronio was the patronal church of Bologna as the Baptistery of San Giovanni was of Florence. Jacopo's work, like Ghiberti's, was transitional in style, his Virgin and Genesis stories for San Petronio are distinctly classical, and like Ghiberti he took a very long time over it. The time allowed in this fastidious contract was absurdly short considering how much work was involved. Possibly a new contract was drawn up in 1428 on account of some of the discrepancies between this one and the work which survives; and there was a separate contract for the interior of the door. Jacopo della Quercia had not finished it when he died in 1438.

Italian text in G. Milanesi, 'Documenti per la storia dell'arte senese' (Siena, 1854) ii 125-7. See also J. H. Beck, Jacobo della Quercia's design for the Porta Magna of San Petronio, 'Journal of the Society of Architectural Historians' (May, 1965); A. M. Matteucci, 'La Porta Magna di San Petronio a Bologna' (Bologna, 1966).

3

28 March 1425

Memorandum that on the above-mentioned day the most Reverend Father Our Lord the Archbishop of Arles, Legate and Lord of the city of Bologna, commissioned the making of the great central door of the church of San Petronio to Master Jacopo of the Fountain of Siena, master of wood-carving and master of marble sculpture, according to the form shown in a drawing by his hand, and subscribed by him, with the same details of the work and some additional features that are not in the drawing; and beyond the said details he is to add those mentioned below according to the manner and terms that follow:

First, he must have for the making of the said door 3600 florins of the Papal Chamber, and our aforesaid Lord the Legate promises this, for all the work on the said door and all the features it contains, as in the following manner and terms:

He must for the present have 150 gold florins of the Papal Chamber from the Works Office of San Petronio as part payment for the aforesaid work, which money must be discounted from the subsequent payments; and for this Alberto di Maestro Tomasino of Brescia stands surety, promising to reimburse the said Works Office every time that the aforesaid Maestro Jacopo refuses to come and attend to the aforesaid work at any request of the officials then in power; and the said Lord promises the said Maestro Jacopo that he will be paid in cash by the said Works Office for all the time he gives to the job by monthly instalments according to the amount of the aforesaid sum that is due. This work he promises to have completed by the end of two years, from the time that he has the stone and the day on which he subsequently sets to work.

First, the height of the door must be between 40 and 43 feet.

Item, the width shall be as is requisite in proportion, that is half its height, or really any fraction that seems suitable.

Item, the projection that the door must make in front shall be as the pilasters, or really as the base at present surrounding the whole façade of the Church; because this seems to be appropriate.

4

Item, the principal pilasters of the door should be 2½ feet wide, because thus they will seem in keeping with the building.

Item, the carved columns that are to go on either side of the door should be in proportion to the building, as is customary in work done by the great masters.

Item, the column with three spaces containing the Prophets similarly should correspond to the other features relating to it.

Item, the other foliated column with three spaces should correspond in the accustomed way.

Item, the bases from the foot of the frame to the capitals above should all be in relation to the building and its members.

Item, the fourteen stories from the Old Testament which are to go on the pilasters are to be 2 feet wide.

Item, the three stories of Christ's Nativity which are to go on the lintel (?) are to be 2 feet each.

Item, the twenty-eight lesser prophets are to be each 1½ feet.

Item, the figure of Our Lady seated with the Son at her breast are to be 3½ feet high; Our Lord the Pope to be 3½ feet; Messer San Petronio to be as the Pope; each sculpted in relief. The three figures are to go above the door, the Pope kneeling and of the required size.

Item, the lions on either side of the door are to be as big as real lions.

Item, the two figures above the pilasters, St Peter and St Paul, are to be each 5 feet high.

Item, Our Lord Jesus Christ seated on a throne borne up by angels to be between 4 and 4½ feet high, with the flying angels each 4 feet.

Item, Our Lord on the Cross, above the carved arms on the front, to be 2 feet high.

All of which figures are to be done entirely in relief and the 17 stories of the pilasters and the lintel to be in relief as deep as their beauty requires.

Item, all the Prophets are to be in relief as required to look well.

Item, that all things on the door shall be carved and adorned as appears in the pen drawing on paper by the hand

5

of Maestro Jacopo, and to be executed with the utmost perfection and order that the said drawing shows.

Item, he should ensure that in the said drawing the column of the seven stories, which is not included, should be like the other one.

Item, he must have five figures made which are not in the drawing, as follows: the figure of Jesus Christ and four other figures at the pleasure and will of Monsignore.

2 Letter of Jacopo della Quercia to the Officials of the 'Fabrica' of San Petronio, 26 June 1426

Jacopo della Quercia had to provide his own materials, and this letter gives some idea of the weariness this inflicted on a sculptor. To obtain the right amounts of different marble and arrange for its transport by water he had to visit Venice six times and Verona five times between 1425 and 1438. The letter includes a character reference for his pupil Cino di Bartolo, but the latter was not kept on by the 'Fabrica' after Jacopo's death, and was imprisoned for having seduced a nun.

Italian text in Milanesi, 'Documenti per la storia dell'arte senese', ii 132-3; see also Matteucci, 'La Porta Magna di San Petronio a Bologna', pp. 14-9.

In the name of God, 26 June 1426

Honoured fathers: your servant first commends himself in deepest humility. By this letter Your Reverences will be informed of my arrival at Venice. I have presented Monsignor the Cardinal's letter into the Doge's own hands, and am now waiting to know the effect of the said letter's contents. Apparently there is much business going on, or so they say, and therefore the rapid expedition for which you had hoped cannot be expected; moreover the long wait they have been able to make me endure, and which still continues, has now lasted so long that they are prejudiced against our need. On departure I undertook to pay the duty on 100 pieces of

6

Istrian stone, which I bought for 30½ ducats, the duty amounts to 2½ ducats according to a rough estimate; so that to have free passage, Guglielmo could have this job of paying off the said 2½ ducats. Not wanting to stay any longer in Venice, I have agreed with Guglielmo on the sum of 18 *soldi*: they will be brought to Bologna for 18 *soldi*.

After leaving Venice I came to Verona, and I have had the pink stone for the base cut; you are getting a bargain for the price of 47 ducats. On the twelfth of next month they will be ready for loading, and I shall come by whichever road seems best; for this I have allowed for several days beyond the agreement.

I inform you moreover that the four pink columns that are going on the door, of the same size as the white ones of 40 *braccia*, cost 40 ducats; the two arches that go above cost 35 ducats and are 40 *braccia*. The rest of the pink stone which is going on the door, as in the drawing, would cost 22 florins; so that the total sum will be 102 florins according to the deal I have made, with which I hope Your Lordships are content. And if so, and you wish the deal to go forward, let me know before I leave, and send 30 ducats to have the work started, so that during August the said work can be brought to Bologna. I further beseech you that all my friends there may be recommended, and that you give Cino what he asks for, because he is in need and a good man. Let me know soon what you want me to do before I leave here.
Christ preserve you in life and honour.

From your servant Jacopo of the Fountain of Siena, on the said day in Verona, in the hostelry of the Hat
To the respected and worthy Officials of the Works of San Petronio in Bologna

3 Letter of Jacopo della Quercia to the Officials of the 'Fabrica' of San Petronio, 26 March 1436

Weariness and irritation caused Jacopo della Quercia briefly to walk out on his patrons in 1436; the artist

7

expresses himself eloquently in this letter concerning a dispute he had had with them.

Italian text in I. B. Supino, 'La scultura in Bologna nel secolo xv' (Bologna, 1910) doc. 64, p. 161.

[In the name of] Jesus

Most worthy and excellent officials of San Petronio; first of all the most faithful commendations of your servant Jacopo. The truth is this: that I have left Bologna and your reverend magistracy not to walk out upon my obligation or depart from common reason, but to be free and not captive, because a captive man is neither heard nor understood. And moreover your reverences may be advised that I was and am disposed to do everything which reason obliges me to do; I will never turn my back upon justice and my own honour. Your demands do not accord with my part of the contract drawn up in the past; your reverence knows it all, and that it cannot take place. Therefore I came to my conclusion, that if you are willing to give me what is my due, I shall appear at once, now or whenever you want you will find me ready. But when passion and envy are spent, reason and truth will prevail as much as need be for contentment. I will say no more than the above about this matter. You know, reverend and praise-worthy officials, that I am in Parma, nor could I come nearer on account of the new statute made by the most reverend Lord Legate Missier Daniello and the Lord Marquis of Ferrara. I am here at present, and shall wait three or four days for your reverences' reply. Should there be no reply, I shall take the road for Siena. Even, however, if our Lord God is willing to make good my deficit, he will not be able to remove all the malice; and you know, reverend fathers, that I am writing the same to the Lord Legate. I will say no more: Christ preserve you in happiness.

From your Jacobo, your servant in Parma
26 March 1436

Paintings for Religious Houses

4 Contract of Piero della Francesca with the Austin Friars
of Borgo Sansepolcro, 4 October 1454

This contract is for the work known as the 'St Agostino
Altarpiece', which was subsequently broken up and its
parts dispersed. The contract reveals some details of the
solemnity of a commission granted by a religious house,
and an interesting proposal for part payment in land. The
further instructions, carrying the patronal supervision
even further, do not survive, presumably because they
were not attested by the notary. The work took not
eight, but fifteen years.

See Plate 1.

Latin text in M. Meiss, 'A documented Altarpiece by
Piero della Francesca', 'Art Bulletin', xxxiii (1941) 67-8.
See also K. Clark, 'Piero's Iconography', 'Burlington
Magazine', lxxxx (1947), and 'Piero della Francesca'
(London, 1951) 207-8.

See Plate 1.

4 October 1454

Be it known to all who shall examine the present official
instrument that the Prior and friars of the church and
foundation of Austin hermits at Borgo Sansepolcro were
called together and assembled in chapter in the sacristy by
order of the Prior and at the sound of the bell struck three
times according to custom. There were present the pious friar
Francesco di' Niccolò of Borgo (Prior), friar Giuliano of
Foligno (reader and preacher), friar Pietro Giovanni, and friar
Giovanni di Giovanni de Alemania [Germany], constituting
the chapter; also present were the worthy Nanno Cischii and
ser Uguccio Nofri of Luxemburg, *operarii* of the church, and
Angelo di Giovanni Simone Angeli of Borgo, acting in devout
fulfilment of the wishes of Simone, his late brother, and the

9

lady Giovanna, formerly wife of Simone and [now wife] of the said Angelo. They commissioned from Master Piero Benedetti, son of Piero of Borgo — the painter being present and accepting the commission — a picture for the High Altar of the church, to be painted, decorated and gilded with such images as they agreed upon. And they agreed also that a certain writing or record should be made, signed by the said Ser Uguccio and countersigned by the said Prior and Nanno, the other agent, and by the said Piero. The said work was commissioned for the price, wage or remuneration of 320 florins (at the rate of 5 Cortona lire to the florin). As part payment for the same, the said Angelo, for love of God and on behalf of the soul of his late brother and that of his aforementioned sister-in-law and wife, his soul and the souls of their forbears, allowed to the said Master Piero 100 florins in cash at the said rate as a first instalment, and in further security a piece of arable land in the district of Borgo and Contrada Pelani [?] near to the land of the said church and the road between it and Angelo's property. And beyond the payment of 100 florins and the sum which the said property shall realise, Angelo has himself promised to pay to the said Master Piero, at the completion of the said altarpiece, 50 florins at the rate indicated above. And the remainder of the sum of 320 florins was promised to Piero by the above-mentioned Prior and the friars sitting in chapter and the said *operarii* Nanno and Uguccio, to be paid to him when the said painting and decoration have been completed. And they also assigned to the said Master Piero the panelled frame in the sacristy for the said altarpiece worked in wood according to the said Angelo's orders; and they did this because the said Master Piero the painter promised to paint and decorate the altarpiece with images and to embellish it with good and fine colours and with gold and silver and other materials, representing all the images and figures which have been set down in a writing which they declared should be sealed with the said record. And [Piero promised] to place it in position over the altar completed within eight years from now, with respect only to the front side facing the altar and not the back. And thus the contracting parties were in full agreement.

10

RECORDS OF A FRESCO PAINTED BY NERI DI BICCI FOR THE ABBOT OF SAN PANCRAZIO, FLORENCE, 1455-6

Neri di Bicci was well patronised by this monastery of Vallombrosan Benedictines. In December 1454 he had been commissioned to paint a Crucifixion and Saints for the Refectory and a half-length figure of St Benedict above the door of the Dormitory. In 1456 he painted a Head of St Catherine for a monk called Dorantonio; and the Abbot, Don Benedetto Toschi, was judge or assessor of the Crucifixion he painted in a monastery at Faenza in August 1459. The fresco for the cloister, documented here, has been described as his best work and the survival of both artist's and patrons' records is of some interest.

Italian texts in Poggi, 'Le Ricordanze . . .', 'Il Vasari', i 134-5; see also i 337, and iv 199-200; Vasari, *Opere*, ii 82 n. 5, 84 n. 1.

5 Neri di Bicci's Record of the Contract

1 March 1455

I record that on the above day I Neri di Bicci, painter, undertook to paint for the said Abbot Benedetto, Abbot of San Pancrazio, Florence, a small arch in the cloister of the said house, in which I must do a San Giovanni Gualberto with ten other saints and blessed monks of their Order, and at the foot an abbot kneeling, which figures must appear in a circular chapel. The sky is to be azure and starry, and the eyes cut out, and all must be adorned and rendered as well as I can possibly do it, all at my expense for gold, azure, chalk and every other colour needed.

149 *lire* paid on 18 August 1455

Record of our expenditure in having the painting done of San Giovanni Gualberto and other saints and brothers of our Order which Neri di Bicci is painting in our cloister.

(Signed) I Neri di Bicci, painter, am in agreement with Abbot Benedetto of San Pancrazio to do the whole of the said work for 149 *lire* on this day 1 March 1455.

On 6 March 1455 Neri began to mix the chalk and had cash from me, Abbot, for sand.

On the said day Neri also had a load of grain which Domenico measured, at the price of 20 *soldi* a bushel.

On 26 March 1455 Neri di Bicci had, he said
for buying azure and pieces of gold, 2 large florins.

On 2 April 1455, for azure still needed for the
vaulting, Neri had from me 8 *grossi* in cash 2 *lire* 4 *soldi*.

On 1 May 1455 Master Neri, painter, had
for the said purpose, according as he
said to his needs, 2 large florins.

Master Neri had 3 large florins in cash on 29 May 1455
from me, Abbot Benedetto, he said for gold and azure
 15 *1* 12 *s*.

On 20 June 1455 he needed for gold for
the said work 1 1 7 *s* 6*d*.

On 21 June 1455 Master Neri abovewritten had a
further 4 large florins for the said purpose 20 *1* 18 *s*.

On 18 August 1455 Neri had from me, Abbot, 4 large
florins, by agreement on my going out 20 *1* 18 *s*.

On .. November 1455 Piero d'Antonio, gold-beater,
had on behalf of Master Neri and
in his presence 4 large florins.

12

On 23 December 1455 4 large fl. were paid, Piero d'Antonio, gold-beater had 3 florins and said Neri had

1 fl.

On 24 July 1456 the said Benedetto, sacristan, paid the remainder

18 *l.*

7 Contract of Alesso di Baldovinetti with the Servite Friars of Florence, 27 May 1460

Baldovinetti had previously worked with Andrea del Castagno in the Servites' Church of the Santissima Annunziata; his well-known if faded fresco of the Nativity had to be outside in the forecourt to be as close as possible to the shrine on the other side of the wall, which was under Medici patronage. The arrangements for his payment are slightly obscure; a layman, Arigho Arigucci, had donated 20 florins for the work, but this may not have been enough to provide a normal fee as well as cover expenses (however, cf. no. 120). Some final payments for the work were recorded in August and September 1462.

Italian text in G. Poggi, 'I Ricordi di Alesso Baldovinetti' (Florence, 1909) pp. 17-18; R. W. Kennedy, 'Alesso Baldovinetti' (New Haven, Conn., 1938) doc. v, p. 240, also pp. 101-11.

In the name of God, 27 May 1460

Be it known to whoever sees or reads the present writing how today this twenty-seventh day of May of the said year, I Alesso di Baldovinetti, painter, have undertaken to paint for the friars (the chapter and convent) of Santa Maria dei Servi of Florence a story at the side of the door to the church, on which wall I must do the story of the Nativity of Our Lord, copious with angels, figures and foliage, as may be required for the said story.

And the said story must be worked all in fine colours and fine gold and ultramarine, done with diligence and in a manner acceptable and worthy as required in that place. And I ought to have as payment for the said story twenty florins, that is twenty florins under seal. And I must begin the said story and work on the day I finish the little story which I am doing in San Giglio at the side of the High Altar, and if on finishing this I do not begin the said Nativity and story for the said friars and chapter, the said friars may constrain and burden me in every reasonable way to do the said work. And should I begin the said work and not continue it, or take up some other work, the said friars may constrain me to finish the story and work as aforesaid. And while I am painting the said work I ought to have my expenses paid, that is to say living expenses and one assistant, one boy if necessary, and a room where I can put my things, colours and so forth. And to be clear about this I, the foresaid Alesso, have drawn up this writing in my own hand on the above day, month and year.

And I, Fra Biagio d'Alberto of Florence, friar of the said chapter and convent and at present syndic and proctor of the said friars, by commission from the said chapter and convent, give and commission the said painting to the above-mentioned Alesso in the entrance to our church in the arch behind the altar of the Annunziata, according to the above agreements. And the payment should be in this manner: one part at the time he starts the said work, another when it is half finished, and the rest at completion. And thus it is promised as contained in the above writing by the whole of the said chapter and convent. And in clarification of this I, Fra Biagio above-mentioned, have signed this in my own hand on the above date.

I, the aforesaid Alesso, have received today 28 May three large florins from Fra Biagio of Florence in advance payment for the said work and story.

8 Contract of Domenico and Davide Ghirlandaio with the Franciscan Friars of Palco, 20 August 1490

The most interesting aspect of this contract is the low price accepted by painters as distinguished as the Ghirlandaio brothers, not very much more than what Neri di Bicci was paid. May one infer a certain standardisation of prices for a work of this kind, or else a special price concession to a Franciscan convent?

Italian text in G. Milanesi, 'Nuovi documenti per la storia dell'arte toscana' (Florence, 1901) pp. 6-7.

In the name of God, on the twentieth day of August 1490

Be it noted and known by whoever shall read the present writing that today friar Francescho di Mariotto del Vernaccia allocated a painted altarpiece to Masters Domenico and Davide Ghirlandaio, painters, in the following form: the picture to be about 4 *braccia* wide and 3 *braccia* high; the main panel of the said picture we must make of our own wood, and the said friar Francescho must pay for all the other wood; and in the said panel they must make in the centre a Madonna with the child at her neck, surrounded by four saints, St Francis, St Bonaventura, St Anthony of Padua and St Bernardino, and these saints I Domenico must diligently draw by my hand and colour all the heads, and all the colours and expenses involved in the said picture we must furnish at our own expense; moreoever that the child is to be at the neck of the Madonna is understood; moreover we must paint the predella of the said altar, in which we have to make six half-size figures according to their request and further pleasure; and the said predella we have to render in our own colours; all the rest of the frame and column and frieze has to be done at the expense of the said friar Francescho, panel and predella inclusive, and he must give for our agreed price 35 gold ducats, and we must deliver the said picture in Florence within the next year; and in clear understanding of this I Domenico di Tommaso di Churrado, painter, have made this writing in my own hand, and in the aforesaid year and month I the aforesaid friar Francescho di Mariotto am content with what the foregoing contains.

9 Contract of Pietro Perugino with the Canons of S. Maria
 Maggiore, Spello, 13 March 1521

This late contract of Perugino illustrates not only
continuity (it might have been written a century or two
earlier) but also his willingness in this instance to take a
moderate fee, together with some homely perquisites.
The contrast is great between this and the enormous price
of 500 ducats he had charged the monks of San Pietro,
Perugia, for an altarpiece in 1495. An assistant probably
executed most of the work, but at least it was done on
time, as the inscription records 'Petrus de Chastro Plebe
pinsit ad MDXXI'. The name 'Michelangelus Andine' also
appears on the painting, which suggests a lay patron was
involved, although the canons supervised the commission.
 Italian text in Canuti, 'Il Perugino', ii doc. 484, pp.
280-1; see also i, p. 222 and reproduction of the Pietà as
Plate cli.

13 March 1521, in the time of Our Lord Pope Leo X, drawn
up at Spello in the church of Santa Maria Maggiore of Spello,
in the district of Porta Chiusa belonging to the said church, in
the presence of the lord Damiano Bartholi and Master
Tommaso di ser Francesco of Spello, witnesses.

All the canons named below were summoned and assembled
in chapter at the sound of three rings on the bell in the
accustomed manner, viz. the lords Ventura di Francesco,
Vice-Prior and canon, Bernardino di Venantio, Pietro di
Ercolano Ugolini and Salvator di ser Antonio Angeli, all of
Spello, and canons of the said church. These on one side, and
Master Pietro Perugino, painter of Castel del Pieve on the
other, met together, viz. the said canons on their own behalf
and on behalf of their successors in the said church and it is
the concern of all of them, gave to the said Master Pietro,
here present, stipulating and receiving on his own behalf and
of his heirs etc. the painting of two chapels, one on the right
and the other on the left-hand side of the said church, with
the following agreements and conditions:
 Viz. the one in the chapel of St Biascio is to be a Madonna
in the centre, adorned with gold as needful, with two
16

bishops, one each side, St Biascio and St Fedele, and the frames in gold, and the planets all done in fine gold, and with friezes or letters, according to the wish of the chapter. Item, in the other chapel he must do a Madonna with her dead son in her arms, in the usage of a Pietà, adorned with gold and fine colours as needful; nearby a St John and St Mary Magdalene, and the background between the two figures either with landscape or building as the said figures require; the frames as above, the prescribed figures, landscape and adornments are all to be done by his own hand according to the usage of a good master, and all in fine azure, the figures to be in his own hand, the adornments at his pleasure. And this is to be for the price of 25 gold ducats, in part payment of which the said Master Pietro, painter, acknowledges receipt of 2 large gold ducats from the said canons and chapter, in the presence of the said witnesses and me, the below-named notary. And he promises to do the said work and finish it within the next two months beginning today. And the said canons promised to give the said Master Pietro a room, bed, clothes [= laundry?], bread, wine, oil and wood for his maintenance, and he on the one hand, and they on the other, promised to observe all these conditions.

Patronage of the Papal Court

Perhaps no other Italian city offered such opportunities to artists as Rome, where the papal court returned in 1420 and remained except for the years 1434-43. The following selections reflect the style and munificence of the exalted clerical patronage of popes and cardinals; they cannot convey the volume of it.

10 Statements of Expenditure on the Vatican Palace and St Peter's, 1451

These summary accounts suggest the scale on which Pope Nicholas V (1447-55) planned to change the appearance of Rome, or at least the scale on which he wanted to spend. Rome was to be a permanently safe seat for the papal court, and visually so splendid that it should promote reverence, proving that the popes were worthier successors to the Roman emperors.

Italian text in E. Müntz, 'Les arts à la cour des papes pendant le XVe et le XVI siècles, i: 1417-64' ('Bibliothèque des écoles françaises d'Athènes et de Rome', iv, 1878) p. 113. On Nicholas V's projects, the biography by Gianozzo Manetti is quoted in L. von Pastor (ed. F. I. Antrobus), 'History of the Popes', 2nd ed. (London, 1899) ii esp. pp. 165-93.

For expenses on the glass for windows in the palace
this year 170 ducats 34 *bolognini*

To expenses this year for the glass windows in St Peter's
(this is for the last 3 windows) 240 duc.

18

To expenses for carriage and cartage
 1068 duc. 31 *bol*. 8 *denari*

To expenses of all sorts for paintings 596 duc. 45 *bol*. 8 *d*.

To expenses on wages and expenses of oxen
and carts 426 duc. 2 *bol*. 12 *d*.enar

To expenses in buying bricks, roof tiles,
gutters, painted floor bricks and stone 3013 duc. 30 *bol*. 8 *d*.

To expenses for timber 489 duc. 17 *bol*.

To works on the fabric and wages
on credit 15,736 duc. 1 *bol*. 8 *d*.

To expenses for chalk and *pozolana*[1] 595 duc. 69 *bol*. 8 *d*.

To expenses for beaten gold and other colours,
iron shovels, barrows, rope and wood for
shelters, buckets and tubs and
other equipment 1693 duc. 24 *bol*. 2 *d*.

To expenses for all ironwork and
locksmith's work 2660 duc. 13 *bol*.

Total 31,559 duc. 53 *bol*. 8 *d*.

THE DECORATION OF THE SISTINE CHAPEL, 1481-2

The painting of Pope Sixtus IV's great chapel in the
Vatican Palace was a complicated project, on account of
the series of Mosaic and Christian stories required, and
also the joint involvement of a group of artists. Little
documentation remains beyond the following two texts,
and their meaning has been disputed. According to the

[1] A volcanic earth used for making strong cement.

19

most recent interpretation, the works mentioned in the contract of 1481 as already begun were not Perugino's frescoes upon the Altar Wall. (These painting, of the Birth of Christ and Finding of Moses, with an enormous Assumption of the Madonna in the middle, were probably the subject of an earlier, individual contract.) The reference is, in fact, to the first four frescoes on the side walls, those on the side of the Christ stories, which can be identified as the work of the painters named here. The second document gives the valuation of the same four frescoes, the only ones to have been finished by the following January. In the autumn of 1482 all four painters left Rome, and clearly there was much that was unsatisfactory about the contract or its execution; the completion of ten frescoes in the given time was not practicable, but the imposition of the threatened fine for non-fulfilment also seems to have been a dead letter. A formidable body of assessors was constituted to judge the work, including a specialist in the scriptures as well as two painters, but the inconveniences of sharing the work, being oversupervised and perhaps tardily paid, may all have contributed to the exasperation of the artists and so to the continuation of the work by others.

Latin texts most recently published in L. D. Ettlinger, 'The Sistine Chapel Before Michelangelo' (Oxford, 1965) pp. 120-5; see also the discussion on pp. 17-28.

11 Contract for Wall Paintings, 27 October 1481

27 Oct 1481. At Rome in the Apostolic Chamber, in the eleventh year of the pontificate of the Most Holy Father in Christ and our Lord Pope Sixtus IV.

At Rome in the Apostolic Palace, the honourable lord Giovanni Pietro de' Dolci of Florence, inhabitant of Rome and supervisor or commissary for the fabric of the Apostolic Palace, acting as he says by mandate and commission of our

20

Most Holy Lord Pope, in the presence of me, public notary, commissioned or contracted the circumspect men Cosimo di Lorenzo Filippo Rosselli, Alessandro Mariani [Botticelli] and Domenico di Tommaso Corradi [Ghirlandaio], of Florence, and Pietro di Cristofano [Perugino] of Città del Pieve in Perugia diocese, painters at present in Rome, to paint the large new chapel within the said Apostolic Palace, from the altar wall downwards, with ten stories of the Old and New Testaments and curtains below. The painting is to be done as diligently and faithfully as each of them and their assistants can make it, as in the work already started. And the said painters have agreed and promised to the said Giovanni de' Dolci, acting in the name of the Pope, to paint the said stories and curtains as above, and to finish them by the fifteenth of next March with payment at the rate as the paintings by the said painters already (begun) in the said chapel will be valued, under penalty of a fine of fifteen gold ducats of the Chamber for any contravention, which penalty they have freely imposed, and which if they contravene the agreement, they are willing should fall upon themselves, and which penalty must be applied by officers for the fabric of the said chapel. And the said painters obliged themselves and all their goods present and future on behalf of the same etc.

12 Agreement about Valuation of the Painting of the First Four Stories, 17 January 1482.

17 January 1482

At Rome in the Apostolic Palace in the chamber of the Most Reverend Cardinal of San Clemente [Domenico della Rovere], in the presence of the notary and witnesses below written, by commission and mandate and in the name of Our Most Holy Lord the Pope given by his own word of mouth, and on the other hand, Cosimo Rosselli, Allessandro Mariani, Domenico Corradi (all of Florence) and Pietro di Cristofano of Castel del Pieve of Perugia diocese, the painters under contract to paint the Great Chapel of the Apostolic Palace by mandate of our aforesaid Most Holy Lord the Pope.

They freely agreed with the venerable and honoured lords, Master Antonio of Pinerolo, Master of Divinity, of the Order of Minors, Bartholomeo de Bollis, canon of the Basilica of the Prince of the Apostles in the City, Lauro di San Giovanni of Padua, Giovanni Luigi of Mantua and Ladislas of Padua, both painters, and Master Giovanni Pietro de' Dolci of Florence and inhabitant of Rome, arbiters and judges for the evaluation of the said painting by the said Cosimo, Alessandro, Domenico and Pietro di Cristofano, in the Great Chapel of Our Most Holy Lord the Pope, for the making of the first four stories, furnished with curtains, frames and (portraits of) Popes; the curtains being finished, they have to be judged by the said arbiters present to view the same.

And the said lords arbiters and judges, elected as above and intent on nothing else, having taken counsel declared and judged the said masters ought to have from Our Most Holy Lord the Pope for the said four stories with the said curtains, frames and Popes, 250 ducats of the Chamber at the rate of 10 *carleni* to the ducat, for each story. And the said painters there present praised, approved and proclaimed the present sentence and declaration etc.

CARDINAL OLIVIERI CARAFFA'S PATRONAGE OF FILIPPINO LIPPI

13 Letter of Cardinal Caraffa to Gabriele, Abbot of Montescalari, 11 September 1488

Cardinal Caraffa (d. 1511) was among the most munificent patrons in Rome. Bramante designed for him the cloisters of S. Maria della Pace; Filippino Lippi decorated at his expense the chapel of St Thomas Aquinas in the Dominican church of S. Maria sopra Minerva. Lippi, in common with other Florentine artists, owed his introductions in Rome to Lorenzo de' Medici; he seems to have inspired Caraffa with appropriately 'Renaissance' sentiments.

Italian text in E. Müntz, 'Archivio storico dell'arte', ii

22

(1889) 484; A. Scharf, 'Filippino Lippi' (Vienna, 1935) doc. viii, p. 88.

Venerable Abbot

Today at the twentieth hour we gave letters and licence to our Master Philippo [Filippino], with whom we have concluded and contracted the work, as you will understand at his return. Together with the magnificent orator, we read with pleasure your letter of the twenty-sixth of last month, full of doubt lest he should have been supplanted in our favour by his rivals. But wherefore doubt ye, o ye of little faith! Your paternity could well have thought that even had Master Philippo not been as sufficient as he is, having been commended by the Magnificent Lorenzo, we would have placed him above an Apelles, or all Italy. The truth is that on the very day he arrived in Rome, the intrigues began for one who came from your parts. Although we had not yet seen Master Philippo, because of pressing business, we gave no heed. Then, within the brief hour that your Messer Giovanni Antonio brought him to us, we willingly and with joyful mind saw him, and he has been with us ever since, the work was settled with him, and now he is shortly to return with everything ready. From him you will hear everything. We shall only tell you that having been directed on this by the Magnificent Lorenzo, we would not exchange him for all the painters that ever were in ancient Greece. For the rest, we refer you to the letters that the said Master Philippo bears. Fare you well, and do not cease thanking the Magnificent Lorenzo, to whom give a thousand greetings on our behalf.

Rome, 11 September 1488

To the venerable and religious father Lord Gabriel, our beloved Abbot of Monte Scalari, Olivieri, Bishop of Sabina, Cardinal of Naples

A sequel to the foregoing letter, Lippi's apology to the private patron he had deserted in Florence is a fairly frank confession of self-interest. Filippo Strozzi had offered him 300 florins for decorating his family chapel in S. Maria Novella; Lippi was clearly much more highly rewarded by Cardinal Caraffa (the high figure of 2000 ducats has been quoted for his frescoes in S. Maria Sopra Minerva in Rome, but this is not easy to confirm). Lippi did not return to Florence and take up his previous contract until 1491.

Italian text in Scharf, 'Filippino Lippi', doc. xi, pp. 90-1. Wackernagel, 'Lebensraum des Künstlers', p. 348, quotes the 2000 ducats fee, which does not appear to be mentioned by Scharf.

In the name of God: 2 May 1489

My most dear and honourable Sir, greetings etc.
I know that you will have wondered at me for leaving you so long without ever having written. It was not because I have not always kept you at heart, and your work, too, which you bestowed on me with so much love; in every way you have done much more for me than I merit. On the contrary, my coming here makes me so much more eager to finish your work, that it seems like a thousand years, but on my return I shall hope to satisfy you well for every delay. And in any case I shall come at the Feast of St John, God willing, and for no other reason than to make a start on the work and attend to nothing else; and I commend myself to you, praying you to pardon all my delay. Truly I am with a good Lord here; he does me so much kindness, and treats me so well, that I would not know a better one to choose for anything. My work satisfies him, and he goes to great expense for it, sparing nothing. I have just been making a marble adornment for the altar, which for my mastery alone amounts to 250 large gold florins. Then comes the decoration, and he wants it all thus. The chapel could not be more ornate, porphyry and serpentine pavement, all most subtly done, on the ground, a most ornate marble parapet, and all most rich in effect. I will

24

say no more; I commend myself to you. Christ guard you always.

Your servant Filippo di Filippo Lippi, painter with the Most Reverend Monsignor of Naples, in Rome

15 Contract of Pintoricchio with Cardinal Francesco de' Todeschini-Piccolomini for decorating the Library in Siena Cathedral, 29 June 1502

The Library (one of the best preserved interiors of this period) was planned in 1492 as a memorial to Aeneas Sylvius Piccolomini, Pope Pius II (1458-64), and as a permanent seat for his book collection. It was an act of piety on the part of his nephew, Cardinal Francesco Todeschini Piccolomini, who became Pope in October 1503 but died ten days after his election. This made little difference to the project, which was already far advanced, except that a scene showing the patron being crowned as Pope was added at the entrance. Among points of interest in the contract are its detailed specifications, including landscapes and even nudes (which in practice were confined to the ceiling); above all, the insistence that the work should be copious and rich, not at all in accordance with Alberti's canons for narrative painting, but well suited to the style of Pintoricchio. The reference to 'grottesche' is a reminder nevertheless of the important part Pintoricchio played in the revival of antiquity in painting, by the imitation of Roman decorative schemes revealed by excavation. In the early 1490s Nero's Golden House was discovered beneath the Esquiline Hill, and clearly Pintoricchio must have visited the 'grotte'; he pioneered these imitative decorations in the rooms he painted for Pope Alexander VI in Castel Sant'Angelo and the Borgia Apartments in the Vatican Palace, commissions which most probably account for his being chosen by the Cardinal. How closely Pintoricchio kept to the terms of the contract may be questioned; Vasari alleges that Raphael did the sketches

25

and cartoons, and certainly Pintoricchio took on other work in the course of decorating the Library.

Italian text in Milanesi, 'Documenti per la storia dell'arte senese', iii 9. See also C. Ricci, 'Pintoricchio' (London, 1902); J. Schulz, 'Pintoricchio and the Revival of Antiquity', 'Journal of the Warburg and Courtauld Institutes', xxv (1962) esp. pp. 47-8.

In the name of God, Amen

Be it noted by whoever reads or sees the present writing how on this day 29 June 1502 the Very Reverend Lord Cardinal of Siena has contracted and commissioned Master Bernardino, called *el Pentoricchio*, Perugian painter, to paint a Library in the cathedral of Siena, according to the conditions and agreements set out below:

That during the time he is painting it, he may not undertake any other work of painting, whether a picture or a mural, in Siena or elsewhere, which may cause the decoration of the said Library to be postponed or retarded.

Item, he is obliged to render the ceiling of the Library with fantasies and colours and small panels as lovely, beautiful and sumptuous as he judges best; all in good, fine, fast colours in the manner of design known today as *grottesche*, with different backgrounds as will be reckoned most lovely and beautiful.

Item, if the arms of the Most Reverend Monsignor are not painted on the middle of the ceiling, he shall be obliged to make a rich and beautiful coat of arms of the size necessary to be in proportion to the roof. And if it is already painted, he shall renovate it, or if it is done in marble, he shall likewise be obliged to paint, gild or embellish it as above.

Item, he is obliged, as well as doing the ceiling, to do ten stories in fresco, in which (as will be laid out in a memorandum) he is to paint the life of Pope Pius of holy memory, with fitting persons, events and apparel necessary and appropriate to illustrate it properly; with gold, ultramarine azure, green glazes and azures and other colours as are in accordance with the fee, the subject-matter, the place and his own convenience.

Item, he is obliged to render in fresco as above, touch up

26

in *secco* and finish in fine colours the said figures, nudes, garments, draperies, trees, landscapes, cities, air and sky, funeral scenes and friezes.

Item, it is left to him to decide whether the half-lunette above each picture should be decorated with figures or filled with landscapes etc.

Item, he is obliged to render the pilasters which divide and enclose the panels in which the painted scenes will go, and the capitals, cornices, gilded bases and friezes contained within them all in good and fine colours, as are best and most beautiful.

Item, he is obliged to do all the designs of the stories in his own hand on cartoon and on the wall; to do the heads all in fresco by his own hand, and to touch up in *secco* and finish them to perfection.

Item, he is obliged to do a panel linking the pilasters under each scene, in which shall be an inscription or proper explanation of the scene painted above, and this can be written either in verse or prose; and at the base of these columns and pilasters the arms of the Most Reverend Monsignore shall be painted.

And it has been agreed by the aforesaid Master Bernardino to do the ceiling according to the requisite standard of perfection, and the ten pictures as richly and finely as appropriate; and for his salary and reward the said Most Reverend Cardinal promises to give him 1000 gold ducats of Papal Chamber (*de Camera*) as follows: first, the said Cardinal will have 200 gold ducats *de Camera* paid to him in Venice to buy gold and necessary colours, and 100 more ducats will be paid to him at Perugia for his needs and for the transport of his equipment and assistants to Siena. For this initial payment of 300 ducats the said Master Bernardino shall be obliged to give suitable good security for his execution of the work. And should God so will it otherwise, he will do what is proper and restore all the money to the said Cardinal, saving a discount for whatever part of the work he has already done. The rest his sponsors shall be held to restore in entirety to the said Cardinal, without any exception whatsoever.

Item, on completion of each panel, the said Cardinal will have 50 gold ducats *de camera* paid to him, and he will

27

continue thus for each in turn. When all are entirely finished, he will pay him the 200 ducats outstanding.

Item, the most Reverend Cardinal promises the said Master Bernardino that he will lend him a house near the cathedral church to live in free while he is in Siena.

Item, he will allow him wood to make the scaffolding, and also arrange for him to receive sufficient lime and sand.

And because the said Master Bernardino needs corn, wine and oil while he is working on the Library, he shall be obliged to obtain these from the said Cardinal's factor, at current prices, to be discounted from the payment for his work.

And in security of the above, the contracting parties undertake the following: the most Reverend Monsignor personally pledges himself, his goods both moveable and non-moveable, and his heirs, both present and future, to observe in entirety all the above-named clauses and agreements with Master Bernardino; and to pay him the said quantity of 1000 gold ducats *de camera* in the manner and times set forth above.

And the said Bernardino for his part promises and wholly pledges himself to observe what is detailed above with the most reverend Cardinal, and to give sufficient security for the 300 gold ducats that are to be advanced to him; also pledging his goods moveable and non-moveable, and his heirs, present and future, that in all and every part he will observe in entirety all the things agreed and promised above, understanding that all is in good faith and without any intent to defraud.

And I, the above-mentioned Francesco Cardinal of Siena am content, and promise as above; and with faith in the truth have written these lines in my own hand, on the said day of the said month and year.

And I, the above-mentioned Master Bernardino etc.

Drawn up before me personally, public notary, with the below-named witnesses, the most Reverend Father in Christ and Lord Francesco dei Piccolomini, Lord Cardinal of Siena, and the discreet master Bernardino, alias Pintoricchio, of Perugia, painter ... Enacted at Siena in the house of the said Most Reverend Lord Cardinal situated near the church and in the parish of San Vigilio, Siena, in the presence of the

28

venerable and worthy Lord Francesco Nanni, canon of Sateano and chaplain in Siena cathedral, and Luca Bartolomeo Cerini of Siena, familiars of the said Cardinal; and Fortino Lorenzo, Master Marco and Luca dei Vieri, citizens of Siena, witnesses.

And I Francesco, son of Giacomo of Montalcino, public and imperial notary and judge ordinary of Siena, at present scriptor in the Archbishop's Court in Siena, have written, drawn up and registered these agreements.

16 Letter of Raphael to his Uncle Simone di Battista Ciarla, 1 July 1514

In this letter the famous grace of Raphael is perhaps rather lacking; self-righteous boasting seems dominant. There is no doubt that Raphael's worldly success was prodigious by comparison with most fifteenth-century artists, in terms of both social standing and income. During this heyday of papal court patronage, it sounds as though he was able to name his own prices. His price (revealed here) for the Stanza dell'Incendio in the Vatican Palace higher than that for Pintoricchio's much larger work in the Siena Cathedral Library.

Italian text in V. Golzio, 'Rafaello nei Documenti' (Vatican, 1936) p. 20; see also E. Müntz, trans W. Armstrong, 'Raphael, His Life, Works and Times' (London, 1882) pp. 421-3.

To my dear, very dear uncle, Simone di Battista Ciarla of Urbino, at Urbino

Very dear uncle-father
I have received your letter, most dearly welcome for the knowledge that you are not angry with me, for which you would have been truly wrong, considering how boring it is to write when there is nothing important to say. Now that you press me, I reply to tell you fully as much as I can. About Tordona, I am very happy about the one you wanted to give

me before, and I thank God I took neither.[1] I was wiser than you, otherwise I would not have been so well placed as I now am. I find myself at present with possessions in Rome worth three thousand ducats, and fifty gold *scudi* in income, because the Holiness of Our Lord has provided me with three hundred gold ducats to look after the building of St Peter's, which I shall not lack for as long as I live, and I am sure I shall have more from others. And then I am paid for what I do at whatever price I myself fix, and I have begun to paint another room for His Holiness, which will amount to one thousand two hundred gold ducats. So, dearest uncle, I do honour to you and all our relatives and our country; but always I have you in my heart and hear you calling yourself my father. And don't moan about my not writing; I, who have a brush in my hand all day long, do not moan over having to wait six months from one letter to the next, but in spite of all this, I am not angry with you as you are wrongly with me. I have strayed from the question of a wife, but to go back to it, I reply that Santa Maria in Porticu[2] wants to give me a relative of his, and with the permission of my uncle the priest and yourself, I promised to do what his Reverend Lordship wanted. I cannot break my word, we are more on the verge than ever, and soon I will inform you of everything; have patience that it will work out well, and then if it does not come off I will do what you wish. And you must know that if Francesco Buffala has his friends, so have I; I have found a beautiful young girl in Rome, and so far as I know both she and her family are of good standing. They want to give me three thousand gold *scudi* as dowry, and they (?) live in a house in Rome which, if it is worth a hundred ducats here, would certainly be worth two hundred where you are. About staying in Rome, I cannot be anywhere else for any length of time on account of the building of St Peter's, where I have taken the place of Bramante; but where in the world is there a worthier place than Rome, and what work is worthier than than St Peter's, which is the foremost temple in the world. This is the greatest building project ever seen, which will cost more than a million in gold, and you know that the

[1] This passage is obscure, but seems to be a reference to the search for a wife.
[2] Cardinal Bernardo Dovizi.

30

Pope has authorised spending sixty thousand ducats a year on it, and thinks of nothing else. He has given me as partner a very learned friar, more than eighty years old; seeing that he cannot live much longer, His Holiness decided to make him my partner, as he is a man with the reputation for great wisdom, so that I can learn from him if he has any secret of beauty in architecture, so that I can reach perfection in that art. His name is Fra Giocondo, and every day the Pope sends for us and discusses the building for a while. I beg you to go to the Duke and Duchess and tell them this, for I know they would be glad to know that a servant of theirs is bringing himself honour, and recommend me to them. I continually recommend myself to you. Send my greetings to all friends and relations, and particularly Ridolfo, who bears such love towards me.

1 July 1514
Your Rafael, painter in Rome

17 Letter of Sebastiano del Piombo to Michelangelo Buonarroti, 2 July 1518

Illustrating the bitterness in the papal court of Michelangelo's protégé, the Venetian Sebastiano del Piombo, against Raphael (a bitterness in part justified, perhaps, by the previous letter), this letter also refers to the patronage of Cardinal Giulio de' Medici, later Pope Clement VII. The Cardinal had ordered a painting from each of the rivals: Sebastiano's 'Raising of Lazarus' he sent to his cathedral of Narbonne, Raphael's 'Transfiguration', which followed, remained in Rome. Sebastiano received no less than 1000 ducats for his work.

Italian text in Golzio, 'Raffaello nei Documenti', p. 71; see also C. Gould, 'The Raising of Lazarus by Sebastiano del Piombo' (National Gallery, London, 1967).

Most dear friend, more than a father, greetings

I believe that Leonardo [de' Borgherini] has told you everything about how my affairs are going, and about the slowness of my work, not yet delivered; I have delayed so long because I do not want Raphael to see mine until he has done his own, and Monsignor [the Cardinal], who has been many times to my house, has thus given me his promise. I find him a man of very good judgement, as you once told me, more than I would ever have thought. And at present I attend to nothing but its quick dispatch, now that I am above suspicion, I do not think I will shame you. Raphael has not yet begun his.

Upon my soul I am sorry that you have not been in Rome to see two paintings by the Prince of the Synagogue[1] which have gone to France. I do not think you could imagine anything more contrary to your opinion than what you would have seen in such works. I will only say that they seemed figures passed through smoke, or figures of glowing iron, all light and shade, and drawn in the manner Leonardo will tell you; think what fine ornaments the French have received! I beg you to persuade Messer Domenico [da Terranuova] to have the gilding of the picture done at Rome, and leave it for me to do, because I want to tip off the Cardinal that Raphael robs the Pope of at least three ducats a day for gilding. And my work will have more grace furnished thus than if it were bare. And I beg you to see to this as strongly as I can. Nothing else. Christ keep you in health.

> 2 July 1518
> Your Sebastiano, painter

To the lord Michelangelo, most worthy sculptor in Florence

18 Letter of Sebastiano del Piombo to Michelangelo, 3 July 1520

The room in the Vatican Palace to which this letter

[1] I.e. Raphael.

refs is in fact the one *below* the Sala dei Pontifici, known from its decorations as the Sala di Costantino. The same bitterness of rivalry is expressed in Sebastiano's vivid report, but his hopes were in vain. Even if he were right about Leo X's opinion, the Pope was evidently not prepared to overrule his advisers, and the commission remained in the hands of Raphael's pupils, particularly Giulio Romano.

Italian text in G. Milanesi, 'Les correspondants de Michel Ange: Sebastiano del Piombo' (Paris, 1890) pp. 7-8; see also S. J. Freedberg, 'Painting of the High Renaissance in Rome and Florence' (Cambridge, Mass., 1961) pp. 568-70.

My dearest comrade, after due greetings

It is already many days since I received a most welcome letter from you, with one addressed to Cardinal Santa Maria in Porticu and another to Frizzi. And they were all well received. I took the Cardinal's along, and he bestowed many kind words and offers upon me; but on the matter I asked him about, he told me that the Pope had already given the Sala dei Pontefici to Raphael's pupils, and that they had decorated the wall with a figure done in oil which was a thing of beauty, so that nobody would look any more at the rooms Raphael did: that this hall will put everything else in the shade, and will it not be the most beautiful work of painting done since ancient times. And then he asked me if I had read your letter. I said 'no', at which he joked laughingly, and I took my leave on a friendly note.

I have since heard from Bacino di Michelangelo, who is doing the Laocoön, that the Cardinal has shown him your letter and shown it to the Pope, so that everyone in the palace talks of nothing else, and it has made everyone laugh. And I have been told as a great secret that the Pope does not like what Raphael's apprentices have done, and despite the fact that Zuan Battista d'Aquilà, the Datary, and also Cardinal Santa Maria in Porticu want him to like it, he truthfully does not. And to tell you the truth, this hall is not meant for the work of mere boys, it is meant for you: and do not wonder that I have written to you before I expected

comrade Leonardo to arrive at Florence and discuss it with you as he has done with me: to the effect that this is the most excellent and beautiful and fitting work that man could imagine and he will earn great honour and a lot of money if you should take this for granted.

I think what he wants there are all stories of battles, and these are not works for boys to do: you yourself well know how much they involve. You need have not the slightest suspicion in the world now of me: you will always have me boiled and roasted. I will tell you another time how far this business goes; you are the patron of all. I will say no more; Christ keep you well.

3 July 1520
Your most faithful comrade Sebastiano, painter in Rome

19 The Julius Tomb: Letter of Cardinal Leonardo Grosso della Rovere to Michelangelo, 23 October 1518

The letters Michelangelo himself wrote are better known than those his patrons wrote to him, which may justify the inclusion of this one from the nephew and executor of Pope Julius II. The monumental tomb of Pope Julius cast a cloud over much of Michelangelo's working life, and the third contract for it had been drawn up in July 1516, with further modifications of the design for a two-storied façade with figures (it is uncertain which figures are intended in this letter). Michelangelo declared later that Cardinal della Rovere deceived him; this letter could hardly be more cordial, however, and the Cardinal's role as patron was a difficult one. Leo X had become hostile to the della Rovere family, and diverted Michelangelo's attention from the Julius Tomb to designs for the façade of San Lorenzo at Florence. In fact neither work progressed very far.

Italian text in K. Frey, 'Sammlung ausgewählter Briefe an Michelagniolo Buonarotti' (Berlin, 1899) doc. cvii, pp. 122-3. See also de Tolnay, 'Michelangelo IV: The Tomb of Julius II', pp. 44-8.

Dearest Michelangelo

We have received your letter dated the eighth, to which we reply that we are vastly pleased to hear of the diligence you have shown, and that one Hieronimo of Porto Venere has promised on good security to deliver the marble for the tomb of Pope Julius of happy memory, because as you know we want to see the said tomb finished. We are very sorry to hear that you have been ill, but thank God for restoring you to health as you write and as we have understood from Leonardo [Sellaio], the bearer of your letter. We beg you to take care to regain your strength and keep well, both for your own sake and so that we may see the completion of the said tomb. We wait with eagerness to see the two figures ready at the time you have promised. Be of good spirit and do not be carried away by any passion; we put more trust in your slightest word than whatever the rest may say to the contrary. We know your good faith, and believe in it as much as we possibly can, and as we have said at other times, want you to take every care for your safety, because we love you from the heart and want to do everything we can for you.

Farewell. Rome, 23 October 1518
Your Cardinal San Pietro ad Vincula

To the discreet Michelangelo, the excellent sculptor, our most dear friend

PART II

Guild Patronage

The Cupola of Florence Cathedral

Two Florentine competitions, sponsored by the Guilds responsible for the public buildings concerned, are generally accepted to be of prime importance in the artistic Renaissance: the one for the second door of the Baptistery in 1401, the other for the vaulting and cupola over the central space of the fourteenth-century cathedral, Santa Maria del Fiore. Lorenzo Ghiberti won the first, but only partially won the second, the palm for which went to Filippo Brunelleschi. It was the magnitude of the latter's achievement, rather than the forms employed, which caused Vasari to acclaim it as 'the finest of all achievements of ancient or modern times'.

20 Announcement of the Competition, 19-20 August 1418

 Italian text in C. Guasti, 'La Cupola di S. Maria del Fiore' (Florence, 1857) p. 15.

19 August 1418

The *Operaii* have resolved that it shall be publicly proclaimed throughout the city of Florence, in the accustomed place, that whoever (and of whatever condition) is willing to make a model or drawing for the vault of the great cupola of the said church, and for the construction of the scaffolding or anything else or any other furnishing which pertains to the construction, assembly and perfecting of the said cupola or vault, may do so and ought to have done so by the end of next September. During the same period, should he wish to discuss anything with the said *Operaii* he will be well and graciously heard. Whoever may make such a drawing or

39

model or discuss the matter according to how he will subsequently do it, is hereby notified that he will be paid 200 gold ducats; and moreover, that whoever shall work or undertake anything concerning the said matter, will be rewarded for his work at the discretion of the said *Operaii* of the said work, even if his work should not be accepted. And they resolved it must thus be observed.

On the twentieth day of the said month, Marcus Lupicini, public crier, reported that it had been proclaimed on the aforesaid day.

21 Resolution of the Wool Guild ('Arte della Lana') to place Filippo Brunelleschi and Lorenzo Ghiberti under contract, 28 January 1426

Both Ghiberti and Brunelleschi had submitted models in 1418, and in 1420 had been appointed joint supervisors. Brunelleschi's biographer, Antonio Manetti, tells unconfirmed stories as to why he proved himself better than Ghiberti; the records certainly show that Ghiberti was suspended between June 1425 and January 1426, when the present contract was drawn up, bestowing nearly three times as much money on Brunelleschi.

Italian text in Guasti, 'La Cupola di S. Maria del Fiore', p. 42.

The consuls of the Wool guild and *Operaii* [of the cathedral works], being present and assembled together in the audience chamber of the aforesaid *Operaii*, after due ceremony have elected and confirmed as providers of the great cupola of the said enlarged church, Filippo di ser Brunelleschi, for the forthcoming year 1426 at the salary of 100 gold florins for the said year; and Lorenzo di Bartolo, goldsmith, for the same period of one year, with a salary of three gold florins for each month of the said year. This is on condition that the said Lorenzo shall be obliged to come and stay in the said building works for at least one hour on any working day, to supervise the building of the said cupola; and that both the

40

said Filippo and Lorenzo shall be obliged to provide for the edifice and perform all else that seems fitting for the good honour and use of the said works department and cupola. And during the said year, the said Filippo shall be obliged on the days when he is working on the said cupola to stay and watch over the same, without any break or interval.

The Statues at Or' San Michele, Florence

This famous oratory, the former corn market, enclosed with Orcagna's elaborate shrine in the mid-fourteenth century, was under the joint patronage of the guilds, which were expected to provide statues of their patron saints in niches upon the outside walls. Only a few had done so by 1406, when the commune ordered the rest to comply within ten years, the seven greater guilds were allowed to have statues in bronze. Ghiberti produced his bronze St John the Baptist for the Cloth Guild (Arte di Calimala) *in 1412-14; meanwhile Donatello made his marble St Mark for the Linen drapers* (Arte dei Linaiuoli) *in 1411-13, and his marble St George for the Armourers* (Arte dei Corrazzai) *was ready in 1417.*

22 Contract of Lorenzo Ghiberti with the Money-changers Guild ('Arte del Cambio') to make the Statue of St Matthew, 26 August 1418

This contract illustrates the rivalry which animated the patrons, though it does not suggest that the Money-changers were expecting for their St Matthew a figure whose dignity and stance — in spite of the sweep of drapery — were reminiscent of a Roman orator. It was ready in January 1422, slightly late, and Ghiberti was paid about 1100 florins, a rather higher sum than the Cloth Guild had paid him for their more 'Gothic' St John. Cosimo de' Medici was on the committee and contributed more than the others.

Italian text in A. Doren, 'Das Aktenbuch für Ghibertis Matthaeus Statue an Or San Michele',

'Italienische Forschungen,' ii (Berlin, 1906) 26; R. Krautheimer, 'Lorenzo Ghiberti' (Princeton, 1956) pp. 86-93; see also Gombrich, in 'Italian Renaissance Studies', p. 282.

26 August 1418

Be it manifest to whoever shall see or read the present writing that the noble Niccolò di Ser Frescho Borghi, Averardo di Francesco de' Medici, Giovanni di Barduccio di Chierichinio, Giovanni di messer Luigi Guicciardini (consuls of the said Guild of Money-changers of the city of Florence), and the wise Niccolò di Giovanni del Bellacio, Niccolò d'Agnolo Serragli, Giovanni di Micho Capponi, Cosimo di Giovanni de' Medici (four enrolled members and *operaii* of the said Guild), together hold the *balìa* concerning the matters written below ... Being assembled together in the House of the said Guild, they drew up the following contract for the niche and new figure of St Matthew, which they want to be made of brass and bronze in the niche newly acquired by the said Guild. After holding a diligent and secret scrutiny among themselves and taking a vote with black and white beans, they gave it to the below-named Lorenzo di Bartoluccio [Bartolo] of the parish of Sant' Ambrogio, who was present, willing and acting on his own behalf and that of his heirs. And with the said Lorenzo they signed the following clauses of agreement:

First, the said Lorenzo di Bartoluccio promises and agrees by a solemn undertaking with the said consuls and four Guildsmen to do the said figure of St Matthew in fine bronze at least as large as the present figure of St John the Baptist of the Guild of Merchants [*sic*],[1] or larger if it seems better, at Lorenzo's discretion. And the figure is to be cast in one or two pieces, and if in two pieces the head should be one, and the rest the other piece; and the weight of the said figure with its base should not exceed 2500 pounds. And he promises to gild the said figure either in whole or part, whichever seems best to the present and future consuls of the Guild, as they may require and ordain.

And he promises furthermore to have the said figure made by good and competent masters experienced in such things,

[1] For 'Arte di Calimala'.

43

and he himself, Lorenzo, promises to work continually on the said figure during the below-mentioned time and during the period appointed by the said consuls etc. And he promises to have the said figure delivered and completed and set up in the niche of the said Guild within three years from now, starting on the twenty-first of last July, saving any just impediment which must be explained to the consuls and *Operaii* or two-thirds of them.

The said Lorenzo furthermore promises the said consuls, members and *operaii* that he wishes to have for his salary and remuneration for the said work whatever shall be decided by them. And he promises not to claim to his own benefit the same sum he had as salary from the Guild of Merchants [*sic*][1] for the figure of St John, nor anything he has been paid by anyone else.

23　Resolution of the Wool Guild ('Arte della Lana') to commission the Statue of St Stephen from Ghiberti, 11 April 1427

The proceedings recorded here show, even more than the previous extract, the jealous emulation which the statues provoked. The Wool Guild had been exceptionally prompt in 1340 and commissioned a marble figure of St Stephen. For prestige, they wanted a new one in bronze, but authorised less money than the Moneychangers had paid. Ghiberti's St Stephen was smaller than the St Matthew, and the niche was not remodelled. This may have been partly because Ghiberti was now burdened with his commission to do a further pair of doors for the Baptistery [see nos. 24-5]. Meanwhile the Wool Guild mismanaged their own affairs to the extent of buying the materials in excessive bulk: in February 1429 they were trying to sell off 1080 lbs of brass and 200 lbs of bronze. They sold their original St Stephen to the Cathedral *Opera* (of which they were the patrons) for 175 florins.

[1] For 'Arte di Calimala'.

Latin text in Krautheimer, 'Lorenzo Ghiberti', doc. 107, pp. 385-6; see also pp. 93-5, 385-9.

11 April 1427

The aforesaid Consuls assembled together as usual in the palace of the said Guild, in sufficient number for the discharge of business (though in the absence of Ugolino di Francesco de' Oricellari), and considered the law signed by the Captains and Company of the Blessed Virgin Mary in Or' San Michele, enacting that for the adornment of the Oratory, each of the twenty-one guilds of the city of Florence should cause to be made and furnished the niche assigned to each of them by the said Captains of the said Company. And (as the said law more fully contains) that this should be well and decently done by a certain date, and the niche should be decorated with diligence for the honour of the city and adornment of the said Oratory.

And the aforesaid Lords Consuls considered the fact that all the guilds have fully completed their niches, and that the niches especially of the Guilds of the *Calimala* and Moneychangers so greatly exceed the niche of the Wool Guild in beauty and adornment, that in general it can be said that these Guilds have gained no small degree of honour above the Wool Guild, and have seriously assailed the magnificence of the said Guild, which has always wanted to be mistress and leader over all the other guilds. And the aforesaid Lords Consuls want to provide a sound remedy for the magnificence and honour of the said Guild. And so, with all the accustomed solemnities being observed, according to the form of the statutes and ordinances of the said Guild, they have ordained and solemnly resolved, by force of the authority and *balìa* conceded to them by the said Guild to employ every lawful way they can, that the present Lords Consuls and their successors in office, or two-thirds of them excluding the absentees, holding their present authority for the whole of the month of August, are obliged to have the niche or tabernacle remade and reconstructed, and the figure or image of St Stephen, protomartyr and protector and defender of the said famous Wool Guild, to the honour and reverence of God. It shall be done in whatever mode or form

45

seems most honourable and worthy of the magnificence of the said Guild, or to a majority of two-thirds of them; provided that the said niche exceeds or at least equals in beauty and adornment the more beautiful of the others. In making the figure and niche the said Lords Consuls, or two-thirds of them acting in the absence of the others, may spend up to the sum of 1000 florins. And the said Lords Consuls are to commission the said figure and niche during the said time from whatever person or persons, at whatever price or prices, fixing the contractual agreements as to time etc. as shall seem to them most useful to the said Guild.

The Third Pair of Doors for the Baptistery, Florence

Ghiberti completed the second (his first) pair of doors only in 1424. Another pair were almost immediately commissioned, the most celebrated of the three, which Vasari described as 'the finest masterpiece in the world whether among the ancients or the moderns', adding the famous remark attributed to Michelangelo, that they would grace the entrance of Paradise. Ghiberti himself in his 'Commentaries' described them as 'the most remarkable work I have done'.

24 Letter of Leonardo Bruni to Niccolò da Uzzano and a Committee of the Cloth Guild ('Arte di Calimala'), 1426

This letter provides one of the rare but significant documentary links between prominent Florentine humanists and artists in the 1420s. Bruni reveals something of his own taste and perhaps a certain superciliousness; however, he does not seem to have known that the patrons whom he was advising had already bestowed the contract on Ghiberti (no. 25), and the rather conventional programme for which he enclosed details was ignored, as was the offer of a sort of donnish supervision. Ghiberti, the self-styled 'new Lysippus', reduced the number of panels to ten, though each of these large panels contained several Old Testament stories, making a sum total of thirty-seven, which, it has been suggested, make a far better summary of the Old Testament on patristic lines and may suggest the advice of a different learned mind, Ambrogio Traversari, for instance. The work was certainly 'significant and resplendent', most of all perhaps for its 'Renaissance'

47

architectural settings, perspective, neo-antique details of costume and human form etc.

Italian text in Krautheimer, 'Lorenzo Ghiberti', doc. 52, pp. 372-3, also pp. 169-73. See also the recent discussion in essays by Gombrich, 'Norm and Form', pp. 4-8, 21, 138 n. 23; and on further humanist—artist connections, E. H. Gombrich, 'From the Revival of Letters to the Reform of the Arts: Niccolò Niccoli and Filippo Brunelleschi', 'Essays in the History of Art presented to Rudolf Wittkower'.

I consider that the twenty stories, which you have decided are to be chosen from the Old Testament, should have two qualities principally, being both resplendent and significant. By 'resplendent' I mean that they should delight the eye with the variety of their design; by 'significant' that they should be important enough to rest in the memory. With these two presuppositions in my mind, I have chosen according to my judgement twenty stories, which I am sending to you noted down on paper. It will be necessary for whoever does them to be well instructed about each story, so that he can render well both the persons and the actions which occur in it, and that he has a lightness of touch so that he can adorn them well. In addition to the twenty stories, I have made a note of eight prophets, as you see on the paper. Now I do not doubt that this work, as I have planned it, will succeed excellently. But I would very much like to be with whoever has the job of designing it, to make sure that he takes into account the whole significance of each story. I recommend myself to you.

Your Leonardo of Arezzo

25 Accounts for Ghiberti's Work on the Doors, 1424-52

These extracts recording Ghiberti's work on his second pair of bronze doors are taken from a register formerly among the archives of the Builders' Guild ('Arte dei Fabricanti') which also contains details and payments

48

for his first door, started in 1403. The attempt (in the first entry) to forestall any delays clearly was a hopeless one; this work consumed enormous time as well as expense. Ghiberti did not stress this in his own description of it.

Italian text in E. Müntz, 'Les arhives des arts' (Paris, 1890) pp. 15-21; see also Krautheimer, 'Lorenzo Ghiberti', pp. 370-2. Holt, 'A Documentary History of Art', pp. 160-3 gives an extract in translation of Ghiberti's own description.

2 January 1424

The excellent master Lorenzo di Bartolo di Michele was commissioned to make the third bronze door of the church of San Giovanni, with the stipulation that he should take on no other work until it is finished, which he little observed in making the second door, and that for his trouble and work he ought to have the sum which the Consuls etc. judge. He is to be paid at the rate of 200 [florins] a year.

1437

Michelozzo di Bartolomeo, who is working on the said doors, is to be paid 100 [florins] a year.

Lorenzo di Bartolo may keep the said Michelozzo for the work of the said door, Vittorio, the said Lorenzo's son, and three others.

1440

It has been decided to buy in Flanders 17000 pounds of fine brass to make the said door.

Matteo di Francesco d'Andrea da Settignano, working on the said door, is paid 14 [florins] a month.

1443

There still remain four of the ten stories to go on the said door, and it is agreed with Lorenzo di Bartolo that for the accomplishment of the said ten stories by his own mastery,

49

and for his labour, assistants, iron, wood and charcoal, he is to have 1200 [florins], or more or less at the discretion of the Officials, with the obligation to finish a sixth part every six months. Neither he nor his sons may take on any other work during this time, but he must keep his sons Tommaso and Vittorio continually at work on the said door. Francesco di Papi is appointed to make the frame of the said door.

17 August 1447

It was decided to pay 1200 [florins] to Lorenzo di Bartolo for finishing the stories of the said doors in conformity with what was agreed.

The said Lorenzo was paid 125 [florins] for making the crosspieces.

24 January 1448

Lorenzo di Bartolo was commissioned to do the rest of the third door, i.e. 24 compartments, completely cast and ready to be gilded, each 25 [florins] because we are sure that it takes a good master little less than three and a half months just to do one of them; and allowing for the time Lorenzo will take we add 3 [florins], making 28 florins each, amounting to a total of 672 [florins].

Twenty-four heads, which have to be made in wax, and the moulds for casting, and to complete and polish ready for gilding: we reckon to pay the said Lorenzo 300 [florins] for the expenses of his art, charcoal and wax.

To cast, and make in wax, the cornice above the lintel we reckon the said Lorenzo should have, until it is taken out of the mould, and for the firing and expense of his art 60 [florins].

To cast, and make in wax, the form of the lintel and the threshold, and for each jamb that he has designed and cast, a total of 320 [fl.].

To form in wax and cast about 12 compartment sections, each about 2.1/8 *braccia*, to place on the

jambs and on the lintel round the outside of the
door, where the foliage and animals are, and they
must be more beautiful than those on the door
already made. 30 [fl.] each, total 360 [fl.].

To carve a frieze in low relief on the inner side of the jambs
and on the lintel round the door, about 25¼ *braccia*, total
140 [fl.].

To cast the final frame for the door 100 [fl.].

All the above items have been commissioned from Lorenzo
di Bartoluccio and his son Vittorio, which not being finished
by the year 1450, they are newly contracted to finish within
twenty months from 1 February 1450.

19 March 1451: pivots commissioned from Tinaccio, son of
Piero, smith.

2 April 1452

The third bronze door of San Giovanni being finished, it was
commissioned for gilding to Lorenzo di Bartoluccio and
Vittorio his son for 100 [fl.] for their mastery and labour,
and all the other expenses of their art, to have finished by 20
June next.

16 June

The gilding of the said door was declared finished. 884 florins
were paid for the gold bought to gild the said door. The third
bronze door being wholly finished, it was hung upon the
doorway of San Giovanni facing S. Maria del Fiore.

Some Rigorous Contracts for Lay Fraternities

26 Contract of Piero della Francesca with the Company of the Misericordia, Borgo Sansepolcro, 11 June 1445

The terms of the contract for this famous polyptych, now reassembled at Sansepolcro, suggest that even if the mysterious Piero was appreciated in his home town, the pious fraternity which commissioned him was extremely tentative. In spite of the clause about completion, the work of painting seems to have continued at various times over the next fifteen years; and in spite of the clause demanding that it should be all his own work, his assistants are thought to have had a large part in the accompanying side panels of saints and the predella, though not of the famous central panel showing the Madonna with her cloak held open to protect the patrons kneeling below.

Latin text in G. Milanesi, 'Nuovi documenti per la storia dell'arte toscana,' p. 91. See also R. Longhi, 'Piero della Francesca', trans. L. Penlock (1930) pp. 35-41; Clark, 'Piero della Francesca,' p. 203.

11 June 1445

The following most worthy men, Piero di Luca Benedetti, Prior, and his councillors, Papus di Simone de' Doctis, Guasparre di Niccolò Martini and Ambrogio Massi [took counsel with] Giovanni de' Fichi, Giuliano de' Doctis, Giuliano di Matteo Ciani and Michelangelo Massi, elected *ad hoc*. On behalf of the Company and men of S. Maria della Misericordia they commissioned to Piero Benedetti, son of Piero Benedetti, the making and painting of a picture in the oratory and church of the said Company, to be done in the present fashion, with all his wood and equipment and

expenses for the whole furnishing and adornment of the painting, and for placing it in the said oratory. It must include the images, figures and adornment which will be expressly detailed by the above Prior and council, or their successors in office, and by the said other spokesmen, and it must be gilded and coloured with fine colours, especially ultramarine azure. This is on condition that the said Piero shall be obliged to restore at his own expense every blemish which the said picture may show in the course of time for the next ten years, on account either of the defect of the wood or of the said Piero. And for all the foregoing they have settled with him the payment of 150 florins, at the rate of 5 *lire* 5 *soldi* per florin. Of this sum they have promised at his request to pay 50 florins now, and the rest when the picture is finished. And the said Piero has promised to make, paint, embellish and erect the said picture according to the size and type of the painting on wood which is there at present; and to deliver it completed and placed in position within the next three years, according to the above conditions and qualities of the colours and fine gold; and that no other painter can put his hand to the brush except the said painter himself.

27 Contract of Benozzo Gozzoli with the Company of the Purification, Florence, 23 October 1461

This fraternity, like the Misericordia at Sansepolcro, was stringent about what it wanted of the painter and considered good value; there is something naïve about the requirement that the work should be better than, or at least equal to, anything Benozzo had painted before.
 Italian text in Z. Bicchierai, 'Alcuni documenti artistici non mai stampati' ('per nozze Gentile-Farinola Vaj', Florence, 1855); Kennedy, 'Alesso Baldovinetti', p. 240. The painting is in the National Gallery.

In the name of God, 23 October 1461
Be it noted and known by whoever shall see or hear the present writing that on the above-written day, Domenico di

Stefano, linen merchant and most worthy Florentine citizen, acting as Warden of the Company and Congregation of the Purification of the Virgin Mary, which meets in Florence near the garden beyond the church of San Marco, and with the security and in the name of the said Company, himself undertakes this deed, with the consent and will of Giovanni d'Agniolo, shoemaker, Francesco d'Antonio, mercer, and Ser Piero di Ser Andrea Bonci, Florentine notary, three members of the Company solemnly elected to a committee for the commission of the painting mentioned below. He hereby commissions Benozzo di Lese, painter, of the quarter of S. Maria del Fiore of Florence, here present, to make an altar painting ... *braccia* in length and width, according to the following conditions:

That the aforesaid Benozzo must at his own expense diligently make the plaster and apply the gold to the said picture, and render the whole and do all the figures and decorations to it, so that no other painter has any hand in painting the said picture, neither the predella nor any other part of it. And the said Benozzo is obliged to paint it in such a way that it exceeds all the good painting so far done by the said Benozzo, or at least equals it, and he must do the following figures on the said painting, in the manner and form detailed below:

First, in the middle of the said picture, the figure of Our Lady on the throne, in the manner and form and with the same decorations as the picture above the High Altar in San Marco, Florence. And on the right-hand side of the picture, beside Our Lady, the figure of St John the Baptist in his accustomed clothing, and beside him the figure of St Zenobius in pontifical vestments; and then the figure of St Jerome kneeling, with his usual emblems, and on the left-hand side the following saints: first, beside Our Lady, the figure of St Peter, and beside him St Dominic, and by St Dominic the figure of St Francis kneeling, with every customary ornament. And the said Benozzo must with his own hand paint at the foot, that is the predella, of the said altarpiece the stories of the said saints, each by the corresponding saint; and on the shield where it is customary to put the arms of whoever orders the picture, two children in white with olive wreaths on their heads, holding in their hands the

54

shield bearing the letters P S M in good form. And all the azure used for the picture must be very fine azure. And within it and at the sides must be all the adornments usual for such a painting. And thus the said Benozzo promises to the said Domenico and to each of the said members acting on behalf of the Company, that he will do all this at his expense. And on the other hand, the said Domenico promises in their name to pay the said Benozzo for all his expenses, gold, *gesso* and colours, 300 *lire di piccioli,* and in large florins at the current rate; which 300 *lire* are for all the mastery and labour of the said Benozzo. And the said Domenico promises the said 300 *lire* in the following manner, to reclaim from the said Company: 100 *lire* to be paid at present, and 80 *lire* in six months from now, and the rest of the sum when the said painting is finished; and to have this, the said Benozzo must furnish everything by the beginning of November next year at latest.

The said parties promise to observe all the foregoing stipulations in the said manner, the said Domenico for his part to the said Benozzo, and the said Benozzo to the said Domenicho and the other signatories, and to do nothing in contravention, under the penalty of double the said 300 *lire*, i.e. 600 *lire*; and the said parties wish that if any of the aforesaid things should be lacking, they will be held responsible and their goods or persons may be seized etc.

The Decoration of Guild Halls

28 Contract of Gentile and Giovanni Bellini for decorating the Scuola di San Marco, Venice, 15 July 1492

The 'Scuola' was a peculiarly Venetian institution, with no roots in economic or political life, as had the Florentine Guilds; its functions were social, religious and philanthropic. The Scuola of San Marco was one of the six greatest of these fraternities; it had suffered a disastrous fire in 1485 and its rebuilding was subsidised by the Senate. In spite of the family piety and professed indifference to money of the Bellini brothers, which appear in this decorating contract, neither was able to do very much in the Scuola, largely owing to their major commission in the Hall of the Greater Council.

Italian text in P. Paoletti, 'Raccolta di documenti inediti per servire alla storia della pittura veneziana nei secoli xv e xvi' (Padua, 1894-5) p. 17; see also P. Paoletti, 'La Scuola Grande di San Marco' (Venice, 1929) passim.

15 July 1492

Moved by divine rather than human inspiration, our dear and most beloved brothers Messer Gentile Bellini (at present our most worthy *Guardiano da matin*) and his peerless brother Messer Giovanni Bellini, in whose name the former also acts, are both desirous and avid to make a start, with their praise-worthy skill and art of painting, on the canvases which are to be done for the Hall of this our blessed Scuola. And this is in devotion and memory of their late father Messer Jacobo Bellini, who worked in the said Hall before the burning of the Scuola. This they offer to do not from desire for gain, but only to the end that it should be for the praise and triumph

of omnipotent God, offering themselves according to the conditions written below, viz:

They must start with all the upper façade of the said Hall on a single canvas, on which must be put such stories and works as shall be detailed by the Scuola, though in accordance with the advice and opinion of the said two brothers.

No arrangement is made concerning the fee, nor shall any other arrangement be made, save with reference to their work, their consciences and the discretion of experienced and intelligent persons.

Item, after doing the said work, they are obliged to do as many others in the said Scuola as they shall be ordered, either in excess of the estimate, or by way of making up the difference, for a further 25 ducats each, making 50 ducats, or a total of 100 ducats.

It is resolved that the Scuola bears the expense of everything that is required for the said work, as is just and honest. And in order that the work shall be worthy and deserving of praise, it shall be done with quickness and all possible solemnity. It is also understood that the said work cannot be given to anyone else to do, either in part or in any way at all, provided that the said brothers perform their duty.

All in favour of the motion, to the number of 15.

29 Contract of Giovanni Bellini for decorating the Scuola di San Marco, Venice 4 July 1515

The previous contract leaves open the prospect of more work in the future and this one, over twenty years later, reveals how little had been done to date. Gentile Bellini had painted his scene of St Mark preaching in Alexandria (now in the Brera Gallery, Milan), but other commissions, particularly in the Ducal Palace, and Gentile's death, had delayed the work for the Scuola. Giovanni Bellini started the work commissioned here, the Martyrdom of St Mark, but his own death in 1516

left it to be finished by Vettor Belliniano. The painting (still to be seen in the Scuola) appears to portray some officials of the Scuola on its bottom right side.

Italian text in Paoletti, 'Raccolta di documenti', p. 14.

4 July 1515

[Messer Bellini is commissioned] to make a painting on canvas in which he must paint a story of Messer San Marco, of how when he was in Alexandria he was dragged along the ground by those infidel Moors. And this painting has to go above the door of the Hostel Hall between the two walls, like the other painting above the bench where the Guardian and companions sit. The said picture is to be done by the said Messer Giovanni Bellini, according to the agreements written below as to time, price and conditions. The first of these is that the said Guardian and companions commission the painting from Messer Giovanni Bellini at the expense of the Scuola.

The said Messer Giovanni shall also be obliged to paint upon the said canvas the story written above, with houses, figures, animals and all other details, wholly at his expense, with colours and everything else rendered to perfection, as is fitting to the place, and as the excellence of the said Messer Giovanni's skill may require, and to better the painting opposite which his brother Messer Gentile did.

The Grand Guardian and companions promise to give to the said Messer Giovanni, as his fee for painting the above canvas, the same price the aforesaid Messer Gentile had on the same conditions.

The said Messer Giovanni is obliged to bring the said painting to perfection within the same time as the aforesaid Messer Gentile gave to the above work on those precise conditions.

The above Guardian and companions are obliged to pay the said Messer Giovanni as security for the above work 10 ducats in cash. They are furthermore obliged to pay money to Messer Giovanni from time to time according to the work he does. The said Guardian and companions and Messer Andrea, *provedador*, must from time to time go to view the

58

work and give to the said Messer Giovanni a sum according to the progress of the work. As security for the said Messer Giovanni, so that he has cause to work and so that he may know where he can have what has been promised him from time to time, he is allowed the advantage on the current state loans in the Chamber of State Loans (*Imprestidi*) in the name of Ser Nicolo Aldioni, which have been conceded to the works of the said Scuola, as appears by a motion passed in the general chapter.

I, Vettor Ziliol, Grand Guardian of the Scuola of Messer San Marco, am content as above.
I, Andrea Ruzier, *provedador*, am content as above.
I, Giovanni Bellini, am content as above.

30 Record of a Debate of the Money-changers Guild ('Arte del Cambio'), Perugia, 26 January 1496.

Unfortunately the detailed contract for the programme of lay heroes and virtues painted by Perugino in the Audience Hall of the Guild does not survive; but these proceedings illustrate the opening stages in this act of collective patronage.
 Latin text in Canuti, 'Il Perugino', ii doc. 256, pp. 189-90, see aslo vol i, pp. 134-5.

26 January 1496

A public and general meeting of the members and sworn associates of the Guild of Money-changers was convoked and assembled by the sound of a trumpet and public proclamation by the voice of the crier... [names of the thirty present] ... before whom the Auditors proposed the decoration of the Audience Hall, whether it ought to be decorated throughout with a number of pictures, by the hand of Master Pietro, or of another master. Concerning this matter the Consuls and Auditors may be heard.
 Francesco di Niccolò Tommaso, rising, counselled that if

and when the faculty of the hospital increased, which could be by the judgement of the Lords Auditors and the Prior, it should be done and be more honourable to all.

Alberto de' Baglioni said the same about the decoration.

Cardo Cinaglia, rising, said the same. About the decoration of the Audience Hall, he said that it ought to be adorned, painted or made more beautiful in whatever other way. In the judgement of the aforesaid speakers, men were to be elected who, together with the said Auditors, should have control of commissioning the work, making decisions, and expressly giving [instructions] as will seem right and pleasing to them.

Put to the vote, the motion was carried, with none against. Afterwards, the aforesaid Lords Auditors, wanting to proceed to the election of the said money-changers, nominated and elected the following money-changers and sworn fellows as the sworn representatives of the said Guild, as commissaries for the aforesaid business [six named].

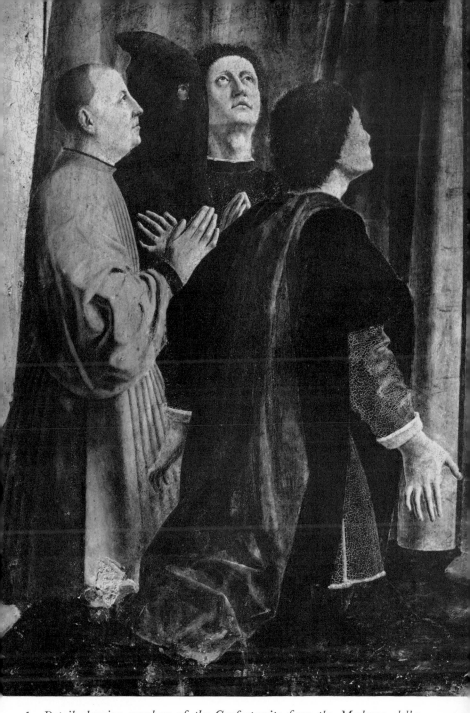

1 *Detail showing members of the Confraternity from the Madonna della Misericordia polyptych by Piero della Francesca (Pinacoteca, Borgo San Sepolcro)*

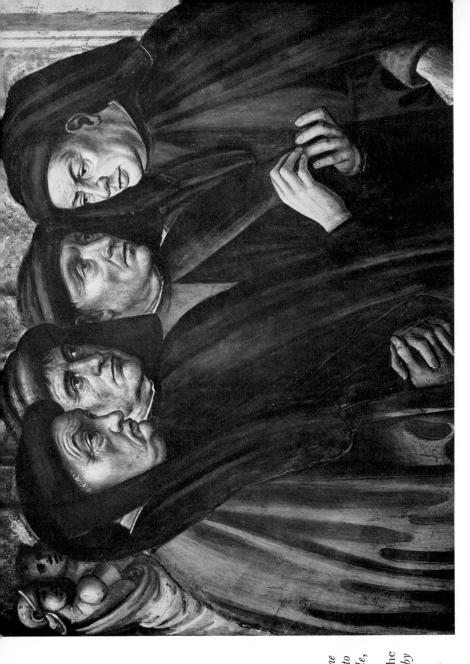

2 Detail from the scene of the Angel appearing to Zacharias in the Temple, showing Giovanni Tornabuoni (first on the left) in the fresco cycle by Domenico Ghirlandaio (Santa Maria Novella, Florence)

3 *The Battle of Love and Chastity* by Pietro Perugino (*Musée du Louvre, Paris*)

 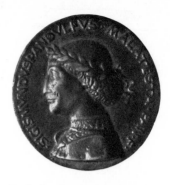

4 Commemorative medal showing Alberti's design for the façade of the Tempio
Malatestiano (San Francesco, Rimini) and the portrait of Sigismondo Malatesta
by Matteo de' Pasti

5 Detail showing crenellation from the façade of Ca' d'oro, Venice

PART III

Civic Patronage

The Pulpit outside Prato Cathedral

This open-air pulpit was not just for sermons, but for display of the Sacred Girdle of the Virgin which, having dropped into the hands of Doubting Thomas, was supposedly acquired by a Pratese nobleman in Constantinople about the time of the First Crusade. Regarded as proof of the Virgin's Assumption, the relic was clearly a matter for civic pride in Prato, the patron of the Chapel being the commune itself instead of a particular fraternity.

31 Contract of Michelozzo and Donatello with the 'Operaii' of the Chapel of the Sacred Girdle and the Commune of Prato, 14 July 1428

Despite the very specific instructions and agreements contained in this contract, it was not observed by Donatello, who nevertheless received payments over a considerable period for doing nothing.

 Italian text in C. Guasti, 'Il Pergamo di Donatello pel Duomo' di Prato (Florence, 1887) pp. 12-14; H. W. Janson, 'The Sculpture of Donatello' (Princeton, 1957) ii 109.

In the name of God, amen 14 July 1428

Be it manifest to whoever shall read the present writing that on the said day the wise and prudent men Ser Lapo, son of Messer Guido de' Migliorati, Niccolò di Piero Benuzzi and Paolo di Donato, all of Prato and *operaii* on behalf of the commune of Prato of the Chapel of the Glorious Virgin Mary in the principal church of Prato, in the absence of their

fellow Leonardo di Tato, and together with [names of representatives of the several quarters of Prato], deputed by the praiseworthy office of the Eight Defenders of the *Popolo* and Standardbearers of Justice, taking council with a good number of men of Prato, ordained and commissioned all the below-written matters, as appears publicly written in the book of decrees of the said Signoria of the Eight by the hand of Ser Iacopo da Colle, chancellor of the commune, under the twelfth of the said month.

All have agreed to commission on behalf and in the name of the said Opera and the commune of Prato the making and erection of the pulpit on the wall at the side of the church at Prato, where the precious girdle of the Glorious Virgin Mary is displayed. They commission both the industrious masters Donato di Niccolò di Betto [Donatello] of the parish of S. Cristofano del Corso and Michele di Bartolomeo di Gherardo [Michelozzo] of the parish of San Marco, Florence, masters of sculpture, but especially the said Michele, in his own presence acting also on behalf of the said Donato, according to the following agreements:

First, that they must alter the rectangular pilaster on the new façade into a fluted pilaster, in such a way that it is a suitable base for the pulpit.

Further, they must make the pulpit according to the form of the model they have left in the sacristy of the chapel, all in white Carrara marble and of the measurements mentioned below:

The pulpit should start 5¼ *braccia* above the ground, upon a cornice on which there are two little angels instead of brackets, each 2 *braccia* tall, and adorned with foliage as shown on the model. And above them a heavy cornice with carved dentils, and above this cornice a projecting ledge carved with leaves and profiles. And the base of the pulpit is to rest on this. And on this ledge there may be foliage or whatever the commissioners *operaii* please. And above this base shall be the rounded parapet of the pulpit, as the said model shows, divided into six spaces in which little angels are to be carved, holding between them the arms of the commune of Prato, or something else as the commissioners *operaii* of the work may please. This parapet shall be 5.2/3 *braccia* round the base. The diameter [floor] on the outside

64

shall be adorned with columns and cornices for sills as the model shows.

And the said masters are obliged to give the form and manner to be followed for the work on the front of the church, above the base of the pulpit and provide the master craftsmen of their choice, all at the expense of the said Opera; similarly chalk, ironwork and anything else needed for the work on the wall is to be at no cost to them, and whatever quantity of marble at present in the possession of the Opera . . . which they want.

And the said Michele promises on their joint behalf that the work will be accomplished by 1 September 1429, well and diligently done all at their own expense and according to the judgement of a good master. And as their reward and payment they ought to have of the goods of the Opera whatever sum in florins and *denari* as shall be named at the discretion and judgement of the famous Doctor of Medicine, Maestro Lorenzo d'Agniolo Sassi of Prato, Florentine citizen, to whom the said parties mutually agree . . . to commit the decision. And should he be unable to do so in the given time, or die . . . it will be remitted to the prudent ser Lionardo di ser Stefano di Macteo di Francho, notary and Florentine citizen.

And so that a start can be made, the said masters must be paid 350 florins, at the rate of 4 *lire* to the florin, in instalments as follows: 50 florins on 30 August next, and for each of the months of October and January next 50 florins, for the following April 100 florins, for July 1429 50 florins, and for the whole of September 1429, 50 florins. . ..

32 Letter of Matteo degli Organi to the 'Operaii' of the Chapel of the Sacred Girdle, 19 June 1434

This letter from a celebrated maker of musical instruments, interceding for the dilatory Donatello, illustrates the difficulty experienced by the patrons. So persevering was their determination to secure a work by his hand that a new contract was issued in May 1434, when

65

Donatello had at last returned from Rome. Even so, it was not until September 1438 that the work approached completion.

Italian text in Guasti, 'Il Pergamo di Donatello', p. 19; M. Cruttwell, 'Donatello' (London, 1911) p. 73.

To the worthy Operaii of the Chapel of Our Lady in Prato

Most dear Sirs
The cause of this letter is that Donatello has finished that story in marble, and I promise you that I know all the experts in this town are saying with the same breath that never has such a story been seen. And it seems to me that he has a good mind to serve you well, he wants us to know it now he is so well disposed; indeed, one does not come across these masters every day. He begs me to write to you for God's sake not to omit to send him some money to spend during this [St John's] holiday, and I charge you to do so; moreover, he is the kind of man for whom enough is as good as a feast, and he is content with anything. So that if the Opera must quieten him by usury, he wants the money to keep himself true to the purpose as he has begun, and no wrong will be done to us.

In Florence, 19 June 1434
Mactheo degli Orghani

33 Contract of Giovanni and Bartolomeo Bon with the Salt Office to construct the Porta della Carta, Venice, 10 November 1438

Venetian civic or state patronage generally involved a complicated procedure of collective decisions and subsequent administration through one or other of the revenue-collecting offices. The Salt Office which derived enormous sums from the traffic in this commodity, had a special responsibility for the exterior of St Mark's Basilica and the Doge's Palace. The Piazzetta entrance to

the latter may have been called 'Porta della Carta' owing to the proximity of the archives or of the desks of scribes and notaries, but what it clearly ought to have been called is 'Porta della Giustizia', since it was the entrance to the many Venetian courts and tribunals of justice as well as to the seat of government generally.

The Venetian judicial system was widely praised and cherished; the sculptures upon this entrance (as upon the neighbouring corner of the Palace) were intended to portray and commemorate it figuratively. Stylistically it has more transitional qualities than the Ca' d'oro (no. 105) though as Ruskin observed, it is also 'a climax of voluptuous Gothic'. The nude cherubs (mentioned in the contract) have a suggestion of Ghiberti and Donatello, as does the surmounting figure of Justice which was intended to stand out against the skyline; the figures of 'Temperance' and 'Fortitude' in the lower side niches were in fact sculpted by the Florentine Lamberti. The work is thought to have been mostly finished by 1443. The 'figure of St Mark in the form of a lion', before which kneels Doge Francesco Foscari, was badly damaged in 1797, and what one sees now in its place dates from the late nineteenth century.

Italian text in Paoletti, 'L'architettura e la scultura del Rinascimento in Venezia', i 37.

Agreement of Maistro Giovanni Bon, stone-cutter, and his son Bartolomeo

10 November 1438

The above are under agreement with Missier Tommaso Malipiero and his fellow 'Provveditori' of the Salt Office at the Rialto for the price of 1700 gold ducats, with the conditions and details written below, as appear in a written deed in his hand. I Giovanni Bon, stone-cutter of the parish of San Marzilian, and my son Bartolomeo, notify to you, the magnificent Signori Provveditori of Salt, acting in the name of the most illustrious Doge and Signoria of Venice, the agreements and conditions that we want you to observe towards us, and that we

67

must observe towards you: concerning the great door at the end of the palace at the side of the church of Missier San Marco. First you, the aforesaid magnificent Signori, must give and consign to us the stone for the frame of the said door, that is two pilasters, the lintel and the threshold above and below. As well as that you must provide the stone from Rovigno for the bases of the said doorway, for as much as it projects on both sides, and also you must provide in similar manner all the marble for carving the figures that will be required for the said door, and the marble for the foliage above the vault of the said door, within which nude cherubs are to appear, as in the drawing; and similarly you must give us the marble for making the necessary small columns, and St Mark above in the form of a lion. And for our part we the aforesaid Giovanni Bon, and my son Bartolomeo, promise to you, the aforesaid Magnificent Signori, to be obliged to furnish the same as above, with all the adornments that are required and with St Mark in the form of a lion, according to the drawing we did and consigned and gave into your hands, with the understanding that we must supply the stone except in the cases noted above, i.e. from Rovigno and Verona, and the said St Mark in the form of a lion we must do in the Rovigno stone provided by us.

We declare that it is understood we are obliged to do the tracery with its arches, so that it is carved both on the inner and outer sides, and that the said door with all its adornment on the sides must be of the width from the said church of San Marco to the palace, and the said door with all its adornments must be as high as the top of the upper balcony, and above it is to be rendered a marble figure representing Justice, according to the content of the said drawing. And if it pleases you that the said figure should be carved on both sides, we are content so to do it. And also the foresaid work is to be rubbed over and pumiced, and fitted neatly so that it looks well. And we are obliged to make and do everything in our art to accomplish the work.

Item, the said work has to be done within the next eighteen months.

Item, we are obliged to transport the whole of the said work to the site where it is to be put up but at the public expense.

68

The respected and generous lords missier Tommaso Malipiero, missier Antonio Marcello, Missier Paolo Valaresso and Missier Marco, 'Provveditori' of Salt at the Rialto, confirmed the above-written deed commissioning the work from Maistro Zuane Bon, stone-cutter, and his son Bartolomeo, on the above-written conditions, for the price of 1600 gold ducats.

...November

Sier Filippo Correr, son of Missier Polo, contributed 50 ducats.

34 Record by Neri di Bicci of his Contract with the Florentine Signoria, 15 August 1454

> Civic patronage of art was not suppressed in Florence by the Medici, any more than were civic institutions. This extract records a commission for the Audience Hall of the Priors in the Palazzo della Signoria; secular justice is again the obvious theme in this representation of Moses the Lawgiver to stand near the collections of the Civil Law. There is a record of an ancient copy of the Pandects of Justinian having been elaborately rebound for the Signoria in 1445, at a cost of 120 florins.[1] Possibly the other book was a Gospel of St John and the 'solemnities' records of the Council of Florence of 1439, but there is little evidence.[2]
>
> Italian text in Poggi, 'Il Vasari', i 332.

[1] A. C. de la Mare, 'Vespasiano da Bisticci, Historian and Bookseller' (Ph.D. thesis, University of London, 1966) p. 190, quoting C. Guasti, 'Capitolo del Commune di Firenze (Florence, 1866) i xvii n. 1.

[2] F. Baldinucci, 'Notizie de' professori del disegno' (Florence, 1681: 1845 ed.) p. 437.

I Neri di Bicci, painter, undertook to gild and paint a taber-nacle of wood in the antique style with columns at the side and architrave, frieze, cornice and pediment; and beneath a base all in fine gold. And in the painted panel of the said tabernacle I did first Moses and the four animals of the Evangelists, and in the front St John the Baptist, and around the said Moses and animals I did lilies of gold; and within the painting, which is to stand beside a cupboard containing the Pandects and another book from Constantinople, certain other solemnities of the people of Florence. All this I must do at my expense for the gold and silver and everything else except the wood, and have it set up in the place where it is to stand, that is in the Audience Hall of the Signoria. And the aforesaid Signori must give me for all the above — that is, gold, blue and my skill as a master — fifty-six *lire* by agree-ment. Tomaso di Lorenzo Soderini was Standardbearer, and involved in the work were Marcho di Christofano, joiner, and Antonio Torrigiani and others who I do not know.

I delivered the said work on 30 August 1454. And on 31 August I was paid as in the entry.

35 Letter of the Lieutenant of Bologna to Aristotele Fieravanti, 14 December 1464

Civic pride in the native artist is certainly expressed in this letter, though one might comment that the salary offered to Fieravanti was not unduly large: perhaps it was more in the nature of a retaining fee for part-time duties. Bologna was under a triple rule, of the papal legate, the dominant dynasty of the Bentivoglio and its surviving communal offices; this document is therefore difficult to classify, but its civic tone may justify placing it in this section. Aristotele's fame was mainly as a hydraulic engineer, and his major achievement lay in

building canals in Lombardy, but he also directed structural work; he was celebrated for straightening (or attempting to straighten) leaning towers. Perhaps there is a note of hyperbole in the letter: he is not generally regarded as a leading architect in the sense in which Vasari understood the term. But he was undoubtedly famous, travelling far afield to Hungary and even to Moscow.

Latin text in C. Gualandi, 'Memorie originali italiane risguardanti le belle arti', 5th ser. (Bologna, 1844) pp. 102-4. See also L. Beltrami, 'Vita di Aristotele da Bologna' (Bologna, 1912).

To our beloved citizen of Bologna, Aristotele Fieravanti, greetings in the Lord

The work of architects is exalted for all time: for without the art of architecture it is impossible for noble buildings, whether private or public, to be erected. Thus we judge it a matter for concern that in a city as magnificent as this architects should be exceptional: so that by their advice and work which they devote to the state many citizens will have buildings and great and noble palaces erected, which would not be possible without the embellishment of the city.

For this reason, considering how the Supreme Pontiffs and sovereign princes and lords have endeavoured to have you at their side, on account of your admirable genius and almost incredible works, we degree that you should be recalled immediately to your native city and be paid a salary from public funds so that you may live here honourably. This is because we are convinced that you have risen so high in your art that you have no equal not only in Italy but in the whole world. Many people bear witness to this, many nations among whom you have worked, and the whole genius of all the architects of the world (if it could be conjoined) knows about you, and it can indeed be said that no one knows anything in architecture which Aristotle of Bologna does not know. On the strength of this we elect you, most excellent man, and likewise constitute and appoint you the architect of this illustrious city of Bologna, at the pleasure of the Most Reverend Lord our Legate and the government of this city,

71

with the salary of 15 *lire* of Bologna which will be paid to you every month by the Camera, and with the emoluments, honours, privileges, prerogatives, dues and other attributes of the office. With this proviso; that whenever you are so ordered you must attend to the fortresses and castles of the commune, to which at all times you will be obliged to make repairs and restorations. For this you can claim no extra salary from the Camera.

We commend you in consequence to all whom it may concern to receive you from 1 January in the aforesaid office, and admit, favour and assist you and in all your concerns obey and satisfy you. And they are to be responsible for your salary and other perquisites at the usual times at the pain of our indignation and that of the Reverend Lord Legate.

Given at Bologna in our palace under the usual seal of the said Very Reverend Lord Legate, 14 Dec 1464

36 Contract of Giuliano da Sangallo with the Hospital of the Misericordia, the Provost and Deputies of the Commune of Prato, 4 October 1485

The site of a former prison at Prato became a place of pilgrimage after a child claimed to have seen the Virgin there in 1484, and a votive church was sponsored by the commune. The winning design, chosen upon the advice of Lorenzo de' Medici, was Sangallo's. His Greek cross plan has been described as one 'which ideally combines the centralising aspirations of the time with the symbolical reference to the form of the Cross'. Sangallo's patrons seem to have imposed rather stringent conditions, though they awarded him a special honorarium of 100 *lire* (in Florentine silver *denari*) on 4 November 1490 for his swift execution of the work.

Latin text in Milanesi, 'Nuovi documenti per la storia dell'arte toscana', pp. 136-9; see also G. Clausse, 'Les Sangallo' (Paris, 1900) i 85-101; Wittkower,

'Architectural Principles in the Age of Humanism', pp. 19-21.

4 October 1485

Drawn up in the town of Prato, in the quarter of Capo di Ponte, in the house of the Hospital of San Silvestro, or del Dolce, in the presence of Domenico di Blasio Bartoli of the quarter of Capo di Ponte, commissary of the said Hospital, and Domenico di Pacino Simone Galli and Antonio di Gerio Bernardi, timber merchant, both of the same quarter of Prato, witnesses etc.

It is set down that the eminent and ingenious Giuliano di Francesco Bartoli, otherwise known as da Sangallo, of the quarter of San Lorenzo-fuori-le-muri of Florence, the Florentine architect, has contracted his work as architect and overseer of building to the Reverend Father in Christ, Lord Carlo de' Medici of Florence, apostolic protonotary and most worthy Provost of Prato, and the following honourable men Girolamo di Lorenzo Cenni of Prato, hospitaller of the Misericordia of Prato, Braccio di Ser Leonardo Braccio of Prato, hospitaller of the del Dolce Hospital [and eight other *operaii*] all the foregoing being deputed by the said commune, as is set down in the records by Ser Niccolo Risorbolo of Florence, honourable Chancellor of the said commune. The said commissaries are acting on behalf of the commune and the said Oratory, in the absence of the aforesaid Provost. They have promised to the said Giuliano, architect, here present, acting for himself and his heirs, to perform and attend to all the following conditions that the said Lord Provost shall ratify, approve and publicly confirm, and he undertakes to devote his work and industry as architect and overseer in the building and raising of the new edifice of the church or oratory of Santa Maria delle Carceri in the town of Prato, near the citadel of the said town, according to the model made by the said architect, which model is at present in the hands of the said *operaii*.

And the said Giuliano has promised, . . . , to work to his utmost, faithfully, studiously and well, to do everything useful and omit anything useless, and to do all else concerning the foregoing and following with all the customary diligence of a good architect and master overseer, during the said

73

period of building the said Oratory, until it is perfected and completed according to the aforesaid model, and saving the following conditions.

And vice versa the said hospitallers and *operaii*, commissaries in this matter in the absence of the said Reverend Father the Lord Carlo, protonotary and Provost, all unanimously agree, on their own behalf and for their successors as *operaii* of the said Oratory and of the commune of Prato, to pay the said architect Giuliano 30 florins *di piccioli* as his salary for every day that the said Giuliano spends in Prato, for his work as architect and master overseer, and beyond this to pay the said Giuliano for the time he spends in Prato his reasonable expenses and the cost of one horse, and no more than this. This is on condition that the said Giuliano shall be obliged to come in person to Prato at every request of the said *operaii* or their successors, to devote his work to the said building, and to stay or leave the town at their every request. And should he not depart (when required) he cannot claim any salary from the day of dismissal until he does depart, saving however that the said Giuliano ought always to be provided with a horse and with materials and cartage for the said work, whenever he comes to Prato on business and returns on dismissal to Florence. And the said Giuliano may not hire, by himself or through others, any master plasterer or mason, or any master of carving stone or marble (known in the vulgar tongue as *maestro di pietra*) or any other manual workers for the said building, but the *operaii* and commissaries and their successors must employ and hire all the masters and workmen in the said building as seems fit and pleasing to them. With this exception: that the said Giuliano may hire and retain for the said new construction a master plasterer or a mason whom he wants, at his own choice and with freedom to dismiss him (or them) and substitute another (or others), the expense and materials being provided, so long as the said two master workmen are in agreement with the *operaii* concerning their wages. Also the said *operaii* must allocate to the said Giuliano all the wood required for the edifice, viz. for the roof, doors and windows, and everything else according to the said model, if he is willing to make them for the price agreed.

74

A Sienese Citizen in Demand: Francesco di Giorgio Martini

A possesive attitude was taken by the Sienese government towards Francesco di Giorgio Martini, the most versatile Sienese painter, sculptor, architect and designer of weird weapons of war and fortifications. Already in June 1485 he had been ordered to return home from his prolonged employment at the court of Urbino. After he had been reinstated as a citizen on 19 December 1485, his civic patrons lessened his availability by imposing public responsibilities upon him, not only those of building and engineering, but even administrative as well. The demands for his services elsewhere were nevertheless flattering enough for him to be released for certain periods to serve Duke Alfonso of Calabria and other patrons, among them (as the second letter below illustrates) the government of nearby Lucca.

37 Letter of the Balìa of Siena to Francesco di Giorgio Martini, 26 December 1485
 Italian text in Milanesi, 'Documenti per la storia dell'arte senese', ii 413; A. S. Weller, 'Francesco di Giorgio' (Chicago, 1943) doc. l, p. 355, and see also pp. 16-17.

26 December 1485

Certain citizens etc. have decreed and ordained that Maestro Francesco di Giorgio shall be taken for life into the service of the commune of Siena, meaning the Camera of the city of Siena, to attend to the needs of the towns and fortresses and other public works of the city, 'contado' and jurisdiction of Siena, as shall be ordained by the Magnificent Lords or

officials of the Balìa, or officials of the Guardia as they shall be appointed. And he shall be obliged to go throughout the 'contado' and jurisdiction of Siena wherever and however often any of the said magistrates shall ordain without any payment. And for his maintenance and the maintenance of his family and as a provision for the said obligation, he shall hereupon be given possessions and goods now or at a future date in the possession of the Camera to the value of 800 florins.

And I Francesco must return and stay in Siena within the next six months.

38 Letter of the Anziani and Gonfaloniere of Justice of Lucca to the Balìa of Siena, 29 August 1491

The intention of this letter seems to be flattery of the Sienese government as well as of the artist, and the suggestion that Francesco di Giorgio has no peer as an architect is a rhetorical exaggeration similar to what was said elsewhere of Fieravanti and Laurana (nos. 35, 104). The reflections upon his character are none the less interesting. They seem to bear out what Alberti wrote about the moral character and intellectual attainments required of an artist; the use of the words *humanitas* and *ingenium* is significant.

Italian text in Milanesi, 'Documenti per la storia dell'arte senese,' ii 443-4; Weller, 'Francesco di Giorgio', doc. xcix, p. 380, also p. 30.

Most illustrious and excellent Lords

Your Excellencies sent us for some days that excellent man Francesco di Giorgio, the distinguished architect, whom we have seen very gladly both because he is a Sienese, and because of the singular and excellent genius he has in his work, as clearly appears from the models made by him. We know him to be wholly modest, and of a kindly and liberal character. He returns to your Excellencies with the great love of ourselves and all the people, which he has inspired as much

76

through admiration of his genius as with his great humanity. We thank your Excellencies for your willingness to let us share a man of genius. It only remains, most excellent lords, for us to offer our congratulations to you and your most excellent republic, that you should have so good and modest a citizen and one so learned in architecture that in our judgement it seems that the whole of Italy does not have his equal. We commend ourselves to your Excellencies. From our palace, 29 August 1491.

The Ancients and Standardbearer of Justice of the People and Commune of Lucca

The Hall of the Greater Council of Venice

The Hall of the Greater Council in the Doge's Palace, where hundreds of Venetian patricians assembled for formal debates on legislation and the complicated elections of one another to innumerable offices of state, was the constitutional heart of the Republic. The interior decoration of this fourteenth-century Hall proceeded slowly. A start had been made with Guariento's great 'Paradise' behind the tribune, and in the 1420s a series was begun of paintings to illustrate historical achievements of Venice, dating in particular from the famous arbitration between Pope and Emperor in 1177; there were also to be portraits of every Doge. The original narrative paintings by Gentile da Fabriano and Pisanello soon deteriorated, and the documents below refer to the replacements for them and continuation of the scheme. The payment was met by funds raised from the Salt Office and the German warehouse or merchant association (Fondaco dei Tedeschi), but it had to be approved at all levels of government. It is noticeable that the voting in the Greater Council was nearly but not absolutely unanimous in favour; opposition may have been on the general grounds of cost, or particular hostility towards an individual painter. The Hall became the major work of the brothers Gentile and Giovanni Bellini for many years, though Alvise Vivarini (no. 41) and Carpaccio joined in. The eagerness of Titian (nos. 42-3) to take part in this prestigious project was not welcomed by the aged Giovanni Bellini; it is thought he was able to use the influence of patrician admirers to quash Titian's first commission, though the opposing faction influenced a report in December 1515 which criticised the slowness and great expense of the Bellini productions, and afforded Titian a new opportunity (no. 43). Destruction of all the wall decorations in the fire of 1577 led to the second series of replacements, still surviving, painted by Tintoretto and others.

Italian text in G. Lorenzi, 'Monumenti per servire alla storia del Palazzo Ducale' (Venice, 1868) i no. 189, p. 86.

Our faithful citizen of Venice, Gentile Bellini, the pre-eminent painter, has offered his services for the rest of his life to maintain the paintings in the Hall of the Greater Council, which for the most part have perished. He requires no salary, but for his maintenance he has humbly petitioned that something may be allowed him. And since the said Hall is among the foremost showpieces of our city we have judged it seemly to provide for its restoration and repair. Therefore, the motion is carried that by the authority of this Council the said Gentile shall be appointed to the work of restoring and renovating the paintings of the said Hall. And he shall be obliged to restore and repair them, when and where the work is needed, as committed to him by the 'Provveditori' of Salt, who must provide him with our expenses for colours and other things necessary to the said work. But in truth since every labourer is worthy of his hire, it may be agreed that in reward for his labours the first *sansaria*[1] of the *Fondaco* that falls vacant shall be conferred upon him for life by the authority of this Council. And if the Council is against, the matter will be suspended for this session.

For	943
Against	29
Undecided	21

40 Resolution of the Greater Council, 29 August 1478

Italian text in Lorenzi, 'Monumenti', i no. 195, p. 91.

On the motion carried in the Greater Council on 29 August 1478 it is decreed that our faithful citizen, the pre-eminent painter Giovanni Bellini, should be chosen to paint and

[1] 'Brokership'.

restore the Hall in which the Greater Council is assembled. And in reward for his skill and labour the said Giovanni shall have the first vacant *sansaria* or *misseteria* of the *Fondaco* of the Germans just like his brother Gentile, who was appointed to the restoration of the said painting. But as the aforesaid Giovanni needs to feed himself and his family and have a mind free for painting, in the meantime, until the said *sansaria* falls vacant, it has been determined and resolved by the below-mentioned Councillors [of the Doge] that the aforesaid Giovanni shall have 80 ducats a year from the Salt Office as the fee for his work, in addition to the expenses of colours and other things paid by the Office. And the money is to be given and paid from month to month with the emoluments and usages for which he looks for his convenience and the feeding of his household, until Giovanni has the *sansaria* of the aforesaid *Fondaco* of the Germans, the said provision then ceasing.

Councillors
Ser Stefano Malipiero Ser Benedetto Priuli
Luca Mauro Hieronymo Diedo

41 Petition of Alvise Vivarini to the Doge and Signoria, 28 July 1488

 Italian text in Lorenzi, 'Monumenti', i no. 221, pp. 102-3

Most Serene Prince and Excellent Signoria

I, Alvise Vivarini of Murano, being a most faithful servant of Your Serenity and of this most illustrious state, have long been desirous of showing an example of my work in painting, so that your Sublimity may see and know from experience that the continuous study and diligence to which I have applied myself has not been vain in success, but in honour and praise of this famous city. As a devoted son, I offer myself without any reward or payment for my personal

80

labour in making a picture to surpass myself; that is, to paint
it in the Hall of the Greater Council in the manner in which
the two Bellini brothers are working at present. Nor do I at
present demand for the painting of the said work anything
more than the canvas and expenses of colours and the
expenses of assistants to help me as the Bellini have. When I
have truly perfected the work, I will then remit it freely to
the judgement and pleasure of your Serenity, that from your
benignity you may deign to provide me with some just,
honest and suitable reward which in your wisdom you decide
the work to merit. I will go ahead with it hoping for the utter
satisfaction of Your Serenity and of all this most excellent
Lordship, to whose grace I humbly recommend myself.

[Subscribed] 28 July 1488

The Lords Councillors named below have admitted the above
petition of the industrious and pre-eminent painter Alvise
Vivarini of Murano, and thus order the noble 'Provveditori'
of Salt that they should put it into execution, causing the
same painting to be prepared in the place where the painting
of Pisan[ello] is and providing for the expenses of assistants
and colours according to the aforesaid petition.

Councillors Ser Luca Mauro, Ser Marco Bollani, Ser Marco
Trevisan, Ser Andrea Quirini, Ser Tommaso Lippomano

42 Petition of Titian to the Council of Ten, 1513

 Italian text in Lorenzi 'Monumenti', i no. 337, p.
 157. See also J. A. Crowe and G. B. Cavalcaselle, 'The
 Life and Times of Titian', 2nd ed. (London, 1881) i
 152-69.

31 May 1513 in the Council of Ten. The following suppli-
cation was read.

To the most Illustrious Council of Ten

Most Serene Prince and Excellent Signori, I, Titian of Cadore,

your devoted servant, set myself to learn the art of painting from childhood onwards, not so much from desire of gain as to be seen to acquire some small amount of fame, and be numbered among those who at the present time profess that art. And although in the past and even now I have been urgently sought after, both by His Holiness the Pope[1] and other Signori, I am anxious as a faithful servant of Your Sublimity to leave some memorial in this famous city. Therefore I have decided, all being agreeable, to undertake to come and paint in the [Hall of the] Greater Council, and to devote all my mind and soul to this for as long as I live. I shall begin, if it pleases Your Sublimity, with the canvas of the Battle scene on the side towards the Piazza, which is the most difficult, and nobody yet has wanted to attempt such a task. I should be willing to accept for my work any payment that might be thought convenient, or much less, but because as I have said above I value only my honour and way of life, as Your Sublimity's pleasure [I beg to ask for] the first *sansaria* for life that shall be vacant in the *Fondaco dei Tedeschi*, irrespective of other expectations, and on the same conditions, obligations and exemptions as are conceded to Missier Giovanni Bellini, and two youths as assistants, to be paid by the Salt Office, and all colours and other things necessary, as was conceded in past months by the said most illustrious Council to the said Missier Giovanni. In return for which I promise to do the work named above, and with such speed and excellence as will satisfy you, to whom I beg to be humbly recommended.

A vote was taken as shown below.

Heads of the Council of Ten:	Ser Girolamo Contarini
	Michele da Lezze
	Giovanni Venier
Petition accepted.	For 10
	Against 6

[1] Giovanni de' Medici, elected Pope Leo X in March 1513. This is a reference to the attempt of his friend Pietro Bembo to persuade Titian to come to the Court of Rome.

43 Petition of Titian to Doge Leonardo Loredan, 18 January 1516

Italian text in Lorenzi 'Monumenti', i no. 354, pp. 165-6; Gaye, 'Carteggio inedito d'artisti', ii 142. See also Crowe and Cavalcaselle, 'The Life and Times of Titian', i 152-69.

Most serene Prince

I Titian, servant of Your Serenity, have heard that you have decided to commission the painting of canvases for the [Hall of the] Great Council.[1] I want you to see a canvas of this type and artistry by my hand, which I began two years ago; and it is not the most difficult and laborious in the whole Hall. I undertake to cover it, as they say, all at my own expense, nor do I want any other payment before it is accomplished save only ten ducats for the colours, three ounces of the azure to be found in the Salt Office, and the payment on my account of one of the youths helping me, which will only cost 4 ducats a month, and I will pay another from my own purse and undertake all other expenses which will be involved in the picture, your Serenity making this promise about the Salt Office. On completion of this painting I would ask for my payment only half of the sum which was promised to Perugino some years ago for making the said canvas: this amounts to 400 ducats, he refusing to do it for less than 800;[2] and that at this time I should have my expectation on the *sansaria* in the *Fondaco dei Tedeschi* as was resolved in your most illustrious Council of Ten on 28 November 1514.

[1] I translate here as 'Great Council' since the Italian text gives 'gran conseio' instead of the more usual 'maggior consiglio' ('mazor conseio' in Venetian dialect). I have translated the latter as Greater Council, disregarding a convention among historians writing in English which ignores this comparative form. The 'maggior consiglio' was larger than any other constitutional body, and the small cabinet of the Doge was by contrast called the 'minor consiglio.'

[2] This refers to a verbal agreement, of which Titian seems to have hazy information, made between Perugino and the Salt Office in 1494. The contract was not notarially authenticated, and was void after Perugino tried in vain to beat up the price from the 400 ducats offered him. See Canuti, 'Il Perugino', i 94-7, and ii 25.

18 January 1516 in the College of Sages.

In execution of the recent decision[1] in the Council *de Pregadi* [Senate] the above resolution and obligation is accepted in all details, except that where it says 400 ducats read 300 ducats in payment, and 4 ducats a month shall be paid on his account to a youth as he asks, and he shall not have more than 10 ducats for colours and the 3 ounces of azure; however this is without prejudice to the expectation of the *sansaria* conceded to him by our Council of Ten in the event of this again becoming vacant, as is just and convenient.

For 20
Against 4

[1] On 30 December 1515 the Senate had discussed 'the excessive sum of money uselessly spent on the painters commissioned for the Hall of the Greater Council'. Francesco Valier, 'Provveditor al Sal', had inspected the paintings, and reported that two of them, which had already cost 700 ducats, had hardly been begun, and that a new master should be found to do one of them for 250 ducats. The motion was carried that all the painters should be sacked, and that the said 'Provveditor' of the Salt Office should be responsible for selecting the best painters available 'according to the judgement of those most expert in the art'. The voting was 150 For, 6 Against, 1 Undecided. (Lorenzi, 'Monumenti', i no. 353, p. 165.)

The Hall of the Great Council of Florence

The exile of the Medici in 1494 and the reinvigoration of republican institutions and ideals in Florence caused a certain revival of civic art patronage. One of the earlier acts of the new Signoria had been to confiscate the works of art of the Medici estate, endowing the various representations of tyrant-slayers, David, Judith and Hercules, with a new heroic significance when placed on public display. The most positive act of the new civic patronage lay in the government's plans for the Hall in the Palazzo della Signoria (significantly described now as the Palazzo del Popolo) where the Great Council assembled. The latter was thought to bear comparison with the Greater Council of Venice, so it was only fitting that there should be comparable decorations of its meeting-place. Few of the plans had been completed when the Republic collapsed in 1512.

44 Contract of Andrea Sansovino to make a Statue of Christ the Saviour, 10 June 1502

The political significance of this statue lay in the date of the coup d'état of 1494, 9 November, the Feast of the Saviour. This was promptly declared an annual holiday. Savonarola's dictum that Christ was King of Florence (Siena, after all, had long claimed the Virgin as mystical sovereign) may also have had something to do with this proposal to have a statue of the Saviour centrally placed above the seat of the Standardbearer of Justice which in 1502 became an office for life, held by Piero Soderini. Andrea Sansovino, who was also under contract to the Works office of the Baptistery, does not seem to

85

have done much towards fulfilling the contract before his summons to Rome by Pope Julius II.

Latin text in K. Frey, 'Studien zu Michelangelo und zur Kunst seiner Zeit', iiic: 'Die Sala dal Consiglio Grande im Palazzo della Signoria zu Florenz', 'Jahrbuch der königlich preussischen Kunstsammlungen', xxx, Beiheft (Berlin, 1909) 126. See also Poggi, in 'Rivista d'Arte', vi (1909) 144, and J. Wilde, 'The Hall of the Great Council of Florence', 'Journal of the Warburg and Courtauld Institutes', vii (1944).

10 June 1502

The most worthy *Operaii* of the Palazzo del Popolo of Florence . . . having heard of the fame and excellent genius of Master Andrea di Niccolò of Monte Sansovino in the *contado* of Florence, sculptor, master and nobleman in sculpture, and having seen a model done in his own hand of the Holy Saviour, consider that an image of the said Holy Saviour in white marble, enlarged from the model, would be very fitting in the Great Council Hall of the People of Florence. It should be placed above the entablature of the loggia of the magnificent and exalted Signoria and in the middle of the same, above the place of the Standardbearer of Justice, in eternal memory of St Saviour's Day, on that day when His festival is celebrated. And by vigour of their authority they have decided to commission from the said Andrea the image of the said Holy Saviour, to be done by his own hand and by no one else, the said image to be in white marble in the likeness of the said Holy Saviour and as shown by the model done by his hand. He is held to the same and to no other images and adornments than those of the said model to which they refer, and to work at and perfect the said image with his own hands and with the utmost diligence, vigilance and perfection. The sum deserved and agreed upon for price, labour and wage will be declared by the commissioners, the *operaii* of the Palace in office at the time, with the condition, however, that he takes a suitable oath to restore the whole sum of money which he should receive for making the said work if it is not rendered perfect; and they declare the afore-

said work must be made by the said Master Andrea with all
his expenses for marble and other things necessary.

45 Resolution of the Great Council concerning Leonardo
 da Vinci's Cartoon and Fresco, 4 May 1504

 Patriotic paintings of vast dimensions were com-
 missioned from both Leonardo da Vinci and
 Michelangelo; Leonardo's was based upon an episode in
 the Battle of Anghiari (1440), though only a part of his
 composition, the 'Fight for the Standard', is known,
 from a copy. This document bears the name of Niccolò
 Machiavelli, who may well have been responsible for
 arranging these terms, in an attempt to keep Leonardo
 hard at work. Payments to Leonardo are recorded
 throughout the year; he certainly finished the cartoon
 and began painting upon the wall of the Great Hall,
 though this work perished very quickly, according to
 Vasari because of the defective technique Leonardo
 used. However, it was not finished when he went to
 Milan in 1506, and the Signoria tried in vain to retrieve
 him.
 Latin text in Frey, 'Jahrbuch der Königlich
 preussischen Kunstsammlungen, xxx, Beiheft, 130-1; see
 also Wilde, in 'Journal of the Warburg and Courtauld
 Institutes', vii, and K. Clark, 'Leonardo da Vinci'
 (Cambridge, 1939) pp. 133-43.

4 May 1504

The magnificent and exalted Signori, the Priors of Liberty
and the Standardbearer of Justice of the Florentine People,
considering that Leonardo, son of Ser Piero da Vinci, under-
took some months ago to do a painting for the Hall of the
Great Council, and has already begun the cartoon for it, and
taken 35 large gold ducats for the same, and being anxious
that the work shall be accomplished as soon as possible, and
that Leonardo should be paid for it by instalments, have

87

resolved that the said Leonardo ought to have finished entirely the painting of the said cartoon and perfected it by the end of next February (1505) without exception, and that 25 florins should be paid to him for each month's work beginning on 20 April last. And should the aforesaid Leonardo not have finished the said cartoon within the same time, the aforesaid Magnificent Signori can then constrain him by any opportune way to pay back all the money he would have received for the work up to that date, and the said Leonardo must leave with the Magnificent Signori however much of the said cartoon as has been finished. And at the same time the said Leonardo is obliged to furnish them with his drawing for the said cartoon. And should it so happen that the said Leonardo had made a good start in painting upon the wall of the said Hall that part which he had designed and finished on the said cartoon, the said Magnificent Signori will then be content to pay him whatever monthly salary is convenient for such a painting, and as they shall agree with the said Leonardo. And in the event of Leonardo thus spending time on painting the said wall, the said Magnificent Signori will be content to prorogue and prolong the above-written period. And because it might also happen that within the time in which Leonardo has undertaken to finish the cartoon he may have no opportunity to paint on the wall, but have finished the cartoon according to his obligation, the Magnificent Signori will still be content and will not be able to commission the painting of it by another, nor in any way deprive him of it without his express consent, but will reserve it for the said Leonardo whenever he is in a position to be able to do it, and for whatever monthly salary they agree upon ... [here follows a stipulation that receipt must be acknowledged of all payments, and Leonardo's attestation].

Drawn up in the palace of the said Magnificent Lords in the presence of Niccolò, son of Bernardo Machiavelli, Chancellor of the said Lords, and Marco Zati, Florentine citizen, witnesses etc.

PART IV

Princely and Private Patronage

(i) The Medici of Florence

LETTERS OF PAINTERS TO PIERO, SON OF
COSIMO DE' MEDICI

*It has been argued recently that the Medici, who dominated
the Florentine republic from 1434 to 1494, were less openly
munificent in patronage than has sometimes been assumed;
that the patronage which Cosimo (d. 1464) gave to architects
and sculptors was piecemeal and cautious, while Lorenzo the
Magnificent (d. 1492) was a savant and connoisseur of art
rather than a direct employer of artists. Lorenzo's financial
difficulties and the loss of many of the works he
commissioned must, however, be taken into account. Piero,
who comes between these two as head of the family (d.
1469), seems to have had more direct dealings with painters
than Cosimo, as these letters testify.*

See in general the remarks by Gombrich, in 'Italian
Renaissance Studies' (reprinted in Gombrich, 'Norm and
Form'); also A. Chastel, 'Art et Humanisme à Florence
au temps de Laurent le Magnifique' (Paris, 1959) esp.
pp. 11-26.

46 Letter of Domenico Veneziano to Piero de' Medici, 1
April 1438

Domenico Veneziano is revealed here as not least an
artist in banal sycophancy, though his ambition to paint
the altarpiece for San Marco was foiled: the commission
went to Fra Angelico. The painting which he insists was
taking up all Fra Lippi's time (cf. no. 47) was 'The
Virgin Enthroned with Saints' for the Barbadori Chapel
in Santo Spirito (now in the Louvre, except for the
predella which remains in Florence at the Accademia).

Italian text in Gaye, 'Carteggio inedito d'artisti,' i 136-7. See also Gombrich, in 'Italian Renaissance Studies', p. 297; E. C. Strutt, 'Fra Filippo Lippi' (London, 1906) pp. 57-8.

Esteemed and noble sir

After the usual commendation. By the Grace of God I am well, and I hope this finds you well and happy. Many, many times I have asked for news of you and have never heard anything, except when I asked Manno Donati, who told me you were in Ferrara and in very good health. I have been much comforted by this, and having found out where you are, I am now writing to you as my consolation and duty. God knows that my humble position does not warrant my writing to your gentle lordship at all, but only the perfect and sincere love which I bear towards you and to all your family emboldens me to the point of writing, considering how much I am beholden and obliged to you.

I have heard just now what Cosimo has decided to have made, a painted altarpiece, and he wants a magnificent work. I am very glad about this, and should be even more glad if I might paint it myself, through your mediation. And should this happen, I hope to God I should produce something wonderful for you, equal to good masters like Fra Filippo [Lippi] and Fra Giovanni [Angelico], who have much work to do: Fra Filippo especially, as he has a picture for Santo Spirito which he is working on day and night, though he won't finish it in five years, it is such a big work. But though it may be that my very sincere inclination to do you service makes me presumptuous in offering myself, even should I do less well than anyone else, I want to be obliged to seize any opportunity of merit and to make every effort needful to do everyone honour. And if the work is so big that Cosimo decides to give it to more than one master, I beg you, so far as it is possible for a servant to beg his lord, that it will please you to turn your noble mind to bestowing favour upon me and help to arrange that I should have some part in the work. If only you knew how great my desire is to do a masterpiece, and specially for you, you would favour me in this. I am certain you would not regret it. I beg you to do all that is

possible; I promise that my work will bring you honour. Nothing else occurs to me at present, except that if I can do anything for you here, order me as your servant. And I beseech you not to omit to send me a reply about the afore-mentioned picture; above all let me know about your health, which I want to hear about more than anything else. May Christ be with you and attend to all your wants.

47　Letter of Fra Filippo Lippi to Piero de' Medici, 13 August 1439

In this display of self-pity, Lippi was wildly exaggerating his penury; he had in fact been paid 40 gold florins just recently. A similar note of hysterical urgency appears in a letter he wrote in 1457 to Giovanni de' Medici con-cerning a painting for presentation to the King of Naples, and more serious aspects of his treatment of patrons are illustrated elsewhere (no. 124).

Italian text in Gaye, 'Carteggio inedito d'artisti', i 141-2; see also Gombrich, in 'Italian Renaissance Studies', p. 297; Strutt, 'Filippo Lippi', pp. 60, 118-19.

In [the name of] Jesus, 13 Aug 1439

In reply to a letter I sent, I have heard from you after about thirteen days, which has caused me much loss. You reply that in conclusion you can agree to no other price for the picture, and that I should keep it for you, that for good or bad this is my lot and you cannot give me another farthing. This has been very painful to me for various reasons, and one of them is that I am clearly one of thy poorest friars in Florence — that's me. God has left me with six nieces to find husbands for, all sickly and useless. That small sum is a great deal for me, being what I am. If you could only let me have at your house a little corn and wine, which you could sell to me, it would make me very happy; you could debit it to my account. Tears come to my eyes when I think that if I die I shall leave it to these poor children. I tell you I have been to

Ser Antonio, servant of the Marquis, to ask what he wanted me to do; he said that for going to serve the Marquis he would lend us five florins at one florin interest, and on leaving the house I saw that he did not want so much as to lend me a pair of shoes. I beg you, two lines to the Marquis about Ser Antonio would not be asking too much of you, that I may be commended to him. Please send your reply the day after you receive this; it is clear to me that within a week I shall be dead, I am so fearful. For God's sake, reply to your house where I am delivering this, so that the same does not happen as to my other letter.

<div align="center">

Fra Filippo, painter in Florence
To Piero di Chosimo at Trebbio, in Mugello

</div>

48 Letter of Matteo de' Pasti to Piero de' Medici, 1441

Matteo de' Pasti also appears ardent in his desire to please, but this is a less grovelling letter than the two previous examples. His joy of discovering in Venice a new method of applying gold serves to emphasise the fact that gold embellishments still had a vogue and a future, in spite of their rejection by Giotto and, more recently, Masaccio. His reluctance to take any initiative over details may have been out of deference; on the other hand he may have preferred working to instructions. The subjects for the painting were taken from the 'Triumphs' of Petrarch.

Italian text in G. Milanesi, 'Lettere d'artisti italiani dei secoli xiv e xv', 'Il Buonarotti', 2nd series, iv (Rome, 1869) 78-9; see also Gombrich, in 'Italian Renaissance Studies', p. 298.

Admirable and honoured Sir

By this letter I beg to inform you that since being in Venice I have learnt something which could not be more suited to the work I am doing for you, a technique of using powdered gold

like any other colour, and I have already begun to paint the Triumphs in this manner, so that you will never have seen anything like them before. The foliage is all touched up with this powdered gold, and I have embroidered it over the maidens in a thousand ways. So I warmly beg you to send me instructions for the other fantasies, so that I can complete them for you; and if you want me to send these to you I will do so: you need only send me the order for what you want me to do and I shall be prompt to obey you in whatever pleases you. And I warmly beg you to forgive me for what I have done, because you know I was forced to do so. Resolve the matter as you wish, and if you so please, send me your instructions to go ahead with the Triumph of Fame, because I have details of the fantasy already, except that I do not know whether you want the seated woman in a simple dress or a cloak as I would like her to be. I know all the rest of what is to go in: the four elephants drawing her chariot, though I do not know whether you want young men and maidens surrounding her or famous old men; so please tell me all, because I shall make a thing of beauty in the way that pleases you. And forgive me for everything; what I am doing now will be worth more one day than all I have done before. So do me this gracious service, deign to let me have a reply, and let me finish it, so that you may see a thing that has never been done like this before, embellished with this powdered gold. I recommend myself to you.

Venice, 24 . . . 1441
From the least of your servants, Matteo de' Pasti

49 Letter of Benozzo Gozzoli to Piero de' Medici, 10 July
 1459

Gozzoli, engaged upon the famous 'Cavalcade of the Three Magi', the fresco cycle in the Chapel of the Medici Palace, professes his concern in this letter at his patron's reaction to a small feature he had introduced, and with no less deference than Pasti in the previous letter,

promises to remove it.

Gaye, 'Carteggio inedito d'artisti', ii 191-2; see also Gombrich, in 'Italian Renaissance Studies', p. 300.

10 July 1459

This morning I had a letter from Your Magnificence through Roberto Martelli;[1] and I learnt that it seems to you the seraphs I have done are out of place. On one side I did one among some clouds, and of this you hardly see anything except tips of the wings; it is so hidden and covered by the clouds that it does not deform the picture at all but rather adds beauty, and it is beside the column. I did another on the other side of the altar, but concealed in the same manner. Roberto Martelli saw them and said they were not worth worrying about. Nevertheless I will do as you command, two little clouds will take them away. I would have come to talk to you but I began putting on the azure this morning and could not leave it. The heat is great and the plaster gets spoilt in a second. I think I will have done with this scaffolding by next week, and I think you would like to have a look before I take it down. And furthermore I understand you have ordered Roberto Martelli to give me what I needed. He has given me two florins, enough for the time being. And I have gone on with the work as best I can: I cannot improve it without knowing what is wanted. God knows I have no thoughts heavier than this, and am continually on the look-out for ways in which I can satisfy you at least in all good faith. Nothing more occurs to me. I commend myself to Your Magnificence.

> Your servant
> Benozzo di Lese, painter in Florence

To the Magnificent Piero di Cosimo de' Medici at Careggi

[1] Roberto Martelli (1408-69) himself wrote to Piero de' Medici on 13 July 1459: 'I presented your letter to the painter and saw those two little cherubs [sic] which he had painted among some clouds, in my opinion they are not bad . . . he is diligent in the work and does good service.' See A. Grote, 'A hitherto unpublished letter on Benozzo Gozzoli's frescoes in the Palazzo Medici-Riccardi', 'Journal of the Warburg and Courtauld Institutes', xxvii (1964) 321-2.

50 A Sophisticated Programme for Botticelli? Letter of Marsilio Ficino to Lorenzo di Pierfrancesco de' Medici, c. 1477

The significance of this letter in relation to art patronage is only hypothetical; but upon it Professor Gombrich based his interpretation of one of the most perplexing of Renaissance allegories, Botticelli's painting known as the 'Primavera' in the Uffizi Gallery. Lorenzo di Pierfrancesco de' Medici, second cousin of Lorenzo the Magnificent, has long been recognised as the principal patron of Botticelli. Two other famous works, the 'Birth of Venus' and 'Minerva and the Centaur', were also painted for the young Lorenzo's villa at Castello, bought for him in 1477. This pedagogic homily ('a horoscope which is really an injunction') is characteristic of the strange, esoteric imagination of Marsilio Ficino, the Platonic scholar and neo-Platonic philosopher. In his astrological fantasy Venus is the Goddess not of concupiscent love, but of courtly love and *humanitas*, the Ciceronian attributes of moral excellence to which 'humanist' thinkers paid tribute and ascribed the motivation of their scholarly pursuits. Adding to this some details from the description of the Judgement of Paris in Apuleius' *Golden Ass*, which includes Venus, Mercury, the Three Graces and the Horae of Spring scattering flowers, Professor Gombrich proposed that we have here the programme suggested to Botticelli by or on behalf of his patron. It is a visual representation of *virtù*, rather than a simple illustration of the rites of spring from Lucretius, or of Poliziano's poem 'La Giostra' celebrating the Florentine beauty known as 'Bella Simonetta': an educational icon appealing directly to the patron as he beholds the work.

Latin text translated by E. H. Gombrich, 'Botticelli's Mythologies: A Study in the Neo-Platonic Symbolism of his Circle', 'Journal of the Warburg and Courtauld Institutes', viii (1945) 16-17. Professor Gombrich generously allowed his translation to be used here. Other interpretations of the painting are expounded by E. Wind, 'Botticelli's "Primavera" ', 'Pagan Mysteries in

the Renaissance', 2nd ed. (Oxford, 1966) pp. 113-27; C. Dempsey, 'Mercurius Ver: The Sources of Botticelli's "Primavera" ', 'Journal of the Warburg and Courtauld Institutes', xxxi (1968).

My immense love for you, excellent Lorenzo, has long prompted me to make you an immense present. For anyone who contemplates the heavens, nothing he sets eyes upon seems immense but the heavens themselves. If, therefore, I make you a present of the heavens themselves what would be its price? But I would rather not talk of the price; for Love, born from the Graces, gives and accepts everything without payment; nor indeed can anything under heaven fairly balance against heaven itself.

The astrologers have it that the happiest man is he for whom Fate has so disposed the heavenly signs that Luna is not contrary in aspect to Mars and Saturn, that furthermore she is in a favourable aspect to Sol and Jupiter, Mercury and Venus. And just as the astrologers call happy the man for whom Fate has thus arranged the heavenly bodies, so the theologians deem him happy who has disposed his own self in a similar way. You may well wonder whether this is not asking too much — it certainly is much, but nevertheless, my gifted Lorenzo, go forward to the task with good cheer, for he who made you is greater than the heavens, and you too will be greater than the heavens as soon as you resolve to face them. We must not look for these matters outside ourselves, for all the heavens are within us and the fiery vigour in us testifies to our heavenly origin.

First Luna — what else can she signify in us but that continuous motion of the soul and of the body? Mars stands for speed, Saturn for tardiness, Sol for God, Jupiter for the Law, Mercury for Reason, and Venus for Humanity.

Onward, then, great-minded youth, gird yourself, and, together with me, dispose your own heavens. Your Luna — the continuous motion of your soul and body — should avoid the excessive speed of Mars and the tardiness of Saturn, that is, it should leave everything to the right and opportune moment, and should not hasten unduly, nor tarry too long. Furthermore, this Luna within you should continuously behold the Sun, that is God himself, from whom she ever

receives the life-giving rays, for you must honour him above all things to whom you are beholden, and make yourself worthy of the honour. Your Luna should also behold Jupiter, the laws human and divine, which should never be transgressed — for a deviation of the laws by which all things are governed is tantamount to perdition. She should also direct her gaze on Mercury, that is on good counsel, reason and knowledge, for nothing should be said or done for which no plausible reason can be adduced. A man not versed in science and letters is considered blind and deaf. Finally she should fix her eyes on Venus herself, that is to say on Humanity. This serves us as an exhortation and a reminder that we cannot possess anything great on this earth without possessing the men themselves from whose favour all earthly things spring. Men, however, cannot be caught by any other bait but that of Humanity. Be careful, therefore, not to despise it, thinking perhaps that *humanitas* is of earthly origin.

For Humanity herself is a nymph of excellent comeliness, born of heaven and more than others beloved by God all highest. Her soul and mind are Love and Charity, her eyes Dignity and Magnanimity, the hands Liberality and Magnificence, the feet Comeliness and Modesty. The whole, then, is Temperance and Honesty, Charm and Splendour. Oh, what exquisite beauty! How beautiful to behold! My dear Lorenzo, a nymph of such nobility has been given wholly into your hands. If you were to unite with her in wedlock and claim her as yours she would make all your years sweet.

In fine, then, to speak briefly, if you thus dispose the heavenly signs and your gifts in this way, you will escape all the threats of fortune, and, under divine favour, will live happy and free from cares.

51 Lorenzo the Magnificent as Arbiter: Letter to Lorenzo from the Commissioners of the Tomb of Cardinal Forteguerri, 11 March 1478

A monument to Cardinal Forteguerri (d. 1474) for the richly endowed confraternity church of San Jacobo,

Pistoia, had been first proposed in 1474 as a civic tribute to his memory. This letter illustrates the deferential manner in which Lorenzo's opinion as a *cognoscente* might be sought, even though he was not concerned as patron. His reply does not survive, but evidently it was firmly in favour of Verrocchio; another letter six days later from the *Operaii* deferred to his opinion most apologetically. Whether on account of hurt pride or pressure of other commitments, Verrocchio did not complete the work; part was undertaken by his assistants, but it was left unfinished until the eighteenth century.

Italian text in Gaye, 'Carteggio inedito d'artisti', i 256; M. Cruttwell, 'Verrocchio' (London, 1904) pp. 252-3 (see also pp. 126-39). On the church of San Jacobo, see D. Herlihy, 'Medieval and Renaissance Pistoia' (New Haven, Conn., 1967) pp. 254-6.

Magnificent Sir and our singular benefactor [after the accustomed recommendations etc.]

We need to trouble Your Magnificence with our present problems. The matter is as follows: after the death of Monsignor [Niccolò Forteguerri] of Thiene, our most esteemed compatriot of blessed memory, it occurred to this community to make some public act in memory of his most reverend Lordship, and because of the benefits this city received from him. Upon our advice it was resolved that 1100 *lire* should be spent on his tomb and memorial, and it was committed to us citizens to have five models made. When these were ready, they were to be referred to the council, and whichever the council chose should be commissioned. Thus five models were presented to the council, among them one by Andrea del Verrocchio, which was liked more than the others; and the council commissioned us to discuss the price with the said Andrea. On our doing this, he asked for 350 ducats, whereupon we took our leave without committing ourselves, because we had no commission to spend more than 1100 *lire*. And being anxious that the work should go forward, we returned to the council saying that we needed more money for the said work than 1100 *lire* if a worthy

thing was desired. The council, on hearing the facts, deliberated again and gave us authority to spend whatever sum of money we saw fit for the said work so long as it was beautiful, and allowed us to commission it from the said Andrea or from any other we saw. Wherefore because we understood Piero del Pollaiuolo was here, we went to see him and asked him to make a model of the work, which he promised to do, so that we postponed commissioning the work. It now transpires that our commissaries have commissioned the work, in order to ensure its execution, from the said Andrea for the said price and manner of design; and we, as obedient sons concerning everything they do and decide, will be content to obey, and thus we have written to them. Now Piero del Pollaiuolo has made the model we asked him for, which seems more beautiful and more worthy artistically, and is more pleasing to messer Piero, brother of the said Monsignore, and all his family, as it is to us and to all the citizens of our city who have seen it, than is Andrea's or anyone else's. For this reason we have begged the said commissaries to make some compensation to Andrea but to accept Piero's model: this will give us satisfaction and much pleasure. We are now sending the said models to you as our protector, because you have very deep understanding of these things as of everything else, and because we are sure that you desire the honour of the said Monsignore and his family and all our city. If, as it seems to us, we are right, lend us your help and favour; our desire has no other motive than the honour of the city and the memory of the said Monsignore. From Pistoia, 11 March 1477.

Your servants the *Operaii* of San Jacopo, officials of the Sapientia and citizens elected as the council concerning the said work in Pistoia.

To the magnificent Lorenzo de' Medici, our special benefactor in Florence

52 Humorous Familiarity towards Lorenzo the Magnificent: Letter to Lorenzo from Bertoldo, 29 July 1479

This curious letter, full of private jokes and allusions, illustrates the close familiarity existing between Lorenzo and Bertoldo. Keeper of the Medici collection of antiques and a practising sculptor (as he professes here, a pupil of Donatello), Bertoldo was famous particularly for his neo-antique bronzes. One allusion is obvious: Count Girolamo Riario is maligned on account of his involvement in the Pazzi Conspiracy against Lorenzo and Giuliano de' Medici in 1478, which had led to the war with the papacy, still in progress at the time this letter was written. The rest is more obscure. Professor Gombrich, who described Bertoldo as 'a kind of valet de chambre', suggests it is an oblique warning about poison. An ingenious interpretation was put forward recently by A. Paronchi that the main target of Bertoldo was Bartolomeo Scala, the humbly born Chancellor of Florence, whose palace courtyard Bertoldo was decorating. Bartolomeo Scala is thus Luca Calvanese of Prato; the name Luca is unexplained,[1] but the rest is a pun alluding to his baldness and tallness, and to the ridge called La Calvana above Prato. Bertoldo also plays upon Bartolomeo's notorius love of eating, which the poet Pulci derided; but the main allusion is to his own weariness with all Scala's suggestions for his courtyard, derived from the artist's own sketch book of Roman antiquities, i.e. the 'cookery book'. Finally, 'Gaius Antonius', from whose encampment the letter is addressed, was an admirer of Cicero; so too was Bartolomeo as a good 'civic humanist'. What is not altogether clear from this is why Bertoldo should have indulged in the dangerous game of playing off one patron against another, and have associated the Chancellor of Florence with Lorenzo's worst enemies, capable of treasonable intrigues ('peppery stews'). There may after all be a simpler explanation in terms of some professional rivalry.

[1] Possibly an allusion to 'Luca bos', 'elephant'.

102

Italian text in W. von Bode, 'Bertoldo und Lorenzo de' Medici' (Freiburg im Breisgau, 1925) pp. 11-13; see also A. Paronchi, 'The language of Humanism and the Language of Sculpture: Bertoldo as the Illustrator of the Apologi of Bartolomeo Scala', 'Journal of the Warburg and Courtauld Institutes', xxvi (1964) esp. pp. 130-6; Gombrich, 'Norm and Form', p. 310.

Magnificent Lorenzo

I have just this moment chucked out my chisels, scalpels, compasses, set-squares, wax, straw, architecture and perspective, given that moulding four kicks and sent back the clay to the potter to make into rubbish-pots. For I learn that the peppery stews of Master Luca Calvanese, our commandant of Prato, are more valued by Count Girolamo than all the other skills, sciences or arts, since they have raised him to a knighthood. And because I now know the said skill of cookery is not a natural gift with Luca, but science, piggishly acquired by virtue of my cookery book, I believe that the most polished work I ever made for you was when I gave you[1] two handfuls of cooked warblers at Monte Guffoni. For this reason I have resolved to abandon all the other arts and devote myself to cookery, and I therefore beseech your Magnificence to commend me to the officials of the Grascia[2] who control the cooks, that I may get back my book, for I hope shortly that Luca of the peppery stews will not be fit to hold the sieve. I wish to God I had been under that fool rather than under Donatello. With the way the wind blows, I would scarcely have made two *giacomini* or two jellies before the Count would have made me Prior of Pisa. And he might like to say he had done it on behalf of the Head of the Giants, or some other head about whom it would be best to say no more, I leave it for you to judge, being a

[1] The Italian text changes the person in the two verbs: 'Ia più pulita cosa facessi mai fu quando vi dette . . .'. They are both translated here in the first person; Paronchi prefers the third.

[2] The Grascia officials were a committee of six responsible for supervising the quality and price of certain types of food and artisan products in Florence. See Martines, 'The Social World of the Florentine Humanists', p. 158.

disciple of Donatello. Above all I beg you to see that I get back my cookery book before Messer Luca takes possession of it, for if I had it, I should be emboldened to put him, the hateful mule, his boy and his benefice, into a pie and cover it with pepper without sieving, and then make plague pills out of it. May God put the sickness on all that court, and I pray I may see the P[ope], the Count and Luca smothered in a vat of peppery stew. And be on your guard against their treacheries.

From the encampment of Gaius Antonius in solitude
From your servant Bertoldo

To the Magnificent Lorenzo de' Medici, my most singular Lord, 29 July 1479, from the sculptor Bertoldo

53 Did Lorenzo pay his Bills? Inventory of Andrea Verrocchio's Works for the Medici drawn up by his Brother after Lorenzo's Death in 1492

Tomasso Verrocchio, Andrea's younger brother, had been appointed heir to Andrea's debts in his will; the artist had already been burdened by Tomasso's own financial troubles (including his unmarried daughters), and Tomasso may well have composed this list in order to try and get what he could. Since the prices are not filled in, it appears that he was not at all well informed about what his brother was really owed. It is hardly credible that Lorenzo can have paid for none of these items; the 'David', which had been made for Piero (d. 1469), was resold by Lorenzo and Giuliano in 1475 to the Signoria, when they received 150 florins. The principal interest of the document is that it constitutes a very ample list of commissions. Not to be overlooked are the painted standards, a form of work frequently required by religious as well as secular patrons, and masks, an even more ephemeral item.

Italian text (from a copy made slightly later than the

104

original) in Cruttwell, 'Verrocchio', pp. v, pp. 242-4 (see also pp. 30-1; Gombrich, 'Norm and Form', p. 306).

Drawn up by Tomasso Verrocchio 27 January 1496

The heirs of Lorenzo de' Medici owe payment as follows for these works:

For a David and the head of Goliath	— florins
For the red nude	— fl.
For the bronze baby, together with 3 bronze heads and 4 lions' mouths in marble	— fl.
For a marble figure which spouts water	— fl.
For a story done in relief, with several figures	— fl.
For making good all the heads above the exits to the courtyard in Florence	— fl.
For a painting on wood of the head of Lucrezia de' Donati	— fl.
For the standard for Lorenzo's joust	— fl.
For the figure of a lady done in relief on a helmet	— fl.
For painting a standard with an angel for Giuliano's joust	— fl.
For the tomb stone of Chosimo at the foot of the High Altar in San Lorenzo	— fl.
For the tombstone of Piero and Giovanni de' Medici	— fl.
For engraving 80 letters in serpentine in the two roundels upon the said tombstone	— fl.

For twenty life-like masks — fl.

For the arms and accoutrements of Duke Ghaleazo — fl.

54 The Value of the Medici Picture Collection in Florence: Extracts from the Palace Inventory, 1492

By far the greater part, and certainly the most highly valued part, of the moveables in the Medici Palace, listed after the death of Lorenzo de' Medici in 1492, were gold and silver ornaments, jewelled rings, cameos, ancient busts etc., certainly not the paintings. Whether or not one reckons this document to be evidence of a discerning collection of paintings (and it was not the entire collection of the ruling line of the family, only what was in their town residence), it clearly took second place beside the other items they were collecting. It seems that to collect paintings was not a financial investment in the modern sense, whereas collecting *objets d'art* decorated with precious metals or jewels clearly was. The estimated value of each painting seems remarkably low, and the works of painters long since dead, Giotto, Massacio or Fra Angelico, do not appear to have appreciated in value. Size seems to have been a criterion (compare the relative assessments of paintings by Angelico); but often the valuations do not stand comparison with current prices paid for newly executed works of art.

It is not possible to include the whole inventory here, but the most important paintings and a few other items are shown. By comparison, the cameos set in gold rise to an average of about 500 florins in value; one item, the 'Tazza Farnese', reaches the fantastic figure of 10,000 florins.

Italian text in E. Müntz, 'Les collections des Medicis au xv siècle' (Paris, 1888) pp. 58 ff.

In the chamber of the Sala Grande *above the loggia*
Two paintings on wood above the chimney piece:
a St Peter and St Paul by the hand of Masaccio 12 florins

A painting of Italy 25 fl.

A painting on wood of Spain 12 fl.

In the first chest, a tapestry to hang on the wall,
20 *braccia*, of the Duke of Burgundy hunting 100 fl.

Large ground-floor chamber called Lorenzo's chamber
Six panels in gold frames above the sofa and bed,
12 *braccia* long and 3½ *braccia* high; three of them
paintings of the Rout of San Romano, one of battles between
dragons and lions, one Story of Paris by the hand of Paolo
Ucello, and one by the hand of Francesco di Pesello showing
a hunt 300 fl.

A large roundel in a gold frame on which is painted
Our Lady and the Magi coming to make their
offerings, by the hand of Fra Giovanni [Angelico] 100 fl.

A painted panel of the head of St Sebastian and other figures,
with the arms and balls,[1] by the hand of Squarcione 10 fl.

A painted panel of St Jerome pronouncing
excommunication, with six small paintings 10 fl.

A painted panel of the head of the Duke of Urbino,
with frame 10 fl.

A painted panel of the head of Duke Galeazzo [Sforza]
by the hand of Piero del Pollaiuolo 20 fl.

The Great Hall of Lorenzo (Sala Grande)

A canvas above the entrance, 5 *braccia* long,
framed in gold, painted with the figure of St John,
by the hand of Andrea [del Castagno] 15 fl.

[1] Insignia of the Medici.

A canvas, framed in gold, 6 *braccia* square,
painted with Hercules killing the Hydra 20 fl.

A canvas, framed in gold, 6 *braccia* square, painted
with Hercules wrestling with the lion 20 fl.

A canvas above the entrance, 4 *braccia*, framed
in gold, showing caged lions, by the hand of
Francesco di Pesello 4 fl.

A canvas of 6 *braccia*, framed in gold, painted
with Hercules lifting Antaeus. All these labours
of Hercules are by the hand of Pollaiuolo 20 fl.

In the anteroom of the Great Hall

A small painting of Our Lord dead, with many saints
bearing him to the sepulchre, by the hand of Fra
Giovanni 15 fl.

A small marble panel by Donato of the Madonna with
the Child at her neck 6 fl.

A gilded bronze panel of Our Lady with the Child

A painted panel with gold frame of St Jerome and
St Francis, by the hand of Pesello and Fra Filippo 10 fl.

A small painting of Our Lord on the Cross with three
other figures, by the hand of Giotto 6 fl.

A marble panel in low relief with St John and many
figures and other things in perspective, by
the hand of Donato 30 fl.

A small roundel of the Madonna by the hand of Fra
Giovanni 5 fl.

A roundel, 2 *braccia* high, of the Story of the
Magi, by the hand of Pesello 20 fl.

108

A *colmo*,[1] 2½ *braccia*, of Rome 20 fl.

A *colmo*, 2½ *braccia*, with the universe painted
on it 50 fl.

A small marble panel above the door of the writing
room, with 5 antique figures 10 fl.

A small marble panel with antique figures 5 fl.

A *colmo*, 3½ *braccia*, with Italy painted on it 25 fl.

A *colmo*, 2½ *braccia*, with two heads done
from life, of Francesco Sforza and Gattamelata, by
the hand of a Venetian

Writing-room (Schrittoio)

A small painting of ¾ *braccia*, of the descent of
Christ from the Cross with nine figures, by the hand
of Giotto

A painting on a *chasetta* of Judith
with the head of Holofernes and a serving girl,
a work of Andrea Squarcione 25 fl.

A small Flemish painting of St Jerome in his study,
with a small cupboard containing books in perspective,

[1] 'Colmo' normally means a top or summit, but the word also has adjectival meaning: 'convesso', 'in rilievo', 'tondeggiante' (Battaglia's Dictionary, reference thanks to Mr. J. Larner) which suggests a round painting ('tondo') in relief. A more precise meaning is given in Tommaseo's Dictionary, for which reference I am grateful to Dr C. H. Clough: 'in the past this term was used for certain round panels, 1 *braccio* in diameter or slightly more, surrounded by a small gilded frame, painted by the hand of good masters on one side, and sometimes on both sides, with sacred stories. Women lying in childbirth used them to put their food on for dinner or supper' (my translation). This sense therefore suggests a decorated tray and similarity to a 'desco da parto'. On the other hand, some of the 'colmi' contained in this inventory seem far too large for the purpose of serving meals in bed, and one example by Fra Angelico specifies that it is for use as an altarpiece.

and a lion at his feet, a work of Master John of
Bruges [Jan van Eyck], done in oil with a cover 30 fl.

A small painting of the head of a French lady
done in oil colour, a work of Petrus Cristus of
Bruges 40 fl.

Small hall opposite the Great Hall

A wooden *colmo* with a nude figure asleep on a couch
(*schanna*) with two clothed figures and buildings,
by the hand of Master Filippo 10 fl.

A painting on canvas of a semi-nude figure seated
within a tabernacle holding a skull, by the hand
of Master Domenico Veneziano, in oil colours and
counterfeited marble 10 fl.

*Room overlooking the street called Monsignor's
where Giuliano lived*

A small *colmetto* framed in gold with a painting of
the Madonna seated, with the Child in her arms, two
small angels at her feet, by the hand of Francesco
di Pisello 10 fl.

A *colmetto* with two side wings, with the painting of
a lady's head, by the hand of Domenico Veneziano 8 fl.

Small upstairs chapel

A *colmo* for use as an altarpiece, 2 *braccia* long,
1.1/3 *braccia* high, framed and gilded, with the story
of the Magi, by the hand of Fra Giovanni 60 fl.

Passage outside Piero's room above the small hall

A small painting on wood, about 4 *braccia*, by the
hand of Fra Giovanni, with stories of the holy Fathers 25 fl.

A story of fauns and other figures by the hand of
Desidero 10 fl.

110

A small rectangular painting, by the hand of Fra
Giovanni, of Christ on the Cross with nine
figures around 12 fl.

(ii) The Gonzaga of Mantua

LUDOVICO GONZAGA AS PATRON: ALBERTI AND BUILDING PROJECTS AT MANTUA

Gian Francesco Gonzaga, created Marquis in 1433, had been the first great princely patron in Mantua; his son Ludovico, educated in the court school of Vittorino da Feltre, and of the same remarkable generation as Guarino's pupil Leonello d'Este of Ferrara and Federigo of Urbino, was outstanding for his interest in humanist learning and the arts. Leon Battista Alberti had not been slow to appreciate the qualities of the Marquis, writing to him a somewhat sycophantic letter in dedication of his 'Treatise on Painting' in 1441. Alberti accompanied Pope Pius II to Mantua for the political congress held there in 1459, and remained as an intimate consultant for the Marquis' architectural projects.

55 Letter of Leon Battista Alberti to Ludovico Gonzaga, 27 February 1460

Alberti's easy familiarity is clearly expressed in this letter, in which he announces his intention virtually to help himself to the comforts of one of Ludovico's villas.
 Italian text in W. Braghirolli, 'Leon Battista Alberti a Mantova', 'Archivio storico italiano', 3rd series, ix (1869) 7.

Most illustrious prince [after due recommendation]

There is no other reply to Your Lordship's letter except what Your Lordship proposes, and in any more important matter in which I can be of service I am

always ready to obey you. But because I did not feel very strong in health, and several friends suggested that I should have a few days' change of air, I besought your secretary, Piero the Spaniard, to provide me with one of your villas where I could have a few days' rest. La Chavriana seemed to him and impressed me as a suitable place, and I hope to be able to go there perhaps next Saturday or Monday. It occurred to me to inform Your Lordship about this, and to thank you for the benefit I receive. I beg you to recognise me as your faithful servant. The models of San Sebastiano and San Lorenzo and the loggia are all made; I think they will not displease you.

> I am your devoted
> Battista de Alberti

56 Letter of Alberti to Ludovico Gonzaga, *c*. 1470

In this undated letter Alberti refers to a new tower at the palace of Mantua which (as a previous letter informs us) was to be inscribed with the name of Ludovico's father, and also to his plans for the church of Sant'Andrea, for which, with customarily brilliant eclecticism, he proposed a façade developed from the form of a triumphal arch.

Italian text in Braghirolli, 'Archivio storico italiano', 3rd series, ix 14-15. On Sant'Andrea, see Wittkower, 'Architectural Principles in the Age of Humanism', pp. 47-56.

Most illustrious Lord [after due recommendation]

Luca Tagliapietra has shown me a letter of Your Lordship about the inscription for the tower etc. It now occurs to me to do it as in the plan accompanying this letter. We shall think it over again. I have also heard in the last day or two that Your Lordship and your citizens have been discussing the building scheme here at Sant'Andrea. And that the

principal intention was to have a great space where many people might go to behold the Blood of Christ. I saw Manetti's model. I liked it. But it did not seem the right thing to realise your intention. I thought it over and devised what I am sending you. This will be more practical, more immortal, more worthy and more gladdening. It will cost much less. This form of temple the Ancients called Sacred Etruscan. If you like it I will do a correct version in proportion.

> Recommendations to Your Lordship
> Your servant,
> Battista de'Alberti

The Tribune of the Church of the Annunziata, Florence

At his death in 1444 Gian Francesco Gonzaga had bequeathed 200 ducats to the Servite friars of Florence for building the tribune of their church; Ludovico added the debt of 2000 ducats which the Florentine government owed to his father and made up the sum to 5000 florins. This was more as a pious gesture to the memory of Gian Francesco than for the sake of art or (as he declares in the letter below) of Florence. The original design by Michelozzo was unsatisfactory, and although objections were also raised to Alberti's revision of it, especially by the Florentine merchant Giovanni Aldobrandini, on the grounds that the rotunda envisaged would bear no relation to the main body of the church, and would be ineffective for the choir, Ludovico was inflexible: the attempts to make him, or his agent Pietro del Tovaglia, spend more were unsuccessful.

Italian texts in W. Braghirolli, 'Die Baugeschichte der Tribuna der S. Annunciata in Florenz', 'Repertorium für Kunstwissenschaft' (Stuttgart, 1879) pp. 266-8; see also L. Mancini, 'Vita di L. B. Alberti' (Florence, 1882) pp. 510-14.

Most illustrious Prince, and my own excellent Lord

I have set to work on the Annunziata and have commissioned all the dressed stone for the walls, so that by March we shall have spent the 2000 florins, I hope diligently and to the utmost advantage. If I took any notice of what they tell me, the total cost would be something not in excess of 10,000 florins. I am taking an honourable line about this, and tell them that Your Lordship does not wish to spoil what has been done so far nor to upset the architect. Everyone opposes me on this, and they say that Your Lordship will not worry about the expense for such a magnificent work. I say that this is true, but nevertheless Your Lordship will not undertake this expense so as not to displease the architect who designed what has been done so far. By going ahead with the original plan the overall sum will be paid of 5000 florins, which Your Lordship wanted to spend; by changing to another plan it will be necessary to pay much more or else leave the work unfinished. So if anyone has written to Your Lordship about this you will know how to reply. I have had the deed and act of donation for Your Lordship and your descendants as patrons of the said Greater Chapel, and similarly of the High Altar of the said Church, drawn up in good and authenticated form, so that it will confer great dignity here upon the House of Gonzaga. I have included in the said deed those little minor chapels which I told Your Lordship should also be dealt with when I go there; and on my going there the same man will prepare all the stone. I shall give part of the stonework of the wall to Maestro Luca's brother-in-law, because one man would not be able to do it all the time, and Lorenzo de' Medici also asked me to give some of the work to a friend of his, which I could not refuse. I have nothing further to add, except to commend myself to Your Lordship.

> Written in Florence, 25 October 1470
> Your servant Piero del Tovaglia

58 Letter of Ludovico Gonzaga to Giovanni Aldobrandini, 8 April 1471

We have received with your letter the drawings you sent and also understood the reasons for persuading us to follow your plan and cancel the previous one. And in reply we do not wish to deny that your design and the reasons you put forward are worthy and well thought out. But to make the matter clear, we want you to know that our intention there was not to try and make thy most beautiful thing in Florence, because we know exactly how much we want to spend and (there being many other very fine buildings in that city) it cannot be done. Our intention was to satisfy our late father's legacy, and not to excite everyone. If there is anybody who would prefer to follow out your design and would be willing to send back here the money assigned for the purpose, we should be happy to defer to him, not wishing to prevent the realisation of such a beautiful work. And we shall seek ways of spending the money in our own city and so satisfy both the other party and ourselves, for we should be much happier this way, and we should be obliged to whoever takes it over, for we shall not decide to change our mind in any other way . . .

LUDOVICO AND FEDERICO I GONZAGA AS PATRONS THE EMPLOYMENT OF MANTEGNA

59 Letter of Ludovico Gonzaga to Andrea Mantegna, 15 April 1458

Ludovico Gonzaga's desire to be in the lead among princely patrons inspired him to lure Mantegna from Padua to be his resident court painter, rather as Leonello d'Este had brought Pisanello to Ferrara in 1441. He had already made overtures in the previous year, though Mantegna was slow to commit himself while still working on the famous altarpiece of San Zeno, Verona, for the Protonotary Gregorio Correr. The

terms offered were certainly generous: 180 ducats a year was a considerable salary to accompany the other perquisites. It is not clear, however, whether on acceptance Mantegna protected himself by a formal contract; the following letter suggests he did not. He finally arrived in the summer of 1459; his mind may have been made up by the Congress held in Mantua that year (the same event which brought Alberti to the Gonzaga court), with its opportunities of further patronage.

Italian text in Kristeller, 'Andrea Mantegna', app. 4, pp. 467-8; see also pp. 181-96.

To the painter Andrea Mantegna

Our most esteemed friend

Messer Luca Tagliapietra has returned to us and has described on your behalf how great is your desire, and how you persevere in your original intention, to enter our service. It pleases us greatly to know this and we received it gladly; and so that you may know at once our good will towards you we advise you that our own intention is to reserve for you in good faith everything which we have promised you in our letter at other times, and still more; that is to say, 15 ducats a month, the provision of rooms where you can live with your family, enough food each year to feed six, and enough firewood for your use. Do not have the slightest doubt about all this; and so that you may not incur any expense in bringing your family here, we are happy to promise that at the time you want to come we shall send down a small ship at our expense to move you and your household and bring you here so that it will not cost you anything. And because Maestro Luca tells us you would dearly like to wait another six months in order to finish the work for the Reverend protonotary of Verona and dispatch the rest of your business, we are very content, and if these six months are not enough for you, take seven or eight, so that you can finish everything you have begun and come here with your mind at rest. Two or three months are not going to make any difference to us provided that we have the certainty from you that when the time comes you will not fail to enter our service, and if you

come next January you would still be in good time. We deeply beg that by that time without fail you will want to come, as we hope. Have no doubt that if our offer seems little to you and if you are not content and inform us, we shall seek in every way to satisfy your desire, because as we have written to you on other occasions, if you come as we hope and bear yourself in this manner, we shall make certain that you will find this arrangement seems only the least of the rewards you will receive from us. And although other people may have told you otherwise, we by the grace of God have never yet broken our promise, and as you are young you will be able to prove this for yourself; we shall show you who tells the truth, them or us, and whether deeds correspond to words. But this is our hope: that every day you will rest more happy and satisfied for having been brought into our service. We wanted to write you this letter to assure you that we have the same disposition towards you as always, waiting to hear from you the precise time when you can move to us with your household. Nor is there any need for you to take the trouble to come here, as Maestro Luca wanted you to do; for us, it will be quite enough to hear from you of your intention by letter without your coming, by means of this gentleman of ours who has to ride as far as Venice. We beg you that on his return he may have your reply to carry here. Farewell.

Mantua, 15 April 1458

60 Letter of Mantegna to Ludovico Gonzaga, 13 May 1478

This querulous letter, written nineteen years after Mantegna had come to Mantua, cannot be taken wholly at its face value. If Mantegna had been exploited and deceived by the Marquis he might have protested more vigorously sooner; if there was no lawful contract he could have gone elsewhere. In fact he had been sufficiently well off and socially confident to buy a title from the Emperor Frederick III in 1469. The Marquis

replied courteously that at the present time he could
not afford to pay more than he was bound to pay; he
had done all he could when he had the means, but at the
present time he had even had to pawn his jewels.

Italian text in Kristeller, 'Andrea Mantegna', app. 4,
p.478, n. 30.

My most illustrious Lord [after the usual recommendation
etc.]

Your Excellency: you remember how you sent Luca
Tagliapietra to me with letters of credence when I was in
Padua in 1458; the said Luca declared many things to me by
word of mouth on Your Excellency's behalf: principally how
much you desired to have certain works by my hand and how
well disposed Your Excellency was towards me, suggesting
that if I was not satisfied with the terms you offered me that
I should say so, and making many other generous offers.
Wherefore in spite of the many persuasions of others to the
contrary, I decided wholeheartedly to enter the service of
Your Excellency, with the intention of so working that you
could boast of having what no other Lord of Italy has: thus I
did. But because it can be seen from the letters Your Excel-
lency wrote to me containing such generous promises that if I
bore myself in the manner of which Your Excellency was
confident, you would make sure that the initial terms would
be the least of the rewards I should receive from you, I have
been in great hope, increasing all the time I have served Your
Excellency, which is nearly nineteen years. And seeing the
great remuneration of property, houses and other assets
which have been lavished on your servants, I meanwhile still
wait deservingly and neglected; it is five years since your
Lordship promised to pay me with that property, which I do
not reckon a good sign. I hoped that in that time your
Excellency would have paid me with the said possession, that
is the 800 ducats, and would have helped me further to pay
the 600 ducats, as Your Excellency promised; and I still had
hope that you would help me build the house as was
promised. I find my affairs much more burdensome than I
did when I came to settle with Your Excellency, with sons
and daughters, one of whom I have to provide for in

119

marriage, and seeing myself grow older every day, and thus is the state of my affairs ... Regarding the offers of Your Excellency and in the opinion of many in Italy, it appears that I swim in milk[1] under the shadow of your Serenity, to whom I humbly recommend myself.

Mantua, 13 May 1478 From your most dedicated servant
ANDREA MANTEGNA

61 Letter of Federico I Gonzaga to Bona of Savoy, Duchess of Milan, 20 June 1480

The truculence of Mantegna is again affirmed in this letter, in which the interesting reflection occurs that it is advisable to humour painters in their whims. Mantegna was quite experienced in painting on a miniature scale: even in his larger paintings, the background details are sometimes minute.

 Italian text in Kristeller, 'Andrea Mantagna', app. 4, p. 480, n. 36; see also M. Meiss, 'Andrea Mantegna as Illuminator' (New York, 1957).

Lady Duchess of Milan

Most illustrious Excellency, I have received the portrait painting that Your Excellency sent me and have done my utmost to make Mantegna make a small reproduction in elegant form. He says this would almost be the work of a miniature-painter, and because he is not accustomed to painting small figures he would much rather do a Madonna, or something the length of a *braccia* or a *braccia* and a half, if it were pleasing to Your Most illustrious Highness. My Lady, if I might know what Your Ladyship wants me to do, I shall endeavour to satisfy your wish, but usually these painters

[1] Mantegna's peculiar metaphor seems too good to abandon for some more free and suave English rendering such as 'I am with milk and honey blest.'

120

have a touch of the fantastic and it is advisable to take what they offer one; but if Your Ladyship is not served as quickly as you wished, I beseech you to excuse me; in your good grace etc.

Mantua, 20 June 1480

GIAN FRANCESCO II GONZAGA AS PATRON
HIS TASTE FOR TOPOGRAPHY

Gian Francesco Gonzaga's interest in art was limited, compared with that of his wife; first and foremost a military man, his taste for topographical views of towns seems characteristic: on the other hand, the non-military Medici also collected them (no. 54).

62 Letter of Giancarlo Scalona to Gian Francesco Gonzaga, 7 December 1493

Views of Venice, Genoa and Paris are known to have been designed by the Bellini workshop, as well as the one of Cairo. Woodcuts, and very shortly engravings, made them available in reproduction for a wider market. Scalona, the Mantuan ambassador in Venice, reveals a nice diplomatic decorum in this letter, explaining his unwillingness to take advantage of an official audience, when he had to expound a matter of ecclesiastical business, to ask for Doge Agostino Barbarigo's portrait.
Italian text in A. Luzio, 'Disegni topografici e pitture dei Bellini', 'Archivo storico dell'arte, I (1889) 276.

My most illustrious Lord

I have used every possible diligence to find the print of Cairo. It is not to be found anywhere. It is true that a compatriot of messer Bellini has it in colour, and I have been told that there is not another in the whole of Venice. Messer Bellini himself, at my prayer in your Excellency's name, has promised me, on

121

the faith of a royal knight, that he will cut a sketch from it. He will do it within three or four days, and give it to me in time to be able to bring it to your illustrious Lordship.

On the morning that I did reverence to the Serene Prince in the Collegio, and expounded the cause of Monsignor the Bishop-elect ... it did not seem to me the right time or place to ask the aforesaid Prince for his portrait; however I thought of writing a good letter to His Sublimity, to notify him of the great desire your Excellency has to have his natural likeness near to you. I thus sent the letter to his chamber, supplicating that he might deign to concede to Your Lordship a picture I had seen with messer Bellini, which is a worthy piece of work. His Serenity was very touched to hear of Your Lordship's desire, sending by means of one of his chamberlains the sweetest and most loving reply in the world. I do not wish to conceal that His Sublimity concluded lovingly that he was unable to concede that portrait to you, because he had given it to a nephew of his, but he will have an order given to the painter to make another for your Lordship. And so tomorrow Messer Bellini must go to the Prince and receive the commission to do it, and I have solicited him to make a start and finish it with the utmost possible speed.

> Venice, 7 December 1493
> Your faithful servant
> Jo. Ca. Scalona

63 Letter of Vittorio Carpaccio to Gian Francesco Gonzaga, 15 August 1511

Carpaccio's self-praise and his stress upon large dimensions may sound naïve, but he certainly understood what a patron like Francesco Gonzaga appreciated. His 'Views of Jerusalem' are among his lost works; whether or not the Marquis bought the larger as well as the smaller version of this view, a picture by the same title was one of those which disappeared in the Sack of Mantua in 1630. The mysterious painter whom he

suspected of being a plagiarist is thought to
Lorenzo Leonbruno, and the 'Story of Ancona
back to the great project of decorating the Hall
Greater Council (nos. 39-43). Carpaccio had joine
team in 1507. The scene he mentions portrayed
event celebrated in Venetian history, or legend; on i
journey to Rome in 1177 of the Emperor Frederic.
Barbarossa, the Pope and the Doge, the Pope presented
a ceremonial sunshade to the Doge at Ancona, in token
of his esteem and gratitude.

Italian text in A. Bertolotti, 'Artisti in relazione coi
Gonzaga duchi di Mantova nei secoli xvi e xvii', 'Atti e
memorie modenesi e parmensi', 3rd series, iii (1885-6)
150. See also P. Molmenti and G. Ludwig, 'Life and
Works of Carpaccio' (London, 1907) p. 58.

My most illustrious Lord

A few days ago someone unknown to me was brought by
several others to see a Jerusalem I have done. As soon as he
had seen it, he arranged that I should sell it to him, since he
knew it would be greatly to his pleasure and satisfaction.
Since the deal was concluded and his good faith pledged, he
has never appeared again. In order to clear up the matter I
questioned the people who had brought him, among whom
was a bearded priest wearing a grey cap, whom I have seen a
number of times with your Lordship in the great hall of the
council, and I asked the name of this man and his condition.
They told me he was master Lorenzo, your Lordship's
painter. From which I easily understood the manner in which
he wants to succeed. And so it has occurred to me to write
this letter to Your Sublime Highness in order to draw your
attention both to my name and to my work. First of all, my
illustrious Lord, I am the painter commissioned by our most
illustrious Signoria [of Venice] to paint the great hall, where
your Lordship deigned to climb up to the ceiling to see my
work, which was the story of Ancona, and my name is
Vittorio Carpaccio. About the Jerusalem, I am proud to say
that there is nothing to equal it in our time for its good
quality and utter perfection, and also for its size: the length
of the work is 25 feet, the width 5½ feet, with all the scale

requisite for such a thing. I know Giovanni Gamberti has mentioned this work to your Highness. It is certainly very true that our said painter has carried off an entire section of this work done on a smaller scale, which I sold as it is; but I think, or rather I am quite certain, that it will not be to your Lordship's satisfaction, seeing that it is not even a tenth of the whole. If my work should be to Your Lordship's liking, having first been seen by men of judgement, for the smallest pledge it shall be yours to command; both the drawing in ink [*de aquarella*] upon the canvas (and it can be wound on a roller without any damage if you like) and the colours according to Your Lordship's command will be executed by me with the utmost study. On my own behalf I say nothing: I remit myself to Your Lordship, to whom I humbly commend myself.

> 15 August 1511, at Venice
> The most humble servant of Your Sublime Highness
> Vittorio Carpaccio, painter

ISABELLA D'ESTE, WIFE OF GIAN FRANCESCO II GONZAGA, AS PATRON

The correspondence of Isabella d'Este relating to the arts has survived in greater abundance than that of any other single patron, and a large selection appears here because of the many points of interest it contains. Isabella was sharp-witted and cultivated rather than learned; she upheld the tradition of patronage at Mantua during the frequent absences of her husband on military commissions. In a sense their court was also the provincial survival of the Sforza tradition in Lombardy, since the early death of Isabella's sister Duchess Beatrice d'Este, wife of Duke Ludovico Sforza, and the fall of Milan to the French in 1499. One of her best-known projects was the collection of paintings by celebrated artists which she began to plan in 1496 for her room (studio or camerino) known as the Grotta *on the ground floor of the palace at Mantua. Most of the letters below refer to this. The ageing court painter Mantegna provided for it his two paintings (now in the Louvre) the 'Parnassus' and 'Allegory of*

124

Virtue'. What appealed to Isabella especially was the ge
allegorical fantasy based upon pagan myth; she resorte
specialists, such as Paride Ceresara and Pietro Bembo,
invent subjects for her. Isabella emerges from the corres-
pondence with the painters and her agents, who acted the
part of go-between, as a somewhat capricious patron. Her
attitudes changed according to her day-to-day sense of
whether her wishes were being fulfilled or frustrated; her
setbacks certainly illustrate the difficulty, and the need to be
conciliatory, when dealing with famous and overemployed
painters such as Bellini and Perugino. Not only was Isabella
d'Este fastidious and importunate, though, she was not over-
generous in payment, so that one may suspect that her
princely patronage was hardly something an established
painter would go out of his way to seek.

The Quest for a Work by Giovanni Bellini

Isabella d'Este had already made approaches to
Giovanni Bellini, Mantegna's brother-in-law, when her
husband was in Venice in 1496. Her perseverance is
remarkable, in disregarding the advice of one of her
connoisseur agents in Venice, Michele Vianello, that
Bellini was busy on the great painting programme for
the Hall of the Greater Council, unenthusiastic about
allegorical fantasies made to order, and reluctant to have
his work hung beside Mantegna's (no. 65). When he
eventually offered to do a Nativity instead (no. 67), she
still tried to impose her own suggestions upon him,
although she had previously conceded that it was best to
leave him to resolve his own subject-matter (no. 66); a
year after the Nativity was delivered — a painting which
later, or was perhaps given away — she resumed
unsuccessfully her quest for an allegorical painting (no.
71).

Italian texts of the letters in W. Braghirolli, 'Carteggio
di Isabella d'Este intorno ad un quadro di Giambellino',
'Archivio Veneto', xiii (1877) 376-83. On the *Grotta* in
general, and a discussion of this correspondence, see J.
Cartwright, 'Isabella d'Este' (London, 1915) I 157-62,
341-61.

64 Letter of Michele Vianello to Isabella d'Este, 5 March
 1501

My most illustrious and excellent respected Lady

On my arrival here I saw Giovanni Bellini about the com-
mission Your Ladyship gave me at my departure. After
telling him of the requirement and desire of Your illustrious
Ladyship and the story in the manner you wished, the said
Giovanni Bellini replied that he was under an obligation to
the illustrious government [of Venice] to continue the work
he had begun in the palace; that he could never leave it from
early morning until after dinner. However, he would make or
steal time during the day to do this work for Your Excel-
lency in order to serve you and for the sake of the love I bear
him. I still warn you that the said Giovanni Bellini has a great
deal of work on his hands, so that it will not be possible for
you to have it as soon as you wanted. I am asking whether he
will be able to get it done within a year and a half, and it will
depend on how much he can do. As to the price, he asked me
for 150 ducats, but he will reduce it to 100 ducats, and this is
all that can be done; so Your illustrious Ladyship knows
what has been attempted in the matter. I await a reply from
Your illustrious Ladyship, to whom I offer and recommend
myself for ever. Please recommend me to the illustrious
lordship of my Lord your husband.

> Your most illustrious and excellent Ladyship's servant
> Michele Vianello

65 Letter of Michele Vianello to Isabella d'Este, 25 June
 1501

My most illustrious Lady

Today I have received your letter from Ziprian, Your Excel-
lency's courier, and from the same I received 25 ducats to
 126

give Giovanni Bellini, who is at his villa. He will be back at his house here, they tell me, within five days. I will be with him immediately, and that Your Excellency may know that I have your service in mind, I have spoken to him several times about this picture. He told me that he was very anxious to serve Your Ladyship, but about the story Your Ladyship gave him, words cannot express how badly he has taken it, because he knows Your Ladyship will judge it in comparison with the work of Master Andrea [Mantegna], and for this reason he wants to do his best. He said that in the story he cannot devise anything good out of the subject at all, and he takes it as badly as one can say, so that I doubt whether he will serve Your Excellency as you wish. So if it should seem better to you to allow him to do what he likes, I am most certain that Your Ladyship will be very much better served. Therefore I beg Your Ladyship will be pleased to give me your views, because he will not do anything until I hear from you.

From Your Ladyship's servant
Michele Vianello

66 Letter of Isabella d'Este to Michele Vianello, 28 June
 1501

Messer Michele

If Giovanni Bellini is so unwilling to do this story as you write, we are content to leave the subject to his judgement, so long as he paints some ancient story or fable with a beautiful meaning. We should be very glad if you would urge him to make a start on this work, so that we have it within the time he has estimated, and sooner if possible. The size of the picture has not been altered since you were here and saw the place where it was to go in the studio. Nevertheless, to be on the safe side I am sending you the measurements again, and Gian Cristoforo our sculptor will write to you about this.

Mantua, 28 June 1501

67 Letter of Isabella d'Este to Michele Vianello, 15
September 1502

Messer Michele

You may remember that many months ago we gave Giovanni
Bellini a commission to paint a picture for the decoration of
our studio, and when it ought to have been finished we found
it was not yet begun. Since it seemed clear that we should
never obtain what we desired, we told him to abandon the
work, and give you back the 25 ducats which we had sent
him before, but now he begs us to leave him the work and
promises to finish it soon. As till now he has given us nothing
but words, we beg that you will tell him in our name that we
no longer care to have the picture, but that if instead he
would paint a Nativity, we should be well content, as long as
he does not keep us waiting any longer, and will count the 25
ducats which he has already received as half payment. This, it
appears to us, is really more than he deserves, but we are
content to leave this to your judgement. We want this
Nativity to contain the Madonna and Our Lord God and St
Joseph, together with a St John the Baptist and the [usual]
animals. If he refuses to agree to this, you will ask him to
return the 25 ducats, and if he will not give back the money
you will take proceedings.

68 Letter of Michele Vianello to Isabella d'Este, 3
November 1502

Most illustrious and excellent Lady

I have just received a letter from Your Ladyship in which you
tell me about the picture by Giovanni Bellini. I have had the
measurements of the picture from Messer Battista Scola and I
at once went to find him and tell him Your Ladyship's wish
about the Nativity scene, and that Your Ladyship wished a St
John the Baptist to appear in the scene. He replied that he
was happy to serve Your Excellency, but that the said saint

128

seemed out of place in this Nativity, and that if it pleases Your illustrious Ladyship he will do a work with the infant Christ and St John the Baptist and something in the background with other fantasies which would be much better. So we left it at that: if this pleases Your Ladyship please let me know, because I will do whatever Your Ladyship commands. As to the price, he agreed to take 50 ducats, and anything more which may seem fair to Your Excellency. So I ordered the canvas to be primed and he promised to begin very soon.

69 Letter of Isabella d'Este to Michele Vianello, 12 November 1502

Messer Michele

As Bellini is resolved on doing a picture of the Madonna and Child and St John the Baptist in place of the Nativity scene, I should be glad if he would also include a St Jerome with the other subjects which occur to him; and about the price of 50 ducats we are content, but above all urge him to serve us quickly and well.

70 Letter of Isabella d'Este to Giovanni Bellini, 9 July 1504

Master Giovanni Bellini

If the picture which you have done for us corresponds to your fame, as we hope, we shall be satisfied and will forgive you the wrong which we reckon you have done us by your slowness. But hand it over to Lorenzo da Pavia, who will pay you the 25 ducats owing on completion of the work, and we beg you to pack it in such a way that it can be carried here easily and without risk of damage. If we can oblige you in

anything we will willingly do so when we have seen that you have served us well.

Farewell
Mantua, 9 July 1504

71 Letter of Isabella d'Este to Giovanni Bellini, 19 October 1505

Master Giovanni

You will remember very well how great our desire was for a picture of some story painted by your hand, to put in our studio near those of your brother-in-law Mantegna; we appealed to you for this in the past, but you could not do it on account of your many other commitments. Instead of the story which first you had promised to do, we resigned ourselves to taking a Nativity scene instead, which we like very much and are as fond of as any picture we possess. But the Magnificent Pietro Bembo was here a few months ago, and hearing of the great desire which we cherish continually, encouraged us to hope it might yet be gratified. He thought that some of the works which have been keeping you busy had now been delivered, and knowing your sweet nature in obliging everyone, especially those in high places, he was able to promise us satisfaction. Since the time of this conversation we have been ill with fever and unable to attend to such things, but now we are better it has occurred to us to write begging you to consent to painting a picture, and we will leave the poetic invention for you to make up if you do not want us to give it to you. As well as the proper and honourable payment, we shall be under an eternal obligation to you. When we hear of your agreement, we will send you the measurements of the canvas and an initial payment.

Mantua, 19 October 1505

Italian text in Gaye, 'Carteggio inedito d'artisti,' pp. 71-3.

I have been with Bellini recently and he is very well disposed to serve Your Excellency, as soon as the measurements of the canvas are sent to him. But the invention, which you tell me I am to find for his drawing, must be adapted to the fantasy of the painter. He does not like to be given many written details which cramp his style; his way of working, as he says, is always to wander at will in his pictures, so that they can give satisfaction to himself as well as to the beholder. Nevertheless he will achieve both ends by hard work. In addition to this, spurred by my great devotion and service to Your Excellency, I beg your good offices about a matter which I have much at heart, with as great a hope of being heard as the desire I always have to do you service. With Messer Francesco Cornelio[1], brother of the most reverend Cardinal, I observe a close kinship and a most dear and familiar friendship, no less than if he were my brother. He has in addition many very singular qualities, so that I hold him infinitely high in honour, and desire to please him. Since he is, like all lofty and gentle souls, passionately fond of rare things, he arranged some time ago with Messer Andrea Mantegna to have several canvases painted for him at the price of 150 ducats. He gave him an advance of 25 ducats, having first sent him the measurements, and the work was welcomed by Messer Andrea, so that he went ahead. Now he tells me that Messer Andrea refuses to go on with it for that price, and asks a much larger sum, which seems to Messer Francesco the greatest novelty in the world, as it appears to everyone he tells about it. This is especially so because he possesses letters of Messer Andrea in which he particularly confirmed the said agreement they made together. Messer Andrea alleges that the work turns out to be bigger than he had estimated, so he

[1] Francesco Cornaro affected the name Cornelius to imply descent from the Roman family of that name. One of the paintings under discussion is presumably 'The Triumph of Scipio' in the National Gallery, London. See Cartwright, 'Isabella d'Este', i 357-9.

131

wants more payment. I therefore beg and implore Your Ladyship to persuade Messer Andrea to keep faith with Messer Francesco and make a start on the pictures he has undertaken for him; above all he should be reminded that he who is called the *Mantegna* of the world ought above all men to keep (*mantenere*) his promises, so that there should not be the like discord when he does otherwise, being and not being Mantegna at the same time. M. Francesco does not take issue about one hundred or two hundred florins for something which merits so little gold (thank God he has abundant means for a man of his rank), but takes issue against being made a fool of and derided. Should your Excellency think that the work, once delivered, deserves a much higher reward, he will act in such a way that Messer Andrea will not be able to call him boorish, and he wants to stand by Your Ladyship's judgement, and that she should commit him to whatever seems right and pleasing to her. But that he should now say — the bargain having been arranged long ago and the advance payment accepted — 'I no longer want it thus, but like this; do not imagine that the work is going ahead' — Messer Andrea should for God's sake see that these matters are no more burdensome to him than damaging to Messer Francesco, who would not want his pictures except that it is a very important issue for him. Messer Francesco is in no doubt of obtaining this favour from you by my intercession, reckoning that I can do much more with you and that Messer Andrea should and can deny you nothing. It will be most highly appreciated by me if Your Ladyship deigns to act in such a way that Messer Francesco is confirmed in the estimated price; it will show that I am not excluded from the grace of Your most illustrious Ladyship, which [token] I will certainly receive in place of a very great benefice. I hope also that Messer Andrea's courtesy and good nature (*gentilezza*), from which two virtues he never strays far, will mean that your Ladyship has little trouble in this task. Nevertheless I promise you that all the help Your Ladyship gives in resolving the matter of Messer Francesco's pictures with Messer Andrea, Messer Francesco will gratefully repay by helping on your business with Giovanni Bellini, with whom he is usually able to do a great deal. In the meantime he and I remain obliged to Your most illustrious Ladyship, to whose grace we

132

both kiss our hands.

In Venice, 1 January 1506
Your most illustrious Ladyship's servant
Pietro Bembo

The Quest for a Work by Perugino

With Perugino Isabella d'Este was more successful; at
least his 'Battle of Love and Chastity' was in the end
delivered for her *Grotta*, though the correspondence
shows that this was also a triumph of patience. The high
evaluation of Perugino as one of the most excellent
artists available (nos. 73-4), commanding the same
prices as Bellini, is interesting; though it may be
wondered whether Isabella had seen much of his work,
which was not much concerned with allegorical
fantasies. She does not seem to have been interested in
the possibility of a work by Filippino Lippi or Botti-
celli; perhaps because she was not sufficiently informed.
The suggestion that Perugino was unreliable did not
deter her, though events justified the warning of
Malatesta, her ambassador in Florence, and some of
Vasari's disparaging remarks about Perugino's character
are confirmed. Moreover, she seems to have been
disappointed with the painting when it arrived. The
most remarkable document is the letter containing the
instructions of Isabella's adviser of allegories (no. 76), a
rare example of detailed instructions copied into a
notarial contract, instead of being delivered to the
painter separately.

Italian texts in Canuti, 'Il Perugino', ii 209-35; most
of the letters are also discussed by Cartwright, 'Isabella
d'Este', i 328-40.

73 Letter of Isabella d'Este to Francesco Malatesta, 15
 September 1502

Francesco

Since we desire to have in our *camerino* pictures with a story
by the excellent painters now in Italy, among whom Perugino
is famous, we want you to approach him, or use a friend of
his if it seems better, and see if he is willing to undertake a
picture according to the story or invention we will give him.
The figures will be as small as you know the others are in the
said *camerino*. And if he accepts the offer to serve us, find
out what he wants as payment; and if he will apply himself to
work soon, we will then send him the measurements of the
picture with our fantasy. Please reply with diligence.

Mantua, 15 September 1502

74 Letter of Francesco Malatesta to Isabella d'Este, 23
 September 1502

My most illustrious Lady

I see Your Ladyship writes to me that I must look for
Perugino, the famous painter, and wishes for a picture by his
hand. I find that he is at present working in Siena, and is not
coming here for eight or ten days. When he returns, I will talk
to him and I will use all the diligence I know to make him
willing to serve Your Ladyship. It is true that I have heard he
is a slow man; I might put it this way, he hardly ever finishes
a work he has once begun, so long does he take.

I have heard of another famous painter, who is also much
praised, called Filippo di Fra Filippino and I wanted to talk
to him. He told me that he could not begin such a
work for the next six months, being busy on other works,
and that perhaps having finished these he could serve Your
Ladyship.

Another, Alessandro Botticelli, has been much praised to
me as a very good painter and a man who serves willingly and

134

is not so encumbered as the former. I have spoken to him and he says that he will take on the commission at once and serve Your Ladyship gladly.

It has occurred to me to send this news to your Ladyship so that you can choose whichever pleases you the most. I continually recommend myself.

Your servant,
Francesco de' Malatesta

75 Letter of Francesco Malatesta to Isabella d'Este, 24 October 1502

My most illustrious Lady

I have just been with the painter Perugino, about whom Your Ladyship wrote to me some days ago concerning your wish to have a picture by his hand for your *camerino*. The said Perugino says that he will accept the job of doing it, and will compel himself to serve Your Ladyship well. And he asks for you to send the measurements of the picture and similarly the figures to go on it, and to write out the story or subject of the painting as you want it to be. He will then send a reply about the price and the time that it will take him to do it. He says he will use the utmost diligence to serve Your Ladyship both for his own honour and your entire satisfaction.

And, most illustrious Lady, I remain your servant,
Francesco Malatesta

76 Instructions of Isabella d'Este to Perugino, 19 January 1503

Drawn up at Florence in the parish of Santa Maria in Campo in the below-mentioned house, in the presence of Bernardo Antonio di Castiglione, Florentine citizen, and Fra Ambrogio, Prior of the Order of Jesuati, near Florence, witnesses.

135

Lord Francesco de' Malatesta of Mantua, procurator of the Marchioness of Mantua, in the best manner he was able, commissioned from Master Perugino, painter, there present, the undertaking on his own behalf and that of his heirs to make a painting on canvas, 2½ *braccia* high and 3 *braccia* wide, and the said Pietro, the contractor, is obliged to paint on it a certain work of Lasciviousness and Modesty (in conflict) with these and many other embellishments, transmitted in this instruction to the said Pietro by the said Marchioness of Mantua, the copy of which is as follows:

Our poetic invention, which we greatly want to see painted by you, is a battle of Chastity against Lasciviousness, that is to say, Pallas and Diana fighting vigorously against Venus and Cupid.[1] And Pallas should seem almost to have vanquished Cupid, having broken his golden arrow and cast his silver bow underfoot; with one hand she is holding him by the bandage which the blind boy has before his eyes, and with the other she is lifting her lance and about to kill him. By comparison Diana must seem to be having a closer fight with Venus for victory. Venus has been struck by Diana's arrow only on the surface of the body, on her crown and garland, or on a veil she may have around her; and part of Diana's raiment will have been singed by the torch of Venus, but nowhere else will either of them have been wounded. Beyond these four deities, the most chaste nymphs in the trains of Pallas and Diana, in whatever attitudes and ways you please, have to fight fiercely with a lascivious crowd of fauns, satyrs and several thousand cupids; and these cupids must be much smaller than the first [the god Cupid], and not bearing gold bows and silver arrows, but bows and arrows of some baser material such as wood or iron or what you please. And to give more expression and decoration to the picture, beside Pallas I want to have the olive tree sacred to her, with a shield

[1] 'Amore' in the original; Cupid (Eros) is clearly intended, but the English 'Love', which Cartwright uses in her translation, 'Isabella d'Este', i 331-2, is too vague to make the point. To be consistent I have translated the 'mille varii amori' who appear further down as 'cupids' (with a small *c*); Isabella seems to have recognised that her vocabulary might be confusing, as she specifies these are not the same as the god, 'a rispetto di quel primo debbono essere più picholi'. Cartwright, also consistent, has to call them 'thousands of little loves', which sounds mawkish.

leaning against it bearing the head of Medusa, and with the owl, the bird peculiar to Pallas, perched among the branches. And beside Venus I want her favourite tree, the myrtle, to be placed. But to enhance the beauty a fount of water must be included, such as a river or the sea, where fauns, satyrs and more cupids will be seen, hastening to the help of Cupid, some swimming through the river, some flying, and some riding upon white swans, coming to join such an amorous battle. On the bank of the said river or sea stands Jupiter with other gods, as the enemy of Chastity, changed into the bull which carried off the fair Europa; and Mercury as an eagle circling above its prey, flies around one of Pallas' nymphs, called Glaucera, who carries a casket engraved with the sacred emblems of the goddess. Polyphemus, the one-eyed Cyclops, chases Galatea, and Phoebus chases Daphne, who has already turned into a laurel tree; Pluto, having seized Proserpina, is bearing her off to his kingdom of darkness, and Neptune has seized a nymph who has been turned almost entirely into a raven.

I am sending you all these details in a small drawing, so that with both the written description and the drawing you will be able to consider my wishes in this matter. But if you think that perhaps there are too many figures in this for one picture, it is left to you to reduce them as you please,[1] provided that you do not remove the principal basis, which consists of the four figures of Pallas, Diana, Venus and Cupid. If no inconvenience occurs I shall consider myself well satisfied; you are free to reduce them, but not to add anything else. Please be content with this arrangement.

And to this manner and form the parties are referred.

Master Pietro promised Lord Francesco to devote himself with his skill to achieving the said picture over a period from now until the end of next June, without any exception of law or deed; Lord Francesco promised, in the said names, to pay for the making of the said work a hundred gold florins, in large gold florins, to the said Lord [sic] Pietro, with the agreement that of the said sum twenty gold florins, in large gold florins, should be given at present to the said Lord

[1] He did. Polyphemus and Pluto, for instance, seem to be missing from the painting. See Plate 3.

Pietro, painter; which the said Lord Pietro in the presence of me, the notary, and of the witnesses written above, acknowledged he had received of the said Lord Francesco, and the remainder the said Lord Francesco promised to pay to the said Lord Pietro when the said Lord Pietro completes the said work to perfection and shall give it to Lord Francesco Malatesta of Mantua. And the said Lord Pietro is obliged to complete the said work himself, bearing all the expenses for the same; with an agreement that in the event of the death of the said Master Pietro, should it happen that the said work is not completed, the heirs of the said Master Pietro shall be obliged to restore the said sum of 20 large gold florins to the said Lord Francesco Malatesta, or however much more he has had; or else, in the event of the said work not being completed on account of the death of the said Lord Pietro, that the said Lord Francesco shall be obliged to receive the said work in the form and style so far devised for it, and the said work must be valued by two experienced painters and he must take it for the price they estimate.

See Plate 3, and references to Pietro Perugino in documents 77-84, below.

77 Letter of Perugino to Isabella d'Este, 10 December 1503

Most Excellent Madam

Having learnt the story which Your Ladyship commissioned from me a short while ago, it seems to me that the drawing sent to me does not correspond very well with the size of the figures, which seem to me to be very small and the height of the picture seems too great in proportion to them. I want to know what is the size of the figures in the other stories which are to go beside it, because if the whole scheme is to turn out well all the measurements must agree, or there must be very little difference. Therefore please arrange for me to be sent this information, so that I can give satisfaction to Your Excellency as is my desire. Nothing else; I recommend myself humbly, praying God keeps you well.

Florence, 10 December 1503
Your Excellency's faithful servant, Pietro Perugino

138

78 Letter of Isabella d'Este to Perugino, 12 January 1504

Excellent friend

The enclosed paper, and the thread wound round it together give the length of the largest figure on Master Andrea Mantegna's picture, beside which yours will hang. The other figures smaller than this can be as you please. You know how to arrange it. We beg you above all to hasten with the work; the sooner we have it, the more we shall be pleased.

79 Letter of Perugino to Isabella d'Este, 24 January 1504

My most illustrious Lady, Marchioness of Mantua, greeting and infinite recommendations

I sent a letter to you a month and a half ago and I have never had a reply to the said letter. I will repeat what it is about in this: I have drawn some of your figures, which come out very small; I would like Your Ladyship to send me the size of the other stories which are to accompany my story, so that they should conform; and so that the principal figures are all of one size, otherwise they will contradict each other a great deal, one being big and another small. So send me the measurements of the other figures in the other stories that you have had done, and I will at once show my diligence. Nothing further; I recommend myself to Your Ladyship.

> 24 January 1504
> Your Pietro Perugino, painter in Florence

80 Letter of Isabella d'Este to Paride Ceresara,[1] 10 November 1504

Lord Paride Ceresara

Messer Paride — we do not know who finds the slowness of these painters more wearisome, we who fail to have our *camerino* finished, or you who have to devise new schemes every day, which then, because of the bizarre ways of these painters, are neither done as soon nor drawn in entirety as we would have wished; and for this reason we have decided to try our new painters in order to finish it in our lifetime.

81 Letter of Isabella d'Este to Agostino Strozzi,[2] Abbot of Fiesole, 19 February 1505

Your Reverence

Domenico Strozzi has informed me that Perugino is not following the scheme for our picture laid down in the drawing. He is doing a certain nude Venus and she was meant to be clothed and doing something different. And this is just to show off the excellence of his art. We have not, however, understood Domenico's description very well, nor do we remember exactly what the drawing was like; so we beg you to examine it well together with Perugino, and likewise the instructions that we sent him in writing. And do your utmost to prevent him departing from it, because by altering one figure he will pervert the whole sentiment of the fable. The instruction was sent as information of what he had to do, so

[1] Paride (Paris) Ceresara, of a Mantuan family, was a fairly well-known poet of the court circle. See E. Faccioli (ed.), 'Mantova: Le Arti' (Mantua, 1962) ii, esp. p. 403, n. 61. I am grateful to Dr C. H. Clough for this reference.

[2] Apparently a descendant of the branch of the Strozzi family who had fled to Mantua in 1382. Agostino Strozzi, formerly a canon of San Bartolomeo, Mantua, had been well known as a preacher with literary interests before becoming Abbot at Fiesole. P. Litta, 'Celebri Famiglie Italiane', Strozzi di Firenze, tav. xiii, is clearly mistaken in giving the year of his death as 1503.

140

that he could better understand the significance of the fable and not stray from it. We know that Your Reverence will understand it clearly and will know how to correct him if any trouble prevails; but should you be in any doubt you could write to me so that we can clarify it with Messer Paride [Ceresara], who was the author.

82 Letter of Agostino Strozzi to Isabella d'Este, 22 February 1505

My most illustrious and excellent Lady

If Your Excellency's expectation and the hope I have raised in my letters to have your picture by Perugino next Easter should not be fulfilled, you will understand that my utmost solicitude and diligence have not been lacking. But the behaviour of this man, unknown to me formerly, I fear will make me seem a liar to Your illustrious Ladyship. It is already about a fortnight since he left Florence, and I cannot discover where he has gone nor when he is going to return. His wife and household either do not know where he is or are unwilling to tell me. I think myself that he has gone to do some work outside Florence and that when it is about Easter he will return. And he intends to finish the work hastily and spoil it, which will cause me unbelievable annoyance and displeasure, because he wanted Your Excellency to be well served, as he was certain he was able and had intended to show, meaning to apply himself with the requisite diligence and to spend the time reasonably needed on it. I do not know what more to say or promise to Your Ladyship: not a day passes without my sending one of us to find out about him, and while he was working on the picture not a week passed without my going to see him at least once. As soon as he returns, should God so please that he does return, I shall be on to him, and I will not fail you in all the diligence of which I am capable so that Your illustrious Ladyship may be well served. I should have thought it might have been a good idea to send him some money to fire his zeal into finishing

141

the work soon and making a good job of it, had he gone on with it. Now I do not know what to say of this man, who does not seem to have the wit to make any distinction between one person and another. I shall be very astonished if art can accomplish in him what nature has been incapable of showing.

I shall not fail with all my strength to labour that you shall be well served.

> From our abbey of Fiesole, 22 February 1505
> Your illustrious Ladyship's most dedicated
> Agostino Strozzi

83 Letter of Perugino to Isabella d'Este, 14 June 1505

Most Illustrious and Exalted Lady, Most Worshipful Lady

I have received the 80 ducats promised me as the price of the picture from the bearer Zorzo, sent by Your Ladyship, and I have consigned the said picture to him; in this I hope I have used sufficient diligence to satisfy both Your exalted Ladyship and my honour, which I have always placed before profit. And I humbly beseech God to grant me the grace of having pleased Your Ladyship, because I have the greatest desire both to serve and please you in whatever I can; and thus I ever offer myself to Your exalted Ladyship as a good servant and friend. And I have done it in tempera because Andrea Mantegna did his that way, so I have been told. If I can do anything else for Your exalted Ladyship I am ready, and I humbly recommend myself to Your Ladyship. Christ keep you in happiness.

> Written on 14 June 1505 by your most humble servant
> Pietro Perugino, painter in Florence

The picture has reached me safely, and pleases me, as it is well drawn and coloured; but if it had been more carefully finished, it would have been more to your honour and our satisfaction, since it is hung near those of Mantegna, which are painted with rare delicacy. I am sorry that the painter Lorenzo of Mantua advised you not to employ oils, for I should have preferred this method, as it is more effective. None the less, I am, as I said before, well satisfied, and remain kindly disposed towards you.

The Quest for a Work by Leonardo da Vinci

It is not surprising that Isabella d'Este made approaches to Leonardo almost as soon as to Bellini: his work for the Milanese court of Ludovico Sforza and her sister Beatrice must have been well known to her. Since the fall of Milan in 1499 Leonardo had already visited Mantua: she mentions the portrait he had sketched early in 1500 (nos. 85, 88). Isabella appears in this correspondence rather more resigned to Leonardo's idiosyncrasies than to the unreliability of other painters. There is no pressing of her proposal that he should paint a work for the *Grotta*: she was equally ready to take another work, irrespective of her decorating scheme. The final letter suggests that the commission was still fairly open. But the specification that she wanted something 'sweet' (no. 85), though it might have done for Perugino, was perhaps not well conceived to attract Leonardo, who certainly took himself too seriously for this sort of appreciation. The replies of her Florentine correspondent Fra Pietro, Vicar-General of the Carmelites (the Order which had patronised Masaccio, and to which Fra Filippo Lippi had belonged), are not reassuring. They emphasise Leonardo's preoccupation with geometry, and tantalisingly describe two lost works: the Madonna and Child with St Anne, a masterpiece of *contrapposto* painted for the Servite friars, which was reputedly the wonder of all Florence, and the Madonna of the Yarn-Winder (nos. 86-7). After

143

Leonardo had started work on his Battle of Anghiari composition for the Hall of the Great Council in Florence (no. 89; see also no. 45), there was not much hope for Isabella; not just on account of Leonardo's caprices and his preoccupation with this and other commissions in Florence, but because he was attracted in 1506 by the much more bountiful prospects of patronage from the French, first from the occupation government in Milan, then in France itself. For all his intellectual inquiries and search for scientific truth, Leonardo seems to have been as mercenary as many minor artists, and could well afford to be capricious.

Italian texts in A. Luzio, 'I precettori d'Isabella d'Este' (Ancona, 1887) pp. 32-4, the same author's 'Ancora Leonardo da Vinci e Isabella d'Este', 'Archivio storico dell'arte', i (Rome, 1888) 318-28, and L. Beltrami, 'Documenti e memorie riguardanti la vita e le opere di Leonardo da Vinci' (Milan, 1919). See also Clark, 'Leonardo da Vinci', esp. pp. 103-8, 112-13, 132-42.

85 Letter of Isabella d'Este to Fra Pietro da Novellara, 27 March 1501

Most Reverend Father

If Leonardo, the Florentine painter, is now in Florence, we beseech Your Reverence to find out what sort of life he is leading; whether (as we have been informed) he has begun some new work, and what sort of work this is. And if you think he will be staying there for some time, Your Reverence might then sound him as to whether he will take on a picture for our 'studio'. And if he is pleased to do this, we will leave both the subject and the time of doing it to him. But if you find him unwilling, you might at least induce him to do a little picture of the Madonna, holy and sweet as is his natural manner.

144

Please also beg him to send us another sketch of our portrait,[1] because our illustrious lord and husband has given away the one which he left us here. For all of this we shall be no less grateful to Your Reverence than to Leonardo. Offering etc.

Mantua, 27 March 1501

86 Letter of Fra Pietro da Novellara to Isabella d'Este, 3 April 1501

Most illustrious and excellent Lady

I have just received a letter from Your Excellency, and I will do as you write with the utmost speed and diligence. But from what I hear Leonardo's life is changeable and very erratic, so that he seems to live just from one day to the next. Since coming to Florence he has only done one sketch, a cartoon depicting the infant Christ about one year old, almost jumping out of his mother's arms to seize hold of a lamb, and he seems to be squeezing it. The mother, almost rising from the lap of St Anne, is taking hold of the child to draw him away from the little lamb, a spotless creature signifying the Passion. It looks as though St Annne, rising slightly from her seat, wants to restrain her daughter from parting the child and the little lamb; perhaps she symbolises the Church, not wishing to prevent the Passion of Christ. And these figures are life-size, but they are on a small cartoon because all are either seated or bending over, one of them being slightly in front of the other on the left-hand side; and this sketch is not yet finished. He has done nothing else, except that his two apprentices are painting portraits and he sometimes adds a few touches. He is working hard at geometry and has absolutely no patience to spare for painting. I am only writing this so that Your Excellency may know that I have received your letter. I will perform the

[1] During his short stay at Mantua in 1500 Leonardo had done a charcoal sketch of her: Clark, 'Leonardo da Vinci', p. 103.

145

commission and send you the news very shortly; and I pray
God to keep your Excellency in His Grace.

<div style="text-align:center">

Florence, 3 April 1501
Fra Petrus Nuvolara, Vicar-General of the Carmelites

</div>

87 Letter of Fra Pietro da Novellara to Isabella d'Este, 14
 April 1501

Most illustrious and excellent Lady

This Holy Week I have succeeded in learning the painter
Leonardo's intentions by means of his pupil, Salai, and some
of his other friends, who, to make him more known to me,
took me to see him on Wednesday in Holy Week. In short, his
mathematical experiments have so distracted him from
painting that he cannot bear the sight of a paintbrush. Still, I
endeavoured as skilfully as I could to make him understand
Your Excellency's point of view. Then, finding him well
disposed to gratify you. I frankly told him everything, and
we came to this conclusion: if he can, as he hopes, break off
his engagement with the King of France without falling into
disfavour, within a month at the longest, he would serve
Your Excellency sooner than any other person in the world.
But in any case, as soon as he has finished a certain little
picture which he is painting for one Robertet, a favourite of
the King of France, he will do your portrait immediately and
send it to you. I left two good petitioners with him. The little
picture which he is painting is a Madonna, seated as winding
[thread on] spindles, and the Child, with his foot on the
basket of spindles, has taken up the winder, and looks atten-
tively at the four rays in the shape of a cross, as if wishing for
the cross, and holds it tight, laughing and refusing to give it
to his mother, who seems to be trying to take it from him.
This is all I have been able to settle with him [Leonardo]. I
preached my sermon yesterday; God grant it may bring forth
much fruit in proportion to the copious numbers who heard
it.

<div style="text-align:center">

Fra Petrus de Novellara
Florence, 14 April 1501

</div>

88 Letter of Isabella d'Este to Leonardo da Vinci,[1] 14 May 1504

To Master Leonardo da Vinci, painter

Master Leonardo — Hearing that you are staying in Florence, we have conceived the hope that something we have long desired might come true: to have something by your hand. When you were here and drew our portrait in charcoal, you promised one day to do it in colour. But because this would be almost impossible, since it would be inconvenient for you to move here, we beg you to keep your good faith with us by substituting for our portrait another figure even more acceptable to us: that is, to do a youthful Christ of about twelve years old, which would be the age he was when he disputed with the doctors in the Temple, and executed with that sweetness and soft ethereal charm which is the peculiar excellence of your art. If we are gratified by you in this strong desire of ours, you shall know that beyond the payment, which you yourself shall fix, we shall remain so obliged to you that we shall think of nothing else but to do you good service, and from this very moment we offer ourselves to act at your convenience and pleasure. Expecting a favourable reply, we offer ourselves to do all your pleasure.

Mantua, 14 May 1504

89 Letter of Isabella d'Este to Leonardo da Vinci, 31 October 1504

To Master Leonardo Vinci, painter

Master Leonardo: Some months ago we wrote to you that we wanted to have a young Christ, about twelve years old, by your hand; you have replied through Messer Angelo Tovaglia that you would do this gladly; but owing to the many commissioned works you have on your hands, we doubt

[1] Enclosed in a letter to Angelo Tovaglia.

147

whether you have remembered ours. Wherefore it has occurred to us to send you these few lines, begging you that when you are tired of the Florentine historical theme, you will turn to doing this little figure for us by way of recreation, which will be doing us a very gracious service and of benefit to yourself.

> Farewell
> Mantua, 31 October 1504

90 Letter of Alessandro Amadori, Canon of Fiesole and Uncle of Leonardo, to Isabella d'Este, 3 May 1506

My most illustrious and respected Lady

Since I came back to Florence I have been acting all the time as Your Ladyship's proctor with my nephew Leonardo da Vinci. I do not cease to urge him to make an effort to satisfy Your Ladyship's desire concerning the figure for which you asked him, and which he promised several months ago in his letter to me which I showed to Your Excellency. He has promised that he will begin the work shortly in order to satisfy Your Ladyship's desire; and commends himself very warmly to your graces. And if while I am in Florence you could signify whether you would prefer to have one figure rather than another I will take care that Leonardo satisfies your taste. Above all it is my desire to oblige you. I visited Madonna Argentina[1] this afternoon, and she was very glad to hear of Your Ladyship's safe arrival at Mantua. I added that Your Ladyship commended and offered yourself to her and she was much obliged, and it occurred to her to write the enclosed note to Your Ladyship. Nothing else occurs to me at present. May God prosper Your Excellency, to whom I humbly commend myself.

> Florence, 3 May 1506
> Your servant, Alessandro Amadori

[1] Wife of Piero Soderini, Standardbearer of Justice or first magistrate of the republic from 1502 to 1512.

148

Isabella d'Este was too late, and faced disappointment again, in her desire for a work by Giorgione of Castelfranco. On the other hand, had she tried to commission one of her elaborate 'stories' during his lifetime, she might have been equally dissatisfied. Giorgione, master of the enigmatic *poesia*, probably had little patience for pedantically contrived allegories. Neither of the pictures described by her agent Taddeo Albano as *una nocte*, a night scene, are known; no such painting was listed among Taddeo Contarini's collection in Marcantonio Michiel's notes of 1525. G. M. Richter suggested that the word might have been used, as in seventeenth-century usage, to mean a Nativity; but there does not seem much to support this. In the Bellini correspondence, for instance, the term used for such a scene is *presepio*.

Italian text in G. M. Richter, 'Giorgio da Castelfranco' (Chicago, 1937) p. 304 (see also pp. 5-6). See also Cartwright, 'Isabella d'Este' i 389-91.

91 Letter of Taddeo Albano to Isabella d'Este, 8 November 1510

Most illustrious and excellent and my most respected Lady

I understood that as Your Excellency wrote in your letter of the twenty-fifth of last month that you had heard that a picture of a very beautiful and singular night scene was to be found among the belongings and inheritance of a certain Giorgio of Castelfranco, you wanted to see if you could have it. To which I reply to your Excellency that the said Giorgio died some days ago, of plague, and out of my wish to do you service, I have spoken to several of my friends who had very close dealings with him, who inform me that no such picture is among his inheritance. It is true that the said Giorgio did one for Messer Taddeo Contarini, which according to information I have had is not as perfect as you would wish. The

149

said Giorgio did another night picture for a Vittorio Becharo,
which I understand is better designed and finished than
Contarini's. But this Becharo is not to be found here at
present, and from what I have been told neither picture is for
sale at any price; they had them painted for their own
enjoyment. So I regret not being able to satisfy your
Ladyship's desire etc.

> At Venice, 8 November 1510
> Your Servant, Taddeo Albano

The Quest for a Work by Raphael

92 Letter of Isabella d'Este to Matteo Ippoliti, 24 May
 1512

> Federico Gonzaga, Isabella d'Este's child, was kept in
> the papal court for several years as a hostage for his
> father's political loyalty. In this letter, his mother's
> expressed preference for Raphael to paint his portrait is
> hardly surprising: few artists could have been more
> congenial to her taste for 'sweetness'.
> Italian text in A. Luzio, 'Federico Gonzaga ostaggio
> alla corte di Giulio II', 'Archivio della reale società
> romana di storia patria', ix (1886) 548. Further
> communication with Raphael is recorded in Golzio,
> 'Raffaello nei Documenti,' p. 37.

Because I had to give away the portrait of our son Federico
which was done at Bologna, we want another one, especially
since we hear he has grown even more handsome and more
graceful. We want you to see whether the painter Raphael,
son of Giovanni Santi of Urbino, is in Rome, and ask him
whether he is willing to paint him in armour from the chest
down. If Raphael is not to be found, seek the next best
painter, because we do not want a second-rate man to do the
portrait but a good master. We will treat him with honour
and courtesy, as you know to be our custom, and warn him
to do it life-size and as quickly as possible. You could do
nothing to please me better.

> 24 May 1512

(iii) The Sforza of Milan and Other Italian Princes

TASTE AT THE COURT OF MILAN

93 Letter of Duchess Bianca Maria Visconti, Wife of Francesco Sforza, to Rogier van der Weyden, 7 May 1463

Little is known about Zanetto Bugatto, the Lombard painter sent to Flanders, but this letter documents with precision the close northern influence upon the circle of painters patronised by the Sforza, which included Foppa and Bergognone. Taste in court circles was generally more drawn towards France and the Duchy of Burgundy than towards Tuscany. Rogier van der Weyden is believed to have visited Rome for the Jubilee of 1449-50, and there were a number of his paintings in Italy according to the short 'Life of Rogier' by Bartolomeo Fazio.

Italian text in F. Malaguzzi-Valeri, 'Pittori Lombardi del Quattrocento' (Milan, 1902) p. 127; see also Fondazione Treccani degli Alfieri 'Storia di Milano', vii (Milan, 1956) pp. 786-7; E. Müntz 'Rogier van der Weyden à Milan et à Florence', 'Revue de l'art chrétien', 5th series, vi (1895); M. Baxandall, 'Bartholomaeus Facius on Painting', 'Journal of the Warburg and Courtauld Institutes', xxvii (1964).

To the noble and favoured Master Rogier of Tournai, painter, in Brussels

Hearing from time to time of your fame and great ability, we have decided to send our master Zanetto to you so that he may learn from you something about the art of painting. And on his return here we hope to hear how gladly and lovingly you have seen and received him, and what careful study and diligence you have shown on our behalf to demonstrate to him all that you have learnt in your profession. Having foreseen the result already, we thank you exceedingly,

151

hoping that for this service and for all your singular virtues you will avail yourself of anything that we can do for your welfare, honour and pleasure.

Given at Milan, 7 May 1463

94 Letter of Duke Galeazzo Maria Sforza to Leonardo Botta, 8 March 1476

As well as paying tribute to the memory of Rogier van der Weyden's pupil Zanetto, this letter indicates the great interest aroused by the elusive Antonello da Messina, who had studied Flemish techniques in Naples and mastered van Eyck's method of mixing oils which dried as though varnished. Apparently Antonello did not succumb to this invitation to Milan.

Italian text, under the title 'Curiosità di storia italiana del secolo xv', in 'Bolletino storico della Svizzera italiana', v (Bellinzona, 1884) 79.

Master Leonardo

Since our painter Master Zanetto, who drew from life with singular perfection, is dead, we want to have another who will satisfy us with similar art. And since our brother the most illustrious Duke of Bari has brought us a portrait drawn from life by a Sicilian painter established in the city [Venice], we wish that on receiving this you will send for Luigi Cagnola, merchant and citizen of Milan, who knows the said painter and is well informed about him. And have him brought to us; persuade him in whatever ways may strike you as expedient to come to us with all his belongings; because if his works are as we desire we shall treat him in a manner that will make him glad to have come. And if he has any need of money for his journey here give it to him, because we will reimburse you with whatever you write for; do it as though everything came from us.

Given at Vigevano 8 March 1476

To the worthy knight and lord Leonardo Botta, our most dear councillor and orator at Venice, Express

95 Memorandum among the Papers of Duke Ludovico 'Il Moro' Sforza, c. 1496

The extraordinary interest of this fragment is in its evaluation of four of the best-known painters working in Florence in the 1490s. Promptitude is emphasised as a merit, and attributed only to Ghirlandaio; the description of Botticelli's work as possessing 'anima virile' is perplexing.

Italian text in P. Müller-Walde, 'Beiträge zur Kenntnis des Leonardo da Vinci', 'Jahrbuch der königlich preussischen Kunstsammlungen', xviii (Berlin, 1897) 165.

Sandro de Botticello. A most excellent painter both on canvas and wall. His works have a virile air. They are worked out with the utmost reason and proportion.

Philippino son of the great Fra Philippo. Pupil of the above and son of the most singular master of his day. His works have a sweeter air. I do not think they have so much art.

Perugino, a singular master and especially on walls. His things have an angelic air and are very sweet.

Domenico Ghirlandaio, a good master on canvas and more on walls. His things have a good air. He is an expeditious man who carries out much work.

All these masters have shown their skill in the Sistine Chapel except Philippino, but all of them at the Ospedaletto of Lorenzo the Magnificent.[1] And it is rather ambiguous which of them bears the palm.

[1] The 'Spedaletto' was a villa decorated for Lorenzo the Magnificent, of which no traces survive. According to Vasari in his Life of Botticelli, it was near Volterra ('Opere', iii, 318).

If one may judge from these examples, working for the arrogant and wealthy Sforza, well aware of their primacy among the princes of northern Italy, was less relaxed and congenial than at Mantua, Ferrara or Urbino. The Visconti tradition of the capricious, authoritarian ruler prevailed. A well-known story is related by the Milanese historian Corio to illustrate Galeazzo Maria's love of painting: 'Sometimes Galeazzo Maria Sforza wanted a room to be decorated with the noblest figures in a single night, and well rewarded those who served him.'[1]

96 Letter of Galeazzo Maria Sforza to Vincenzo Foppa, 3 March 1463

 Italian text in C. J. Ffoulkes and R. Maiocchi, 'Vincenzo Foppa of Brescia' (London, 1909) pp. 292-3; Malaguzzi-Valeri, 'Pittori Lombardi del Quattrocento', p. 156.

To Vincenzo of Brescia, painter

We want you when you receive these letters to come to us here, and bring with you the picture you received from Papi, our chamberlain as your model for a portrait of Our Lady. Come whether or not your own work is finished, because we want to employ you in other matters. Come at once with the said picture.

 Milan, 3 March 1463

[1] Corio, 'Storia di Milano', ed. F. Colombo (Milan, 1857) iii 314-15.

97 Letter of Zanetto Bugatto to Duke Galeazzo Maria
Sforza, *c*. 1474-6

> Italian text in Malaguzzi-Valeri, 'Pittori Lombardi del
> Quattrocento', pp. 134-5.

Most illustrious and excellent Lord

Your most faithful servant and poor Master Zanetto, painter,
begs Your Lordship will deign to be happily satisfied with the
below-mentioned works done by him for Your Lordship, so
that he can discharge various debts, and provide for his needs
and have the means to buy things, so that he may do credit
and honour to Your Lordship, to whom he humbly recom-
mends himself.

> First, a large portrait of Your Lordship.
> Item, a portrait on a small panel of the Count your elder son.
> Item, a portrait of the dog called 'Bareta'.
> Item, various expenses incurred by him in one place or
another on different occasions for the portrait of Your
Lordship and the Madonna, for which he has not yet received
anything.

> > For this he remits himself to Your Excellency
> > On behalf of Master Zanetto, painter

The Chapel of the Relics in the Castle of Pavia

> One of Duke Galeazzo Maria's most ambitious projects
> was the construction of an enormous decorated re-
> liquary (including 200 caskets for the relics as well as
> devices carved in wood) and accompanying painting in
> the Chapel on the ground floor of the castle at Pavia.
> The outlay of 2000 ducats upon this work seems large,
> but the Duke decided to economise so far as possible:
> some remarkable bartering ensued and led to Foppa and
> his assistants being passed over in favour of a cheaper
> tender for the ceiling. The work was never finished
> owing to the death of the Duke in 1476.
> Italian texts and translations in Ffoulkes and
> Maiocchi, 'Vincenzo Foppa', docs. 23, 24 pp. 299-305;
> see also pp. 99-104.

My Illustrious and Excellent Lord

The other day I sent to Pavia masters Vincenzo [Foppa],
Bonifacio da Cremona, and Jacobino Vicemala, the painters,
to see the *ancona*[1] and the chapel, in order to make draw-
ings, and an estimate of the cost of adorning and painting it,
which masters have now made the said drawings and the
estimate, that is to say the designs for the *ancona* in two
different ways, one in gold, the other in white, burnished and
outlined in gold, with an architrave for each compartment of
the said *ancona*, which architrave is to be either in gold, or in
white, according to the ornamentation of the *ancona*. The
architrave or architraves have never before been taken into
consideration, nor have they ever been discussed till now, but
the painters say the *ancona* will not look well without them.
For the ceiling of the chapel they have made only one
drawing, that is with the dove surrounded by rays, on a blue
background, which ceiling has never been taken into account
either, but I have heard that it would not look well in any
other way. Therefore in order that Your Excellency may
decide which of the two designs is to be adopted for the
painting and decoration of the said *ancona*, I am sending
these masters, Vincenzo, Zanetto and Bonifacio, the painters
named above, with the said drawings. But in order that Your
Excellency may understand the relative cost of adorning and
painting the *ancona* and ceiling, I would observe in the first
place that to decorate the *ancona* with gold as in the design
would cost, according to the estimate, including the two
hundred saints which are to be painted and the ornamen-
tation of the two hundred reliquaries, about 1506 ducats,
and to gild the architraves of the ceiling according to the
drawing would cost about 602 ducats, everything included.
To execute the *ancona* in the other way, that is in white,
burnished and outlined in gold, would cost about 1175
ducats, and to paint the architraves also in white and gold

[1] A panel, either single or multiple as a polyptych, with mouldings
forming an essential attachment to the work.

156

would cost about 155 ducats, and to decorate the gallery of the chapel would amount, they say, to about 50 ducats. For all of which about 1000 ducats are available out of the 2000 assigned for the work. The other 1000 has been spent in carving the *ancona*. Therefore it is necessary that Your Highness should arrange as seems best about the money that is still required, and should decide which painters are to be employed to paint the said *ancona*, for all the painters in Milan, both good and bad, desire to be employed on it and leave me no peace, but if Your Highness desires to know which are the painters most competent for the work, Master Vincenzo will tell you, for every painter is not equal to it. I have stated above what would be the probable cost, yet when the work is finished we must abide by the valuation, which will be carried out, as is customary, by three or four other painters, for the original estimate is only approximate. . . .

> Your Lordship's servant
> Bartholomeo da Cremona
> Milan, 8 June 1474

99 Letter of Bartolomeo Gadio to Duke Galeazzo Maria Sforza, 27 June 1474

My illustrious Lord

On the day of St John the Baptist I received a letter from Your Highness relating to the painting of the ceiling of the chapel, in which, among other things, it was stated that certain painters had been to see Your Lordship, and that some had offered to do the work for 200 ducats, some for 150 ducats, and others for 100. As in that letter Your Excellency commanded me to summon all these painters, so that the commission might be given to those who would make the best terms, I sent for them and others as well; among them were the Masters Giovanni Pietro da Corte, Melchiorre da Lampugnano, Stephano de' Fideli, Gottardo de' Scotti, and Pietro Marchesi, on the one hand, who offered to do the painting for 175 ducats; on the other were the

Masters Bonifatio da Cremona, Zanetto de' Bugati and Vincenzo Foppa, who declared they would do the painting for 160 ducats; finally the above-named Giovanni Pietro and his companions offered to do the painting for 150 ducats, according to one of the designs which I am sending by one of the painters, so that Your Excellency may see which he prefers, namely, with or without little cherubs with a representation of the Eternal Father in a robe of ultramarine azure with rays and a glory of fine gold in relief, the ceiling to be painted in azure, as fine and good in quality as in the design, with stars in fine gold in relief, and also with twelve angels in each section of the chapel, except in the part near the window, where there would only be room for six, though the painters would introduce more if possible. For the price of 150 ducats they will also paint a border, half a cubit in width, of the same colour as the woodwork of the *ancona*, reaching to the top of the roof, which is to be painted like the *ancona*, and they are to remove the old plaster of the ceiling and renew it at their own expense with fine plaster . . . they are also to supply the beams, woodwork, iron clamps and other requisites for making the scaffolding, all of which is to be included in the 150 ducats; and having found no other painters willing to make better terms, I have given them the order, subject to the approval of Your Highness. Wherefore, should my choice be approved, I would beg Your Highness to inform me which of the two designs is preferred, so that I may attend to its being carried out, returning me the design chosen that I may keep it in order to see, when the work is finished, whether the azure is as good and fine in quality as was promised.

Those masters who, according to Your Excellency, offered to paint the ceiling for 100 ducats are not forthcoming; they all say there was never any question of such a sum, but those who are to do the work undertake to execute it to perfection with good colours, and in such a way everything will be satisfactory; and if Your Highness should wish either of the designs to be made simpler, the price would also be reduced, or *vice versa*, adding anything would also increase the price.

I commend myself etc.
Bartolomeo da Cremona

100 Letter of Duke Gian Galeazzo Sforza to the Referen-
 dary of Pavia, 8 December 1490

 Italian text in Malaguzzi-Valeri, 'Pittori Lombardi
 del Quattrocento', pp. 134-5.

To the referendary of Pavia

Having resolved to have our ballroom at Milan painted
immediately with stories, at all possible speed, we will and
commit you, under threat of a fine of 25 florins to be paid
into our chamber and our displeasure, to command Master
Bernardo Butinone di Zenaro and Master Bernardino [Rossi],
painters in our Duchy, that within a day of your receiving
this letter they come to Milan with their two apprentices and
report to Ambrogio Ferrario, our commissary-general, con-
cerning these works. From him they will learn what they
have to do and in this matter you will not fail us if you hold
our pleasure dear; advising us of what you have done.

 Vigevano, 8 December 1490

101 Letter of Duke Ludovico 'Il Moro' Sforza to Arch-
 bishop Antonio Arcimboldi, 8 June 1496

 Italian text in Canuti, 'Il Perugino', ii 201.

To the Lord Archbishop of Milan

Monsignore, the painter who was painting our apartments has
today caused a certain scandal, on account of which he has
gone away. We now have to think of another painter to
contract the work, and who will be ready to take over the
work of the absentee. Having heard that Master Pietro
Perugino is there [at Venice], it occurs to us to give you the
charge of speaking to him and of finding out if he is willing
to come into our service:[1] telling him, that if he comes, we
will offer him such terms that he will be well contented. But

 [1] See no. 43 above.

159

in this matter you must warn him that he should not be under any obligation to that most illustrious Lordship, because in that case we do not intend to make him any offer, indeed if he were here we should send him back there. And so have a regard to this, and on speaking to the said master, let us know what he replies to you, and if it seems to you we can hope to have him.

> Milan, 8 June 1496
> Ludovico Maria Sforza, Duke of Milan

COURT PATRONAGE AT FERRARA AND URBINO

The example of patronage set by the Visconti and Sforza rulers of Milan, lavishly followed by the Gonzaga of Mantua, was pursued with no less zeal in the other courts of north Italy. Space is limited: it is not possible to give here more than these few illustrations of minor princes' eagerness to surround themselves with works of art.

102 Letter of Guarino of Verona to Marquis Leonello d'Este, 5 November 1447

This letter provides another link between the worlds of scholarship and art patronage (cf. no. 24). Leonello d'Este, Marquis of Ferrara 1441-50, was one of the most distinguished pupils of Guarino of Verona, the celebrated Latin and Greek scholar, as well as the patron of Pisanello, to whom Guarino had addressed his famous poem in 1427. This painting of the Muses was to be executed by Agnolo da Siena in the palatial villa of Belfiore, since destroyed. A description of the work by Cyriac of Ancona confirms that while Clio was painted as Guarino prescribed, other details were different: Guarino may have revised his advice, or the painter disregarded it, or else Leonello might have followed alternative suggestions, for instance from the Greek scholar Theodore of Gaza, who was also

teaching in Ferrara at the time.

Latin text in R. Sabadini, 'Epistolario di Guarino Veronese', ii, 'Miscellanea di Storia Veneta', 3rd series, xi (Venice, 1916) no. 808, pp. 498-9.

I have just learnt from Your Lordship's letter of your truly splendid and magnificent idea for a painting of the Muses; this praiseworthy invention, one which is not filled with vain and lascivious images, shows merit in a prince. But my pen could run on, writing a longer essay than you expect. And turning my mind to the number of the Muses, many have expressed different opinions: some say say there are three, others say four, five or nine. Let us disregard the rest and follow the extremists who argue for nine. Therefore it must be summarily understood what the Muses stand for, what ideas and perceptions they are, the various activities and works which they have devised for human studies and industry. . . .

Clio, then, was the inventress of historical studies pertaining to fame and olden times, so let her be holding a trumpet in one hand, and a book in the other; her garment is of various hues and covered in many ways with figures, as we see in the silken cloth of former times. Thalia devised a branch of agriculture, planting in the soil, as her name, derived from budding, indicates; and so her garment is decked with leaves and flowers. Erato watches over the bonds of marriage and the duties of proper love: let her be between a boy and a girl, holding both by the hand and joining them with a ring. Euterpe is the inventress of flutes: let her be shown as a teacher, bearing the instruments of choral music; her joyful face comes first, as the origin of the word proves. Melpomene contrived song and vocal melody; on this account there should be a book with musical notation in her hands. Terpsichore divulged the rules of dancing and the foot movements frequently used in divine sacrifices; therefore she should have around her dancing boys and girls, showing herself in the role of a teacher. Polymnia invented the tilling of the fields: let her be giving out little mattocks and a vessel of seed, bearing in her hand bunches of grapes and ears of wheat. Urania, holding an astrolabe, should be contemplating above her head the starry sky, of which she devised the

161

science, i.e. astrology. Calliope, patroness of learning and high priestess of poetry, representing a voice for the remaining arts, should be wearing a laurel crown and be composed of three faces, since she represented the nature of men, demi-gods and gods.

I know there are many who ascribe other duties to the Muses, to whom I shall reply with the saying of Terence, 'There are as many opinions as there are persons.' Farewell, magnanimous prince and glory of the Muses; I beg you to favour the business of my son Manuele, commending his works as you have done.

From Ferrara, 5 November 1447

103 Letter of Francesco Cossa to Duke Borso d'Este, 25 March 1470

The wall paintings in the Great Hall of the Schifanoia (a town house of Duke Borso on the outskirts of Ferrara, rather than a country villa as its name perhaps suggests) were undertaken between 1469 and 1471. They consisted of twelve multiple scenes representing the Labours of the Months, the Signs of the Zodiac, Triumphs and other scenes. Several artists were engaged; the panels for March, April and part of May have been identified as the work of Cossa. His letter is a curious mixture of the importunate and the servile. He asserts his superiority over merely artisan painters; on the other hand he does not sound greatly at ease, socially and intellectually, in court circles.

Italian text in G. Campori, 'I pittori degli Estensi nel secolo XV', 'Atti e memorie modenesi e parmensi', 3rd series, iii (2) (1886) 592-3. See also E. Ruhmer, 'Cosimo Tura' (London, 1958) pp. 27-34; A. Warburg, 'Italienische Kunst und internationale Astrologie in Palazzo Schifanoja zu Ferrara', 'Gesammelte Schriften', ed. G. Bing (Leipzig and Berlin, 1932).

Most illustrious Prince and Excellent Lord, my most singular Lord etc.

Some days ago I (together with the other painters) petitioned Your Lordship about the payment for the hall of the Schifanoia, to which Your Lordship replied that payment was about to be made. Most illustrious Prince, I do not want to cause a lot of bother to Pelegrino da Prisciano[1] and others, but I have resolved to apply to Your Lordship simply lest it be said that I am the sort of man who is content and overpaid at the rate of 10 *bolognini*. Let me humbly remind you that I am Francesco del Cossa, who on my own did the three panels on the wall next to the anteroom. And for this, most illustrious Prince, you are unwilling to give me more than 10 *bolognini* a foot, so that I am losing 40 or 50 ducats. I should be contented and well provided if I were only a manual worker, but the circumstances are very different, and it pains and saddens me. This is especially so because, having now begun to get something of a name, I am treated and judged and compared with the poorest apprentice in Ferrara; and because all my studying, for I study continually, has brought me no greater reward, above all from Your illustrious Lordship, than those who do not bother with such study receive. Certainly, most illustrious Prince, I could not feel otherwise but pained and saddened. And then it really does seem strange that my working in good faith as I have done, decorating with gold and fine colours, should be priced at the same rate as the parts done by others who have got by without such trouble and expense. And I say, this, my Lord, because I have done nearly all of it in fresco, which is skilled and fine work, and recognised as such by all masters of the art. However, most illustrious Lord, I cast myself at your Lordship's feet. And I pray that although I have such good cause to speak I do not wish to speak about it to you, because I should have to do so to the others. My Lord, Your Lordship could always say that it had been estimated in this way. And should Your Lordship not wish to exceed the

[1] A Ferrarese courtier—humanist and devotee of astrology, concerned with the programme of the Schifanoia frescoes. See A. Rotondò, 'Pellegrino Prisciani', 'Rinascimento', xi (1960) 69 ff.

estimate, I beg you to give me a part as seems fair according to your grace and benignancy. And I will accept and proclaim this as a gracious gift.

> I commend myself to Your most illustrious Lordship
> At Ferrara, 25 March 1470
> Your Illustrious Lordship's unworthy servant
> Francesco del Cossa

104 Patent of Federigo di Montefeltro, Count[1] of Urbino, on behalf of Luciano Laurana, 10 June 1468

Federigo di Montefeltro has always been revered as a paragon among princely patrons. His enormous, rambling palace (worthy to be acclaimed simply for its incongruity in a small hill town) consisted of a series of extensions to an earlier building; the Dalmatian expatriate Laurana had already been set to work on the second phase of the rebuilding some time before this document, a verbose confirmation of his contract as overseer, was drawn up. The opening paragraphs are a fine piece of humanist rhetoric, in which Federigo reveals his primary motive, to erect a monument to the fame of his dynasty, and bestows some rather generous flattery upon Laurana (a fruitless search for architects in Tuscany sounds improbable at a time when Alberti, Michelozzo, Bernardo Rossellino, Francesco di Giorgio, Filarete and others were flourishing).

Italian text in P. Rotondi, 'Il Palazzo Ducale di Urbino' (Urbino, 1950) i 109-10. See also J. Dennistoun, 'Memoirs of the Dukes of Urbino' (London, 1851) ii 147-8; and a recent eulogy of Federigo, claiming he was inspired by Pliny's description of a Villa in designing his own apartments, in L. H. Heydenreich, 'Federigo of Montefeltro as a building patron', 'Studies in Renaissance and Baroque Art presented to Anthony Blunt' (London, 1967).

[1] Later Duke.

Federico of Montefeltro, Count of Urbino and Castel Durante, Captain-General of the Serenissima and the League etc.

We deem as worthy of honour and commendation men gifted with ingenuity and remarkable skills, and particularly those which have always been prized by both Ancients and Moderns, as has been the skill (*virtù*) of architecture, founded upon the arts of arithmetic and geometry, which are the foremost of the seven liberal arts because they depend upon exact certainty. It is an art of great science and ingenuity, and much esteemed and praised by us. And we have searched everywhere, but principally in Tuscany, the fountain of architects, without finding anyone with real understanding and experience of the mystery. Recently, having first heard by report and then by personal experience seen and known how Master Luciano, the subject of this letter, is gifted and learned in this art, and having decided to make in our city of Urbino a beautiful residence worthy of the rank and fame of our ancestors and our own stature, we have chosen and deputed the said Master Laurana to be engineer and overseer of all the master workmen employed on the said work, such as builders, carpenters, smiths and any other person of whatsoever degree, engaged in any kind of work in the said enterprise. Thus we will and ordain the said masters and workmen, and each of our officials and subjects who have anything to do with the said work, to obey the said Master Luciano in all things and perform whatever they are ordered to do by him, as though by our own person. In particular we order Ser Catoni, our Chancellor and Treasurer of the revenues endowed for the said house, and Ser Mattio dall'Isola, appointed to provide all supplies for the said work, in the payments they have to make and the supplies they have to provide and order to do neither more nor less than is in accordance with Master Luciano's power and authority: to strike off and dismiss any master or workman who does not please or satisfy him in his own manner, and to be able to hire other masters and workmen under contract or by the day as he pleases, and to be able to punish, fine or hold back the wages and supplies of anyone who fails to perform his duty. . . . And he may do all the other things pertaining to an

165

architect and master of the works, whatever we ourselves might do if we were present; and in faith of this we have had our present patent drawn up and sealed with our own great seal.

Dated at Pavia, 10 June 1468
[Ser Antonio signed below]

(iv) Patronage of Some Private Individuals

105 Contract for Jean de France to paint the Outside of Ca' d'oro, Venice,[1] 15 September 1431

The documents concerning the building and decoration of Ca' d'oro, found among the archives of the Procurators of San Marco, form one of the fullest illustrations of a private individual's patronage in the early Quattrocento. Marin Contarini was clearly and fastidiously aware of exactly what sort of work he wanted done, and businesslike in keeping his records. For no other Venetian patrician's house are there such copious papers; but perhaps for no other house would they have been so interesting. For Ca' d'oro represents a florid peak of Venetian Gothic art, built at the same time as a more sober and Romanising architecture was under way in Florence. Marin Contarini had been employing stone-cutters since 1421, but it was only in April 1430 that the contract with Giovanni and Bartolomeo Bon was drawn up for the final rendering of the façade, followed by the present contract for touching it up in colour. Nothing much is known about the painter, described in the Venetian form as 'Zuan de Francia' (Jean Charlier?), though his name is a reminder of the northern influences which continued to enter Venice. The contract gives a startling impression of how garish the (now faded) stone must have appeared. Had Ruskin known about the faked marble on the merlons or pinnacles which embellish the roof, he might not have described Ca' d'oro so enthusiastically as 'a noble pile of quaint Gothic once superb in general effect'. Such deception he regarded

[1] The house of Marin Contarini.

as 'spurious art . . there is not a meaner occupation for the human mind'.

Italian text in B. Cecchetti, 'La facciata della Ca' d'oro dello scalpello di Giovanni e Bartolomeo Bon', 'Archivio Veneto', xxxi (1886) 203-4; also, with a translation, in G. Boni, 'The Ca' d'oro and its polychromatic decorations', 'Transactions of the Royal Institute of British Architects', N.S. iii (1887) 32-4.

15 September 1431

The following is the work of painting that Miser Marin Contarini, son of the Procurator Miser Antonio, wants to have done on the façade of his house at San Sofia on the Grand Canal.

First, the gilding of all the balls on the top of the merlons, and all the round moulding on the merlons beneath the flowers.

And the gilding of the roses at the foot of the arches.

And the gilding of all the foliage on the two large capitals on the corners where the lions are placed.

And touching up the field on the said capitals with fine ultramarine azure.

And gilding the two lions upon the said capitals, together with the shields they hold in their paws, which shields shall be in ultramarine. And the front of the slab on which the said lions are placed shall be gilded all over. And below it is to be done in fine ultramarine azure fretted with small golden stars, and be it understood that only the part of the moulding round the capitals is to be gilded.

And similarly he wants the rope mouldings on the front of the arches to be gilded.

It is understood that he wants the twenty roundels with balls in the centre to be gilded and twelve flowers all gilded.

Also he wants the large coat of arms to be gilded, i.e. the whole escutcheon with the dentils and foliage, and he wants to have the bands painted with two coats of fine ultramarine azure, so that it will last very well. And this is all the gilding that he wants on the said façade.

Then he wants the whole of the crowning cornice painted in white lead and oil, with the arches and cusps around the
168

said arches, and the cornice on which they are placed, and all the merlons veined in the manner of marble, with some black touches round the edges of the said merlons if it looks right.

The field of the cusps in the interior of the arches he also wants to be touched up in black.

All the red stone of the façade and all the red dentils shall be painted with oil and varnish, so that the colour looks red.

And all the roses and vines on the façade shall be painted with white lead and oil, and their fields shall be painted black so that they look well.

Similarly he wants the fields of all the foliage of the cornice on the ground floor to be pitch-black, together with the vaults at the corners and the four sills towards the *calle*, to be painted black with oil.

All this work Master Jean de France, painter of the parish of Sant'Aponal, must do at his own expense, on the understanding that the said master must use ultramarine azure at the price of 18 ducats per pound. And he shall have for this work 60 gold ducats.

I Francesco,[1] son of the said master Jean de France, have written down these agreements at his wish.

See Plate 5.

106　An Exacting Patron in Ferrara: Contract of Baldassare d'Este with Ser Simon Ruffino, 1472

> The patron's caution and suspicion lest he should be cheated by the artist is the main point of interest in this contract. He drove a rather hard bargain: the sum agreed upon was not much for a narrative cycle of frescoes (and the inclusion of the notary's portrait makes one wonder whether Ser Ruffino was making a further saving on the contract in return for this favour). His suspicions of Baldassare d'Este seem unreasonable. The latter was highly reputable; he had worked for Duke Borso in the Schifanoia Palace, and

[1] 'Franzesco' in the Venetian original. Presumably he was christened 'François'.

in the same year he undertook to value Tura's frescoes in the ducal chapel at Belriguardo. This fact may suggest the risk of a *quid pro quo* understanding between the artists, accounting for Ruffino's placing a limit on any increase of the payment.

Italian text in L. N. Cittadella, 'Ricordi e documenti intorno alla vita di Cosimo Tura' (Ferrara, 1866) pp. 26-7. See also E. Ruhmer, 'Cosimo Tura' (London, 1958) p. 57, n. 72.

10 ... 1472

Agreements and items of the contract made between the excellent Ser Simon Ruffino, Ferrarese citizen and merchant, and the circumspect Master Baldassare d'Este, painter, for the other, as follows:

First, that the said Master Baldassare d'Este, painter, shall be held and obliged, and hereby pledges his present and future goods, to paint with good colours and decorate with gold of fine quality, the said Ser Simon's chapel in the Church of San Domenico in the city of Ferrara, with the story of St Ambrose according to the design and fashion in which the said Ser Simon shall give him the form and instructions. And he promises by solemn obligation and stipulation on his own behalf, and that of his heirs, himself to bear the expenses of colours and gold and everything else which is to go in the chapel, which by agreement made between the two parties shall be entirely at the expense of the said Ser Simon.

Item, that the said Master Baldassare d'Este shall be held and obliged to paint the said chapel worthily and meritoriously according to the judgement of any proved and expert master of the said art, and with well-prepared colours and gold where appropriate, making and painting in the said chapel the said story of St Ambrose under twelve headings, and including a Christ in Majesty on the altar wall of the said chapel, according to the manner the said Ser Simon shall detail and show, painting the said Majesty in fine and good ultramarine azure and elsewhere as fitting, and with other azure as needed, and decorating the front of the said chapel competently with gold, where required, for the embellish-

ment and decoration of the said chapel, according to the judgement of a worthy man expert in the said art.

Item, the said Master Baldassare shall be obliged as above to paint in the said chapel as well as the story of St Ambrose the portraits (wherever shall be best) of the said Ser Simon and his wife, and of Messer Antonio and Messer Ambruoso, sons of Gabriel Trissino and nephews of the said Simon, and also the portrait of me, Zohanne de Castello, wherever seems best and pleases him most; painting on the side walls of the said chapel or elsewhere as Master Baldissare thinks best and most convenient for the beauty of the said chapel, by agreement made between them.

For his part, the said Ser Simon Ruffino shall be obliged, and hereby obliges his present and future goods and his heirs, to pay to the said Master Baldissare d'Este and his heirs 130 gold ducats as the price of the painting, by instalments according to the work Master Baldissare puts into the painting, working from day to day. And if when the whole work is finished more than the above price is estimated, Master Cosmo Tura, the excellent painter and citizen of Ferrara, being chosen by the said parties as assessor of the said matter, the said Ser Simon shall be obliged and promises to pay to the said Master Baldissare 10 gold ducats beyond the said 130 gold ducats and no more, even if the painting in the said chapel should be valued by the said Master Cosmo at much more than 10 ducats in excess of the said sum of 130 ducats, the price agreed and fixed by the two parties as above. And if the said chapel should be valued by the said Master Cosmo as assessor at less than the said 130 gold ducats, it shall be lawful for the said Master Simon to claim the difference from Master Baldissare d'Este even if it should be 50 ducats, either more or less. And thus it is agreed and signed between the said parties in the presence of me, Zohanne de Castello, notary and Ferrarese citizen, Messer Don Christophoro de' Ridolfi, canon of Ferrara, and Master Piedro Paolo Maron of Milan, dyer and citizen of Ferrara, the witnesses of this writing signed below.

I, Giovanni da Castello, notary and Ferraraese citizen, was present at all the above-mentioned, and have signed this with my own hand at the wish and request of the said parties.

171

Contract of Domenico Ghirlandaio with Giovanni
Tornabuoni for Frescoes in the Church of S. Maria
Novella, Florence, 1 September 1485

The commission to decorate this chapel in S. Maria
Novella which, according to Vasari, the Tornabuoni
had taken over as patrons from the impoverished Ricci
family, was the last great fresco programme under-
taken by Domenico Ghirlandaio. His St Francis series
for Francesco Sassetti in the church of Santa Trinità
was not yet finished when the present contract was
drawn up. Both patrons were prominent members of
the Medici establishment: Sassetti as Bank Manager,
Tornabuoni as Lorenzo's cousin. Ghirlandaio, a pupil
of Baldovinetti, was in many respects the dependable
epitome of later Quattrocento Florentine painting —
certainly not a capricious individualist like his own
pupil Michelangelo. What Giovanni Tornabuoni re-
quired and received was a predictable, workmanlike
production in keeping with established conventions of
style and sentiment. He did not even insist that all the
work should be in Domenico's hand (much of the
execution clearly was not); it was only after the con-
tract had been made, apparently, that he wanted to
inspect preliminary drawings. The instructions are
notably detailed: little scope was left to the painter's
imagination except perhaps in the permissive clause
about 'figures, buildings, castles, cities, mountains, hills
etc', the prevailing taste for which Ghirlandaio was
able to indulge most fully in the scene of the Visitation
of St Elizabeth. It is only surprising that no instruc-
tions for portraiture are included; the large number of
persons identifiably portrayed in the frescoes must
have been the outcome of the patron's afterthoughts
and perhaps his verbal instructions. The portraits in the
scene of the angel appearing to St Zacharias in the
Temple are the best authenticated: a list of them
survives which was drawn up in his old age by
Benedetto di Luca Landucci (b. 1472). Giovanni
Tornabuoni himself appears in this scene, and also
appears with his wife at the base of the north wall.

Italian text in Milanesi, 'Nuovi documenti per la storia dell'arte toscana', pp. 134-6; see also G. S. Davies, 'Ghirlandaio' (London, 1908) pp. 103-27, 170-2.

1 September 1485. Drawn up at Florence in the house of the below-mentioned Giovanni, in the parish of San Michele Bertoldi of Florence, in the presence of Domenico Andrea dei Alamanni and Martino Gugliemi de Alemania, witnesses.

To the praise, magnitude, and honour of Almighty God and His glorious Mother, ever Virgin, and of St John, St Dominic and other saints as detailed below, and of the whole host of heaven, the magnificent and noble Giovanni, son of Francesco Tornabuoni, citizen and merchant of Florence, has proposed, as patron of the greater chapel in the church of Santa Maria Novella in Florence, to decorate the said chapel with noble, worthy, exquisite and decorative paintings at his own expense, as an act of piety and love of God, to the exaltation of his house and family and the enhancement of the said church and chapel.

Therefore the circumspect and discreet Domenico, son of Tommaso Corrado, painter, and recognised master painter, in his own name and on behalf of his brother David and his own son, has contracted with the said magnificent and noble Giovanni, son of Francesco Tornabuoni, to provide the services and work of the said Domenico and David in painting and decorating the whole of the said chapel in the church of Santa Maria Novella in the manner and form detailed below: namely, to paint and decorate the ceiling (called in the vulgar tongue 'the heaven') of the said chapel in azure, and there on the said ceiling to paint ornately the four Evangelists, as is right and proper, in fine gold. On the main wall of the said chapel on the right-hand side he is to paint the seven stories of the Virgin Mary, the first of which, the Nativity of the Virgin, should begin on the lower part of the wall; and thus in ascending order, second, the betrothal and marriage of the Virgin; third, the Annunciation; fourth, the Nativity of Our Lord Jesus Christ, with the Magi coming to pay homage; fifth, the Purification of the Virgin; sixth, Jesus Christ as a boy disputing with the doctors in the Temple; seventh, the

173

death of the Virgin with the twelve Apostles.

On the main wall on the left-hand side seven other stories should be painted in ascending order as follows: first, on the lowest part of the wall, Zacharias in the Temple; second, the visitation of St Elizabeth by the Blessed Virgin Mary; third, the nativity of St John the Baptist; fourth St John going into the desert; fifth, the preaching of St John in the desert; sixth, the baptism of Christ; seventh, the banquet of Herod and beheading of St John. And the said stories are to be painted one above the other with the decorations and details as below:

On the main wall opposite the altar, i.e. the wall in which there are stained glass windows, he is to paint in ascending order, starting from the bottom right-hand side, St Antonio, the former Bishop of Florence, then St Thomas Aquinas, and above him the figure of St Dominic. On the left-hand side he is to paint in ascending order from the bottom St Catherine of Siena, St Vincent Ferrer and St Peter Martyr. Above the said windows, having first of all closed and walled in the 'eye' at present there with materials provided by the said patrons, he is to paint the Coronation of the Virgin Mary in glory, with a representation of the Glory of Paradise. And the said contractors have promised to paint and embellish all the said stories, figures, and pictures with colours rendered in *fresco* (as it is called in the vulgar tongue), and with fine ultramarine azure where the work of the said figures should be in azure, and with fine German azure where all the other details and backgrounds should be rendered in a less deep azure. And all the surroundings which represent marble he must paint in the colour of marble, with decorations in fine gold and other colours appropriate and requisite for the beauty and quality of such a work. And the *pilasters* (as they are called in the vulgar tongue) in the said chapel he is to paint with foliage resembling the colour of marble, with a background of fine gold and the capitals rendered in fine gold and other colours suitable and requisite for such a work. And the arch above the said pilasters he is to paint with rectangles resembling the colour of marble with an azure background and roses embellished with fine gold. And the surface above the columns of the said chapel he is to paint in stone colour (*grey*, as it is called in the vulgar tongue) on the outer side. And in all the

174

said stories and pictures mentioned above, and on the whole of the wall of the said chapel, the ceiling, arch and the columns inside and outside the said chapel, he is to paint and depict figures, buildings, castles, cities, mountains, hills, plains, water, rocks, garments, animals, birds, and beasts, of whatever kind as seems proper to the said Giovanni [Tornabuoni], but according to the stipulation of colours and gold as above; and he shall apply and paint all the arms which the said Giovanni should require on any part according to his own wish and pleasure.

It is further agreed between the said commissioner and the contractor that the aforesaid contractor shall begin to paint one or other of the above-mentioned stories and paintings only after first doing a drawing of the said story which he must show to the said Giovanni; and the said contractor may afterwards start this story, but painting and embellishing it with any additions and in whatever form and manner the said Giovanni may have declared, saving nevertheless all the limitations and stipulations written above about colours and gold.

And the said contractor has promised to the said Giovanni, the commissioner, to paint and work diligently, and according to the arbitration of a just man both to perfect and bring to perfection the whole of the said work and all the paintings in the said chapel, and to paint the whole of the said chapel by the month of May 1490, beginning the said work next May, and thus working on it during the whole of the next four years. And the said magnificent Giovanni, the aforesaid commissioner of the whole work, was promised to pay to the said Domenico the sum of one thousand one hundred large gold ducats at the rate of six *lire* a florin in monthly instalments.

See Plate 2.

108 A Roman Baron boldly confronted: Letter of Antonio
 Pollaiuolo to Virginio Orsini, 13 July 1494

 Pollaiuolo displays a certain temerity in this letter to
 one of the most turbulent and prominent warrior lords

(*condottieri*) of the Roman Campagna. His suggestion that he might do instead of just a head a seated figure of Virginio Orsini on horseback was understandable. His ambition may have been to emulate Donatello's Gattamelata, or the equestrian statue of Colleoni which Verrocchio had begun; but the Francesco Sforza monument upon which Leonardo laboured was probably most in his mind (Vasari recounts that after Pollaiuolo's death a model of a statue of Sforza on horseback was found in his workshop). Political events were unfavourable to any such commission: the famous meeting at Virginio Orsini's castle of Vicovaro between Alfonso, Duke of Calabria and Pope Alexander VI was contemporary with this letter.

Italian text in A. Venturi, 'Miscellanea', 'Archivio storico dell'arte', v (Rome, 1892) 208-10; M. Cruttwell, 'Antonio Pollaiuolo' (London, 1907) p. 256.

My most illustrious and generous Lord

My Lord, I shall take this liberty of writing with my trust in your human goodness since I have no chance of addressing you by word of mouth.

At Ostia it came to my ear from Master Agniolo, the doctor, speaking on your Lordship's behalf, that it was Your Lordship's wish I should do a life-size head of Your Lordship in bronze. I replied to him at once that I took this as a gracious favour, and thus I confirm that I will come for a couple of days to Bracciano and do the drawing and then return to Rome to cast it in bronze. But I would much rather do the whole of you seated on a large horse, which would be to your eternal fame. We can do the head first and then think about the rest.

My magnificent Lord, I leave on Monday, 14 July to stay in Tuscany. I am taking with me two bronze figures, and want to go to my property some fifteen miles from Florence, and because of the plague they have ordered that no one coming from Rome can stay within twenty miles of Florence. I request Your Lordship that on account of love towards Piero de' Medici he should be pleased to grant me a pass to go

to my property between Poggio a Caiano and Pistoia, and I think that he will grant this willingly, because he knows that I have always been a supporter of their house. Just think, it is thirty-four years since I did those Labours of Hercules in the hall of his palace; I and my brother did these, and I know that you must have seen them.

I ask Your Lordship to take this step so that I may have cause to remember Your Lordship.

And it also occurs to me that one of my nephews here lent to Messer Manfredi two gold ducats and three *carleni* for his journey; he promised to repay him at Rome but has never done so. If possible when he has his pay, could he remit them to Rome, care of Piero Panciatichi, who acts for Your Lordship, to return to my nephew? I think Messer Manfredi is from Vicenza.

I beseech you my Lord to pardon me if I have taken your good lordship for granted. My love for you is great and I hear that you liked my work on Pope Sixtus' tomb.

Your servant Antonio del Pollaiuolo in Rome

PART V

The Artist's Working Life: A Miscellany

This letter is the only record in Alberti's own hand of his part in re-designing the church of San Francesco, Rimini, as the famous Temple of Sigismondo Malatesta. He writes far from the building site in the Olympian tone of the architectural consultant, exhorting the overseer to persevere with his model (best understood from Pasti's medallion struck in 1450) and not to heed proposals to modify or alter it. Alberti's main preoccupation concerns the upper part of the building. He wants a barrel-vaulted roof (as used at Sebenico, the other side of the Adriatic, and in various Venetian churches), not one which would weigh upon the external walls; his projected rectangular window, surmounted by a decorated arch, on the front; and scrolls at either side of the upper storey. Characteristically, he claims as his authorities the architects of Antiquity, and the mathematical science of proportion and harmony. In fact neither these details, nor the great cupola, which appear on Pasti's medallion, were executed, for work on the building ceased altogether in about 1458.

Italian text in C. Grayson, 'An autograph Letter from Leon Battista Alberti to Matteo de' Pasti Nov 18 1454' (Pierpont Morgan Library, New York, 1957). Professor Grayson's edition of the original text at last clarifies Alberti's intention and meaning in this letter; he has generously permitted his own translation to be given here. An imperfect text appears in the monumental work by C. Ricci, 'Il Tempio Malatestiano' (Milan and Rome, 1924) pp. 587-8. See also Wittkower, 'Architectural Principles in the Age of Humanism' (1952 ed.) pp. 29 ff.

See Plate 4.

To the eminent Matteo de' Pasti, our very dear friend, Rimini Greetings. Your letters were most welcome for more than one reason, and I was particularly pleased to hear that my Lord was doing as I had hoped he would, and taking good

counsel with everyone. But as for what you tell me Manetto[1] says about cupolas having to be twice as high as they are wide, I for my part have more faith in those who built the Terme and the Pantheon and all those noble edifices, than in him, and a great deal more in reason than in any man. And if he bases himself on opinion, I shall not be surprised if he often makes mistakes.

About the pilaster in my model, remember that I told you that this façade must be entirely independent, because these widths and heights of the chapels cause me some concern. Remember and bear well in mind that in the model, on the right and left sides along the edge of the roof, there is a thing like this: ⟨ornament⟩ and I told you, I am putting this here to conceal that part of the roof, i.e. the covering, that will be put on inside the church, since one cannot reduce the internal width with my facade, and the object must be to improve what is already built, and not to spoil what has already been done. You can see where the sizes and proportions of the pilasters come from: if you alter something, all that harmony is destroyed. We also talked of putting a light roofing on the church. Don't trust those pilasters to put any weight on them. That is why it seemed to me a barrel-vault in wood was the most suitable. Now that pilaster of mine, if it does not match up with that of the chapel, it does not matter, as the latter will have no need of support from my façade, and even if it should need any, it is so near, and almost corresponds to it, that it will get quite an amount of support. So if otherwise you see no objections, follow the design, which in my view is perfectly in order.

As to the matter of the round windows, I do wish the man in the trade knew his job. I ask him, why do they open up the wall and weaken the structure to make windows? For the sake of the light. Well, if you can let me have more light with less weakening of the fabric, aren't you making a mistake giving me an inconvenience of this kind? From right to left of the round window the wall is broken into, and the arch the size of the semicircle has to hold the entire weight above, while below, the fabric is none the stronger for having the round window, and the opening that should give you light is

[1] Antonio di Ciacheri Manetti (d. 1460).

blocked up. Many arguments could be adduced in this respect, but the following one must suffice, namely that you will never, never find, in any building praised by those who once understood what nobody understands today, any round window at all except like a tonsure in the summit of cupolas: and this happens in certain temples dedicated to Jove and Phoebus, who are patrons of light, and they have special justification in their great size.

Should anyone come here to see me, I shall do all in my power to give satisfaction to my Lord. I beg you consider, and hear the opinion of many others, and let me know. Perhaps someone will say something worthwhile. Commend me to Lord Robert and to Monsignor the Protonotary and to all those you think hold me in affection. If I have some trusty messenger, I will send you my 'Ecatomphile' and other writings. Farewell.

> From Rome this eighteenth November
> BAPTISTA ALBERTI

110 Ancient or Modern? Record by Neri di Bicci of his Contract with the Friars of S. Maria delle Selve, 14 September 1454

The main interest of this and the following extract from Neri di Bicci's register lies in the vocabulary. The style *al antica* to Neri is clearly not a would-be Renaissance of the lost paintings of Antiquity, but a traditional, trecento style, though the implication is that is is a style which has been superseded. In the first passage he uses the phrase *alla grecha molto anticha*, showing that he was prepared to paint even in the manner which Ghiberti in his 'Commentaries' (followed later by Vasari) disparaged as 'the crudeness of the Greeks, abandoned by Giotto'; in the following extract, however, Neri undertakes to paint *all'uso di oggi*, whatever he obligingly meant by that.

Italian text in Poggi, 'Il Vasari', i 333.

183

14 September 1454

I Neri di Bicci, painter, undertook to paint and gild for the
friars and chapter and convent of Santa Maria delle Selve, and
for Agniolo di Nicholo, master mason of Porta a Signa, their
proctor, a tabernacle with shutters about 2½ *braccia* high,
and about 4 *braccia* wide with the shutters open, in which
there is to be a little picture of about one *braccia* square,
containing Our Lady with the Child in the lower half, painted
in the very antique Greek style. On the inside of the shutters
I have to do on one side Elijah and St Albert, and on the
other Elisha and the Holy Lamb of Jerusalem, and above the
aforesaid little picture of Our Lady there is to be a God the
Father with many seraphs and a background of blue with
stars: and on the outside of the shutters an Annunciation
with the Angel. And I must arrange it all well, rendering the
inside in fine gold and azure from Germany. And when it is
all done as above, it must be shown to Tomaso di Lorenzo
Soderini, who will judge how much I shall be paid, which
both parties must agree to. And thus the agreement was
made.

The Art of Restoration

111 Record by Neri di Bicci of his Restoration of a
Painting, 31 October 1471

Italian text in Uffizi Gallery Library, MS. ii, f.
169v.; Vasari, 'Opere', ii 86, n. 5.

31 October 1471

I restored for messer Tommaso Soderini an old painting
which was in the church of San Frediano, Florence, at a
newly made altar beside the door leading from the sacristy.
The picture was done in the antique style (*anticamente*) and I
restored it in the manner of nowadays. I mended the top
edges, redid four little angels, as new, touched up and re-
painted almost all the old figures, and I made a St Margaret
out of San Frediano etc. for 12 large florins.

The Art of Copying

112 Contract of Michele Giambono to reproduce a Painting
by Giovanni d'Alemagna, 31 May 1447

Making and studying sketch copies of the works of
others enabled artists to follow recent work and build
up their own stock-in-trade of ideas. Cennino Cennini
(born *c*. 1370) in his painter's manual 'Il libro
dell'Arte', which was written sometime between 1396
and 1437, recommended as a means to skill 'constantly
copying the best things which you can find done by
the hand of great masters. And if you are in a place
where many good masters have been, so much the
better for you. But I give you this advice: take care to
select the best one every time and the one who has the
greatest reputation.'[1] In some cases this might lead to
fresh development; in others to more or less plagiarism.
The following order for a reproduction copy[2] in fact
resulted in a rather modified or more up-to-date
version of the original if, as seems almost certain, this
is the painting of Giambono's now in the Accademia
Gallery at Venice.[3]

Italian text in P. Paoletti and G. Ludwig, 'Neue arch-
ivalische Beiträge zur Geschichte der venezianischen
Malerei', 'Repertorium für Kunstwissenschaft', xxii
(Berlin, 1899) 433, n. 72.

[1] Cennino d'Andrea Cennini, 'Il libro dell'Arte', ed. and trans. D. V.
Thompson, Jr (New Haven, Conn., 1933) p. 15.
[2] Another example is the commission in 1485 to Giovanni
Barbagelata to copy Foppa's altarpiece in San Domenico, Genoa, on
behalf of the Brigettine house in Genoa: Ffoulkes and Maiocchi,
'Vincenzo Foppa of Brescia', doc. 38, p. 316, also p. 133.
[3] Catalogue, n. 8. I am grateful to Professor John Steer for this
information.

(The learned) Ser Giovanni, son of Ser Francesco of the parish of Sant'Agnese, syndic and proctor of the said church, on the one hand, and Ser Michael, son of Giovanni Bono, painter, of the parish of San Gregorio, on the other, have come to an agreement for the making of an altarpiece; viz. that Ser Michael,shall be obliged and must and promises to make a painting at the high altar of the said church of Sant'Agnese to be in the form and similitude in its fabrication, decoration and wooden framing as the altarpiece in the chapel of All Saints in the church of San Pantaleon in the said diocese, which the parish priest of the said church had made two years ago by the hand of Ser Giovanni, the German painter, with this condition, that this painting must and shall be made wider than the aforesaid painting in San Pantaleon. . . . Ser Michael promises to do this painting in the said manner and finish it eight days before the festival of Easter 1448 at the price of a·hundred and thirty gold ducats. This clause, however, states that if Ser Michael de Giovanni Bono does not complete the picture before Easter he shall in that case not have more than a hundred ducats for his labour, excepting in the case of illness of the said Ser Michael; he shall, however, be obliged to complete the said work within the next month for the said price of a hundred gold ducats. And they promise to implement all this and they have as pledge all his goods. . . .

The Conditions of Apprenticeship

113 Record by Neri di Bicci of his Contract with Cosimo Rosselli, 1 March 1456

Neri di Bicci was perhaps unlucky with his apprentices, or treated them badly (some of the clauses in this agreement may suggest exploitation). His private records between 1455 and 1473 show that among more than twenty apprentices he had during this period, about a third walked out on him before their time was up. Rosselli was only 17 in 1456 and stayed briefly. The breach of contract did not lead to proceedings: in this case an accommodation was evidently reached, and Neri paid him fairly. Rosselli's work (in the Sistine Chapel, for instance) does not suggest an individual genius beyond the scope of his temporary master.

 Italian text in Poggi, 'Il Vasari', iii 232. See also Vasari 'Opere', ii 87-9.

1 March 1456

When I took on Cosimo Rosselli as pupil. I record that on the above day I Neri di Bicci, painter, took as pupil in the art of painting Cosimo di Lorenzo, for the forthcoming year beginning on the said day, and ending on the same day in 1457. The conditions were: that the said Cosimo has to come to my workshop at any time that suits me or I please, either day or night, and on holidays if necessary, to work diligently and without taking any time off, and if he does take time off he must make it up. And I the aforesaid Neri must pay the said Cosimo as his wages for the said year 18 florins in *lire*, at the rate of four *lire* to the florin, paying him the said salary every three months. And thus the agreement was made with

188

the said Cosimo in my house, moreover I made this record with his wish and consent.

Cosimo left me and went to Rome on 4 October 1456, and was with me for six and a quarter months at 6 *lire* a month.

114　Contract of Tomasso de' Rossi with the Father of Cambio Tortorella, 28 October 1460

> Here, both master and pupil are obscure figures, but the contract (taken from a notarial register) is again very different from the foregoing, in that the apprentice is a mere child of nine; hence the artist is having to act very much *in loco parentis*, while the apprentice is unable to bargain for himself and his father is to receive the eventual payment for his services.
>
> Latin text in Milanesi, 'Nuovi Documenti per la storia dell'arte toscana', pp. 110-11.

28 October 1460

Be it enacted that Michele, son of Giovanni Marco del Tortorella, of the parish of S. Niccolò within the walls of Florence, by agreemment has given to Tommaso, son of Ricco Vanni Boccacio de' Rossi, inhabitant of the said parish and sculptor in stone . . . his son Cambio, aged about nine years, to learn and practise the art of sculpture or stone-carving for the next five years, starting on 1 November next. And the said Michele has promised to the said Tommaso to make sure and see that the said Cambio perseveres in learning the said art, and will produce good work, and will not leave him during the said time. And for his part, the said Tommaso has promised the said Michele to teach the said Cambio all that he knows about the said art, and to clothe and feed him according to the condition and status of the contracting party, and to give the said Michele for his salary and hire for these five years 30 *lire* in small florins in the following manner: 2 *lire* this present month of October and 4 *lire* 5 *soldi* on 10 November next, and the rest of the said sum at the end of five years.

H. C.P.A.I.R.

189

Subcontracted Work

These examples further illustrate how artists with overall responsibility for a work might become patrons, employing the specialist skills of others.

115 Contract of Ghiberti with Benozzo Gozzoli and Others for work on the Baptistery Doors, Florence, 24 January 1444

> Latin text in Krautheimer, 'Lorenzo Ghiberti', doc. 94, pp. 382-3 (see above, nos. 24-5).

24 January 1444, in the presence of the witnesses Leonardo de' Altoviti and Benedetto Bernardi de' Oricellari, [in the court of the consuls of the Calimala Guild] in the presence of me, Francisco, notary and scribe of the said Guild, and the above-written witnesses.

Vettore, son of Lorenzo di Bartolo, master of the doors of San Giovanni, on behalf and in the name of the said Lorenzo, his father, and Benozzo di Lesse, painter, of the parish of San Frediano of Florence, together reached this agreement concerning the contract written below, viz.

That the said Vettore, in his own name, hired the said Benozzo, and the said Benozzo contracted personally his labour and all his industry and mastery for the work on the entrance door of San Giovanni which are being made by the said Lorenzo di Bartolo, during the requisite days and hours and according to the usage in similar works, for the term of three years beginning on the 1 March next. And during the said time he will exercise himself faithfully and without fraud, to do whatever is imposed on him by the said Lorenzo.

190

And on the other hand, the said Vettore promises and agrees with the said Benozzo to keep him during the said period and to pay him for his salary, wages and hire, 60 gold florins for the first year, 70 gold florins for the second year, and 80 gold florins for the third year.

116 Record by Neri di Bicci of a Contract with Giuliano da Maiano, 3 November 1456

For a painter to require the services of a joiner was common enough; the records of Baldovinetti similarly show the employment of Giuliano da Maiano for these complicated wooden constructions.
Italian text in Poggi, 'Il Vasari', iv pp. 102-3.

3 November 1456

I Neri di Bicci commissioned and ordered Giuliano di Nardo da Maiano, wood-carver, of the Via de' Servi, to make in wood an altarpiece for the Company of San Nicholo in the church of Poggibonsi, made and framed in the antique style, picture, predella, frieze, frame and foliage, 5 *braccia* high and 3 *braccia* wide from the outside of the columns. The picture in the said altarpiece is to be 3 *braccia* wide, with the cornices around it inlaid, and all the edges of the predella, architrave and frame to be inlaid as appears in a drawing done for the said Giuliano by my hand. The said Giuliano asked me if he could do the said altarpiece at his own expense according to the drawing given to him, for 60 *lire*. I offered him 50 *lire* and set him to do the said altarpiece and to do it well as detailed above. And I came to agreement with him and gave him 60 *lire* in florins.

191

117 Record by Maso di Bartolomeo of a Contract with Luca della Robbia, 1451

Maso di Bartolomeo, sculptor and architect, whose brief account-book has survived like that of Baldovinetti and Neri, supervised the building of the convent of San Domenico, Urbino, for the proctor of the Order, Fra Bartolomeo di Giovanni Corradini (Fra Canovale, himself a painter). He was thus responsible for all subcontracts.

C. Yriate, 'Le livre des souvenirs d'un sculpteur florentin au XVe siècle, Maso di Bartolomeo dit le Masaccio, 1447-1455', 'Gazette des Beaux Arts', xxiv (1881) 143. Photographs of the door appear in Rotondi, 'Il Palazzo Ducale di Urbino', ii Plates 30-4

1451

Lucha di Simone della Robbia is to be paid on 29 June 4 gold florins worth 18 *lire* 8 *soldi* on my account by Friar Bartolomeo of Urbino. And this sum is in part payment for certain figures that the said Lucha must do for me to place on the door [of San Domenico] at Urbino, i.e. a Madonna, St Peter Martyr and St Dominic, and above in a pediment a roundel of God the Father, for the price of 40 florins.

Part-Time Work

118 Resolution of the 'Operaii' of Orvieto Cathedral to
 employ Fra Angelico, 11 May 1447

 Fra Angelico made a businesslike arrangement at his
 own convenience, wishing to avoid the heat of the
 Roman summer; but he also broke this contract and
 never completed the frescoes at Orvieto.
 Latin text in L. Douglas, 'Fra Angelico' (London,
 1900) doc. v, pp. 165-6; J. Pope-Hennessy, 'Fra
 Angelico' (London, 1952) p. 189.

11 May 1447

The Magnificent Lords Conservators assembled together for
debate in the Chamberlain's house: Pietro Paolo Ghiori,
Jacobo Cristoferi and Giorgio Constantii, supervisors of the
said Fabric; the said Chamberlain, the worthy and famous
Doctor of Law Gentile de' Monaldeschi and [eight other
persons named] for the Opera. And they consider that as the
new chapel in the transept of the said church, facing the
chapel of the Corporal, is whitewashed and not painted, for
the honour of the said church it should be painted by some
good and famous master painter. And that there is at present
in the City [of Rome] a certain friar of the Observant branch
of the Dominican Order, who has painted and is painting the
chapel of our Most Serene Lord [the Pope] in the apostolic
palace of St Peter's in the City, and as it happens might come
to paint the said chapel; and he is famous beyond all other
Italian painters. He would stay to paint the chapel during
three months of the year, viz. June, July and August, because
in the other months he has to serve our Lord, and for those
three months he does not wish to stay in Rome. And he asks
for his salary 200 gold ducats a year, with the cost of good

colours, scaffolding and gold, to be paid to him by the Fabric, and three gold ducats a month for each of his two assistants, and their expenses paid. After many discussions, they resolved that Sir Erigus, [?] knight, should on behalf of the said chamberlains and the Fabric hire the said master painter with his said following, according to the said salaries, expenses and other requests, so long as he promises to serve in the labour of painting the said chapel entirely or at least serve for the said three months of each year, until the whole of the said work is finished.

Payment or Conscience?

119 Record of the Contract of Fra Angelico with the
 Linen-makers Guild ('Arte dei Linaiuoli'), Florence, 11
 July 1433

 This document, offering a high price for Fra Angelico's
 'Linaiuoli Tryptych', but with an enigmatic clause about
 conscience, seems to confirm that the artist was not
 painting purely as a devotional exercise, but to earn
 money for the newly established house of Dominicans
 to which he belonged.
 Italian text in Douglas, 'Fra Angelico' (1902 ed.) p.
 163; Pope-Hennessy, 'Fra Angelico', p. 169. The
 painting is in the Museo di San Marco, Florence.

11 July 1433

I record that on the same day the above-mentioned *operaii*
commissioned Fra Guido, called Fra Giovanni, of the Order
of St Dominic of Fiesole, to paint a picture of Our Lady for
the said Guild, painted on both the inner and outer sides,
with gold, azure and silver, of the best and finest that can be
found, with his utmost art and industry. For his labour and
for the making of the picture he will receive 190 florins in
gold, or less according to his conscience. And [it will
contain] those figures which are in the drawing, as all appears
in the book of contracts of the said Guild.

120 Contract of Alesso Baldovinetti with the Hospital of S. Maria Nuova, Florence, 17 April 1461

The work of Domenico Venziano and others in the chapel of San Giglio (St Giles) in S. Maria Nuova, Florence, was destroyed a century and a half later: one of the major losses of fifteenth-century painting. Domenico died on 5 May 1461. Why did Baldovinetti offer to complete his work for nothing? He professes it to have been for the sake of religion; but we have already seen that even Fra Angelico was businesslike (nos. 118-19), so this attitude is unlikely to have been derived from Angelico's influence. Was this an act of piety to the memory of Domenico, or an opportunity to display his own talent? Or was it because Baldovinetti, born of a well-to-do family (Vasari insists on his family wealth) could afford this sort of grand gesture? He was not always so magnanimous nor unconcerned with his own profit (cf. no. 126).

Italian text from Baldovinetti's private book of payments, in Poggi, 'I ricordi di Alesso Baldovinetti', app. D; Kennedy, 'Alesso Baldovinetti', pp. 97-8, 240.

This is to record that today, 17 April 1461, Alesso Baldovinetti promises to Master Jacobo di Piero, superintendent of the Hospital of Santa Maria Nuova, Florence, and acting on behalf of the said Hospital, that within a year from today he will accomplish and complete a story of Our Lady begun by Master Domenico Veneziano in the main chapel of the church of San Giglio, on the wall nearest the cloister, all the expenses for colours, gold and all else being borne by the said Hospital, and on the condition that the said Master Jacobo is obliged to furnish the said Alesso and any assistant with his living expenses only. And the said Alesso offers his labour to the said Hospital for his love of God. And to clarify this, by the wish of the above-named, I, Giovanni di Zanobi di Ser Giovanni Gini, Florentine notary, have drawn up the above record . . .

[Signature]

121 Neri di Bicci's Business Sense: Record of his
Completion of a Painting by his Father, 24 March
1466

Italian text in Kennedy, 'Alesso Baldovinetti', p.
244.

24 March 1466

I record that on the above day Zanobi degli Strozzi, painter,
and Alesso Baldovinetti, painter, were both called upon to
make a valuation of the painting belonging to Bishop
Bartolomeo de' Lapacci, Prior of San Romolo, Florence.
Maestro Salvestro, friar of Santa Maria Novella, as syndic and
procurator of the revenues of the said Bishop Bartolomeo,
acted for that venerable man, and on his behalf was called the
aforementioned Zanobi degli Strozzi, and on my behalf
was called Alesso Baldovinetti. Whereunto the said Zanobi
and Alesso are at present in agreement that for the said
picture, done entirely at my expense for gold, azure, colours,
mastery and certain repairs in wood, I ought to have 136
florins under seal, and in addition they judged that as it is
twenty-five years or more since the said picture was designed
and prepared with *gesso* and bole by .Bicci my father, the 38
lire 9 *soldi* Bicci had had for the same were for the said
design and *gesso*, and this they judged because I had to scrape
it and re-do the *gesso*; so for me 136 florins were awarded,
and for Bicci 38 *lire* 9 *soldi*. Thus it was agreed on the said
day, 24 March 1466, that the said Bishop Bartolomeo must
pay 136 florins under seal.

122 A Painter's Appeal for Tax Immunity: Letter of Pinto-
ricchio to the Officials of the Balìa of Siena, March
1507

An artist of sufficient status or influence might some-
times be absolved from paying dues to a Guild (as was
Giovanni Bellini, for instance, in Venice in 1483), but

to claim tax exemption was perhaps going rather far, especially if one was not employed exclusively by the government. In this letter Pintoricchio's affectation of a style borrowed from humanist learning is striking: he was evidently concerned to be known as a properly 'Renaissance' painter. Because of his abundant use of gold and fussy detail, which earned so much contempt from Vasari, he has not been greatly respected, though recent research has tried to rehabilitate him as an original contributor to 'the revival of Antiquity'.

Italian text in Milanesi, 'Documenti per la storia dell'arte senese', iii 33-4; translations also appear in J. A. Crowe and G. B. Cavalcaselle, 'History of Painting in Italy' (London, 1914) v 400-1; E. M. Phillips, 'Pintoricchio' (London, 1901) pp. 12-13. See also Schulz, in 'Journal of the Warburg and Courtauld Institutes', xxv.

To you, Signori Officials of the Magnificent city of Siena

With due reverence from Master Pintoricchio, servant of your Lordships and said to be not the least among renowned painters. It is said, most respected Officials, that although Cicero writes that the Romans in early times had little esteem for painters, yet with the increase of empire after the victories in the East and the capture of Greek cities, they made every effort to attract them from all over the world; and they did not hesitate to seize famous works of painting and sculpture. They reckoned painting to be a most noble art, similar to the other liberal arts, and a rival to poetry. And similar artists usually being esteemed by those who govern republics, the said Bernardo chose Siena to be his home, hoping to reside there for as long as he lives. Placing his trust in Your Lordships' clemency, considering the adverse nature of the times, the smallness and decrease in profits, and the burden of his family, and especially the information that new craftsmen settling here received grants of immunity under your laws, your servant the said Master Bernardino, with the utmost faith in his application to your Lordships, supplicates the same that it may please you on deliberation to concede a general exemption and immunity to the said master

198

Bernardino and his heirs for the next thirty years. And that he and his heirs shall for the said time be fully exempt and absolved from the payment of every tax, loan, imposition and due imposed or to be imposed in future on the commune and *contado* or jurisdiction of Siena; and from every other communal levy, whether public or personal, and from every tax and payment for the membership of any guild, and with the clause *non obstantibus quibuscunque*; and not only this but also your secret authority. And obtaining this favour, as he hopes, he will consider it the highest gift and grace of Your Lordships, whom God prosper.

Arbitration and Litigation

123 Record of the Award to Domenico di Michelino for his
Dante Fresco, 30 January, 19 June 1466

This is an example of payment by arbitration operating
to the artist's advantage, since he received a bonus for
exceeding the patron's requirements. There may have
been some degree of collusion among the well-
acquainted judges; Baldovinetti, from whom Domenico
took on the work, also judged a work in Neri's favour
[no. 121]

Gaye, 'Carteggio inedito d'artisti', ii introduction,
pp. v-vi See also Kennedy, 'Alesso Baldovinetti', p. 134
(with illustration of the work, which is still to be seen
in the Cathedral of Florence).

30 January 1466

The *Operaii* of the Duomo commissioned from Domenico di
Michelino, painter, in his presence and acting on his own
behalf, a figure in the form and guise of the poet Dante,
which he must paint and colour in good colours, with gold
mixed with other adornments, as appears in the model [*sic*]
given by Alesso Baldovinetti, painter. He must paint it on
canvas and render it finished entirely at his own expense; the
work is to go in the chapel in S. Maria del Fiore. For this he
should have for his mastery 100 *lire*, and he must do it within
six months. And when the said figure is done, he must let the
operaii then in office view the work to decide whether it is
worth the reward of the said 100 *lire*.

19 June 1466

It is understood that a commission was made to the painter
Domenico di Michelino for a figure in the form of the poet

Dante, to go in the church of S. Maria del Fiore in the place where there is already a figure of the said poet. The same was commissioned from him, and viewed, and it was understood that the said figure was complete and perfect, and greatly exceeded perfection with regard to the model he was given. And in order that the money and reward for the same figure can be paid to him without exception, the figure has been valued by the said Alesso and by Neri di Bicci, both painters, elected and deputed to make valuation, and the *Operaii* have seen and understood the report made by these two concerning the said figure. The truth is that the said Domenico has done the figure according to the said model and has added many things in addition to it, which he did not, have to do, and which are very difficult and outside the scope of the said model, and he has done them to adorn and beautify the said figure and painting, giving himself much weariness, expense and difficulty. And having seen and considered all the foregoing, they have resolved to give him 20 *lire* in addition to the said 100 *lire*. And having viewed the work again, and considered how it was so highly valued by the said valuers and so much above the reward for which it was commissioned, they declare that he shall be given a sum total of 155 *lire*.

124 Record of the Dispute between Fra Filippo Lippi and Antonio del Barcha, 11 September 1451

Stringent though contracts often were, it does not seem that artists were often penalised for breach of them. They could generally depend on a patron's patience and deference to their waywardness or pressure of work. This extract from the records of the Tribunal of the Mercanzia in Florence shows one case of an alleged breach of contract which reached the courts, though it was in fact the artist who started proceedings. Fra Filippo Lippi protested that the patron should accept what he had been offered. The original contract does not survive, and Antonio del

Barcha's objections about the quality of the work completed are not clear; but Lippi won his case, and the sum deposited with the Prior of San Marco was paid to him by the end of the month. The painting was intended for San Domenico, Perugia, and Vasari (in his *Life of Lippi*) recorded that there was a Madonna and Saints by him in that church. Justice was not usually on Lippi's side: he had been censured by the Archbishop of Florence as an unsatisfactory beneficed priest, and convicted (after torture) for cheating his apprentice of payment.

Italian text in W. Bombe, 'Urkunden über ein verschollenes Altarbild Filippo Lippis', 'Repertorium für Kunstwissenschaft', xxxiv (1911) 117-18; see also Strutt, 'Fra Filippo Lippi', pp. 79-80, 84-5.

11 September 1451

Antonio del Barcha of Perugia, at the present time inhabitant of the city of Florence, appeared before the said office and court on account of a petition and demand said to have been presented against him in the said court on the ninth of the present month of September by Fra Filippo di Tomasso of Florence, painter and rector of San Quirico at Legnaia. This is said to contain, in effect, that on 16 February 1450 the said Antonio commissioned the said Fra Filippo to paint a picture, with many figures of male and female saints, all expenses being borne by Fra Filippo, of such quality and condition as has allegedly been truly done, and according to the contract made between the parties. He was to have done it in six months, beginning on the twenty-second of the month of September [*sic*, for February?] and having finished it within the same time the said Fra Filippo ought to have had 70 florins. Fra Filippo says that they appeared before the Prior of San Marco with certain agreements which appear in a public instrument. And the said Fra Filippo alleges that the said picture was made according to the quality and manner mentioned in the said charter and contract, as he says the said Antonio was notified by a letter before the said court. Fra Filippo declares that Antonio should be condemned to pay the said 70 florins or be made to give him the deposit

that he was prepared to advance for the said picture, on account of all that is contained in the said petition. Antonio, on the other hand, says that the said Fra Filippo had no intention at all of doing the work, that he should be freed and absolved from the contract, and that moreover a perpetual silence on this matter should be imposed on Fra Filippo; the sentence and declaration should thus be pronounced by our tribunal, and the adversary party be condemned according to the form of the statutes and ordinances of the said body. The said Antonio demands all this for the particular reasons written below, and others, i.e.:

First, that the said petition and demand of the said Fra Filippo is obscure, inept and badly drawn up, with no proper beginning nor conclusion; it lacks the customary requirements, and the matters contained and named in it are not true, especially in the following details enumerated: That the said Antonio, having heard of the fame of the said Fra Filippo as a singular and worthy man in the mastery of painting, and wanting to have a picture painted with certain figures, made an agreement as to how the said painting should be done, and in what time, and a public instrument was drawn up by the hand of a public notary, concerning also the deposit and payment of 70 florins as the price of the said picture, so that if the said Fra Filippo did what he was obliged to do, he would be freely given the said 70 florins. But seeing that the said Fra Filippo did not keep to the said terms, and did not then do the said picture, nor the matters committed to him, and that a picture which he said he has done is not the same as the one he was meant to do for the said Antonio (if perhaps he had had to do this for someone else, he still ought to have done the other), and because the picture was neither done in the given time, nor according to the quality expected in the instrument drawn up between the two parties, the said Antonio ought to be released from the contract, nor is he liable for the deposit paid by him, which should have been returned. And thus he demands to make his cause, and at present declares, saving other matters. At the petition of the said Antonio, Justo of Florence, sent by the said court, refers back that he had sent for the said Fra Filippo to make a special appearance at the first hearing.

125 Vincenzo Foppa threatened with Proceedings: Letter of Erasmo Trivulzio to Duke Ludovico Sforza of Milan, 3 November 1489

There were other ways of bringing pressure to bear upon a recalcitrant artist before resorting to legal action. The following letter illustrates the support offered to a frustrated patron by the despotic regime of Milan, whose high-handedness towards painters has already been illustrated. A similar appeal had been made to Duke Galeazzo Maria Sforza in 1474 by Zaccarina de' Beccaria, a private patron and rich widow of Pavia, whose commission for painting of the Passion of Christ in the church of San Giacomo, near Pavia, were not proceeding according to the contract. This again produced a ducal admonition, although the painters in question were in fact working at the Castle.
 Italian text and translation Ffoulkes and Maiocchi, 'Vincenzo Foppa', doc. 48, pp. 320-1; see also p. 169, and for the Beccaria case pp. 109-11, 306-11.

My Illustrious Lord

Having read what Your Highness wrote to me about the complaint made by the Commune of Savona against Master Vincenzo Foppa, who has not finished the work of the Majestas which he had begun in their cathedral, I immediately summoned the said Master Vincenzo. I gave him to understand what was contained in Your Highness' letter on the subject, and I admonished him to go and furnish the said work without further delay, otherwise I should have him arrested, and proceedings would be instituted against him, so that he would have cause to regret not having obeyed. Which matter I wished to communicate to Your Highness, to whom I always commend myself.

 Erasmo Trivulzio
 Pavia, 3 November 1489

126 Baldovinetti rallies Distinguished Supporters: Valu-
ation of the Frescoes for the Gianfigliazzi Chapel in
the Church of S. Trinità, Florence, 19 January 1497

Baldovinetti had started working for Bongianni Gian-
figliazzi, a prominent Florentine patrician, in 1470,
when he painted an altarpiece for his family chapel. In
July 1471 an agreement was signed for him to under-
take a programme of fresco paintings over a period of
five years for the sum of 200 florins. Baldovinetti kept
an account book for this project until September
1472; it contains this summary record of the contract
and also reveals that he had begun buying materials
some months before it was signed. Neither of the
stipulations about time and price were observed,
though it appears from the following document that
the original terms may have been less definite than
Baldovinetti's note suggests, or else that a new contract
was drawn up at some later date. Bongianni Gian-
figliazzi died in 1484, and Baldovinetti may have had
difficulty in obtaining payment from his heirs; it is not
clear how long the work had been finished before the
following high valuation was made. Vasari mentions
the paintings, scenes from the Old Testament with
many portraits of contemporaries, deploring Baldo-
vinetti's technical experiments which caused rapid
deterioration (only the four Patriarchs now remain).
 Italian text in Kennedy, 'Alesso Baldovinetti', p.
247; see also pp. 172-81, 195-6.

In the name of God, 19 January 1497

We Benozzo di Lese [Benozzo Gozzoli], painter, and Piero di
Cristofano da Chastel della Pieve [Perugino], painter, and
Filippo di Fra Filippo [Filippino Lippi], painter, and Cosimo
di Lorenzo Rosselli were chosen by the painter ¡Alessoı di
Baldovinetto Baldovinetti according to a written agreement
which the said Alesso has with Messer Bongianni de
Gianfigliazzi and his heirs to see, judge and price the
paintings done in a chapel in Santa Trinità, Florence, that is
the larger chapel in the said church. Having seen it and

examined all the expenses for lime, azure, gold and other colours, scaffolding and all other items together with his labour, we are in unanimous agreement and judge that the aforesaid Alesso should have for everything 1000 large florins of gold in gold. And in clarification of the said judgement and its truth, I the aforesaid Cosimo di Lorenzo have written this in my own hand on the above day, and this is my judgement; and the others will sign below in their own hands their contentment with what is written above and their judgement of the amount.

I Benozzo di Lese, painter, have been to judge the aforesaid chapel, and I am content with what is written above, and as a pledge of the truth of this I have written these lines in my own hand on the above date.

I Piero Perugino, painter, have been to judge the aforesaid chapel, and I am content with what is written above, and as a pledge of the truth of this I have written these lines in my own hand on the above date.

I Filippo di Filippo, the aforesaid painter, was present with the aforesaid masters to judge the said chapel, and I thus confirm the judgement, and as a pledge of the truth I have written these lines in my own hand, today the above day.

127 Record of the Appeal of Leonardo da Vinci and Ambrogio Preda[1] concerning the 'Virgin of the Rocks', c. 1504-6

An artist-patron dispute lasting over twenty years arose over Leonardo's early masterpiece 'The Virgin of the Rocks', now in the National Gallery, London. The original contract with the confraternity of the Conception in Milan had been drawn up in 1483: Leonardo and the Preda brothers were to furnish jointly an elaborate altarpiece, of which the centre panel (according to the detailed special instructions) was to include, 'on a flat surface, Our Lady and the

[1] Also known as De Predis.

Child and angels done in oil to perfection'. The infant
St John was evidently substituted for a second angel,
but the work remained unfinished, and the painters
claimed on grounds of their expenses that their patrons
had not played fair: another case, in fact, where the
artists took the initiative in legal action. Leonardo's
departure from Milan in 1499 had complicated the
matter for his partners; he was not party to the appeal
made to King Louis XII of France in 1503. The out-
come of this was the setting up of a special commission
under a learned Milanese lawyer, Bernardino de' Busti,
to whom the present document may have been
addressed rather than to the King or another official,
though the exact date and destination of the appeal is
not known. Its suggestion that the patrons were
philistines is not the least point of interest. Settlement
was reached in 1506, under a panel of judges
composed of Fra Agostino de' Ferrari and two
members of the confraternity: an additional 100 *lire*
was paid to the artists.

Italian text in Beltrami, 'Documenti e memorie
riguardanti la vita e le opere di Leonardo da Vinci,'
doc. 120, pp. 73-4. See also M. Davies, 'Leonardo da
Vinci: The Virgin of the Rocks in the National Gallery'
(London, 1947).

Most illustrious and excellent Lord

Your most faithful servants Giovanni Ambrogio Preda and
Leonardo da Vinci, Florentine, previously made a contract
with the confraternity of the Conception of [the church of]
San Francesco, Milan, to make an altarpiece with figures in
relief, all done with fine gold, and a panel of Our Lady
painted in oil, and two panels with two large angels similarly
painted in oil. The agreement was that they should appoint
for the valuation of the said work two members of the said
confraternity and Fra Agostino as the third, and the
valuation being made, and the said works amounting to more
than 800 *lire imperiali* which have gone on expenses, the said
confraternity are obliged to satisfy the supplicants with more
than the said 800 *lire imperiali* as declared by the above three

[judges]. And despite the fact that the said two works are worth 300 ducats in value, as appears in the statement presented to the said confraternity by the said supplicants, the latter have requested the said commissaries to make the said valuation on oath. However they are unwilling to do so with fairness, wanting to value the said painting of Our Lady in oil, done by the said Florentine, at only 25 ducats, whereas it is worth 100 ducats, as appears in the statement of the said supplicants; and the said price of 100 ducats has been offered by persons wanting to buy the said painting of Our Lady. For this reason we are compelled to resort to Your Lordship.

We humbly supplicate Your Lordship that having regard to the above, and to the fact that the said members of the Confraternity are not expert in such matters, as a blind man is no judge of colour, you will be good enough to arrange without delay either that the said three commissaries value the said two works according to their oath, or that two expert judges are appointed, one for each party, who will have to value the said two works, and according to their judgement the said members of the Confraternity shall have to make satisfaction to the said supplicants. Otherwise the said Confraternity should leave the painting of Our Lady in oil to the artists, considering that the altarpiece with all the work in relief by itself is worth the said 800 *lire imperiali* which the said supplicants have had, and which have gone on expenses as stated above. This will be just and seemly, and we believe Your Lordship will be of like mind, to whom we the supplicants commend ourselves

Giovanni Ambrogio Preda
Leonardo da Vinci, Florentine

Bibliographical Notes

No comprehensive analysis of Italian art patronage in the fifteenth and early sixteenth centuries has yet been written. These notes indicate some of the particular studies which are available, and the principal printed collections of documentary sources: they do not pretend to be a full bibliography of the subject, nor a list of all the books and articles cited in the present work.

1 *Studies of Patronage*

Florentine artists and patrons have deservedly been the most closely studied. M. Wackernagel, 'Der Lebensraum des Künstlers in der Florentinischen Renaissance' (Leipzig, 1938) and H. Lerner-Lehmkuhl, 'Zur Struktur und Geschichte des Florentinischen Kunstmarktes' (Wattenscheid, 1936) are both fundamental. M. Meiss, 'Painting in Florence and Siena after the Black Death' (Princeton, 1951) should be consulted for the earlier period, and for the Medici period E. H. Gombrich, 'The Early Medici as Patrons of Art' in 'Italian Renaissance Studies', ed. E. F. Jacob (London, 1960), reprinted in Gombrich, 'Norm and Form: Studies in the Art of the Renaissance' (London, 1966); and A. Chastel, 'Art et humanisme au temps de Laurent le Magnifique' (Paris, 1959). Aspects of Florentine patrician patronage are discussed in essays by A. Warburg, 'Arte del ritratto e borghesia fiorentina', and 'Le ultime volontà di Francesco Sassetti', in 'La Rinascita del Paganesimo Antico' (Florence 1966), Italian translation by E. Cantimori of his 'Gesammelte Schriften' ed. G. Bing (Leipzig and Berlin, 1932). The best account of business practice among a group of Quattrocento painters is U. Procacci, 'Di Jacopo di Antonio e delle compagnie di pittori del

Corso degli Adimari nel xv secolo', 'Rivista d'arte', xxxv (1961).

Stimulating but tendentious attempts to associate art and patronage with Marxist theories of economic and social development are to be found in F. Antal, 'Florentine Painting and its Social Background: The Bourgeois Republic before Cosimo de' Medici's Advent to Power: XIV and early XV Centuries' (London, 1947); and A. Hauser, 'The Social History of Art' (London, 1951). For warning criticisms of this kind of approach, see the reviews of Antal's book by M. Meiss in 'Art Bulletin', xxxi (1949) 143-50, and of Hauser's by E. H. Gombrich, reprinted as 'The Social History of Art' in 'Meditations on a Hobby Horse and Other Essays on the Theory of Art' (London, 1963), and of both by Y. Renouard, 'L'artiste ou le client?' and 'Aux sources de l'inspiration artistique', reprinted in his 'Études d'histoire médiévale' (Paris, 1968) pp. 115-26.

Civic patronage has been interestingly discussed in two studies more concerned with the fourteenth century: H. Wieruszowski, 'Art and the Commune in the time of Dante', 'Speculum', xix (1944); N. Rubinstein, 'Political ideas in Sienese Art', 'Journal of the Warburg and Courtauld Institutes,' xxi (1958). The patronage of the papal court is mentioned extensively in L. von Pastor (trans. F. I. Antrobus), 'The History of the Popes from the Close of the Middle Ages', i-vi (London, 1891-8); F. Saxl, 'Lectures' (London, 1957) contains essays on various projects in Rome, including the Borgia Apartments and the Villa Farnesina; recent contributions include J. Ackerman, 'The Belvedere as a Classical Villa', 'Journal of the Warburg and Courtauld Institutes', xiv (1951); L. D. Ettlinger, 'Pollaiuolo's Tomb of Sixtus IV', ibid., xvi (1953), and 'The Sistine Chapel before Michelangelo' (Oxford, 1965). Patronage in the north Italian princely courts is well illustrated in the works of Julia Cartwright and her daughter C. M. Ady: see especially J. Cartwright, 'Isabella d'Este' (London, 1903) and 'Beatrice d'Este' (London, 1905). For the patronage of Sigismondo Malatesta of Rimini, see C. Mitchell, 'The Imagery of the Tempio Malatestiano',

'Studi Romagnoli', ii (1951). There is no general work upon Venetian patrons, but attention is drawn to private patrons in Venice by G. Francastel, 'De Giorgione au Titien: l'artiste, le public et la commercialisation de l'oeuvre d'art', 'Annales', xv (1960).

Short studies of particular interest include R. S. Lopez, 'Hard Times and Investment in Culture' in 'The Renaissance: A Symposium' (New York, 1953), reprinted in 'The Renaissance: Six Essays' (New York, 1962); 'Cities, Courts and Artists' (Conference Report), 'Past and Present', xix (1962); A. Blunt, 'The Social Position of the Artist' in his 'Artistic Theory in Italy 1450-1600' (Oxford, 1940); A. Chastel, 'Art and Poetry' in his 'The Age of Humanism' (London, 1963); J. Larner, 'The Artist and the Intellectuals in Fourteenth Century Italy', 'History', liv (1969), which anticipates a detailed study by the same author of artists and patrons before 1420.

Monographs on individual artists often provide detailed analysis of their relations with patrons; see for examples the second paragraph of the following section.

2 Documentary Sources in Print

The great nineteenth-century collections of texts remain splendid quarries, even if their editing may sometimes need revision. The pioneer work, an incomparable anthology in spite of its inaccuracies, is J. Gaye, 'Carteggio inedito d'artisti dei secoli xiv. xv. xvi' (Florence, 1839-40). The collections edited by G. Milanesi are fundamental: these include 'Documenti per la storia dell'arte senese' (Siena, 1854-6) 'Le lettere di Michelangelo Buonarroti' (Florence, 1875), 'Les correspondents de Michel Ange: Sebastiano del Piombo' (Paris, 1890), 'Nuovi documenti per la storia dell'arte toscana dal XII al XV secolo' (Florence, 1901); and his edition of Vasari's 'Lives' is indispensable both for the text and annotation, 'Le Opere di Giorgio Vasari', i-vi (Florence, 1878-82). On artists working in Tuscany, see also S. Borghesi and L. Banchi, 'Nuovi documenti per la storia dell'arte senese' (Siena, 1898) and with reference to the *Oper* of Florence cathedral, C. Guasti, 'Santa

Maria del Fiore' (Florence, 1887) and G. Poggi, 'Il duomo di Firenze' (Berlin, 1909). Many documents illustrating patronage have been published in collections of materials upon other leading Italian churches: for example, L. Fumi, 'Il duomo di Orvieto e i suoi ristauri' (Rome, 1891) or A. Gatti, 'La basilica petroniana' (Bologna, 1913); for the papal court, see the texts in E. Müntz, 'Les arts à la cour des papes pendant le XV et le XVI siècles', i, 'Bibliothèque des Écoles francaises d'Athènes et de Rome', iv (1878); 'Les arts à la cour des papes, 1484-1503' (Paris, 1898). Civic and ecclesiastical patronage in Venice is well documented in the copious works of P. Paoletti, 'L'architettura e la scultura del Rinascimento' in Venezia (Venice, 1893), 'Raccolta di documenti inediti per servire alla storia della pittura veneziana nei secoli XV e XVI' (Padua, 1894-5); see also G. Lorenzi, 'Monumenti per servire alla storia del Palazzo Ducale' (Venice, 1868) and C. Boito, 'Documenti per la storia dell'augusta ducale basilica di San Marco' (Venice, 1888). For artists and patrons in the other great maritime republic, Genoa (often overlooked), see F. Alizeri, 'Notizie dei professori del disegno in Liguria dalle origini al secolo XVI' (Genoa, 1876-80). Princely patronage in the court of Milan is documented by C. Mogenta, 'I Visconti e gli Sforza nel castello di Pavia' (Naples, 1883), and F. Malaguzzi-Valeri, 'Pittori lombardi del Quattrocento' (Milan, 1902). For the patronage of Isabella d'Este at the Gonzaga court of Mantua a new and complete edition of the very copious correspondence is required; meanwhile see W. Braghirolli, 'Carteggio di Isabella intorno ad un quadro di Giambellino', 'Archivio Veneto', xiii (1877), and A. Luzio's articles 'I precettori d'Isabella d'Este' (Ancona, 1887) and 'Ancora Leonardo da Vinci e Isabella d'Este', 'Archivio storico dell'arte,' i (Rome, 1888).

Much material is to be found in the notes and appendices to monographs upon individual artists, or in special collections of their letters and other written remains. Only a few examples can be given here: P. Kristeller, 'Andrea Mantegna' (London, 1901); C. J. Ffoulkes and

212

R. Maiocchi, 'Vicenzo Foppa of Brescia' (London, 1909); L. Beltrami, 'Documenti e memorie riguardanti la vita e le opere di Leonardo da Vinci' (Milan, 1919); F. Canuti, 'Il Perugino' (Siena, 1931); V. Golzio, 'Rafaello nei documenti' (Vatican, 1936); R. W. Kennedy, 'Alesso Baldovinetti' (New Haven, Conn., 1938); A. S. Weller, 'Francesco di Giorgio' (Chicago, 1943); R. Krautheimer, 'Lorenzo Ghiberti' (Princeton, 1956); H. W. Janson, 'The Sculpture of Donatello' (Princeton, 1957). Many others have been cited in this work, and can be found by use of the Index under the appropriate artist's name. On documentation concerning individual painters, the most useful quick guide is U. Thieme and F. Becker, 'Allgemeines Lexikon der bildenden Künstler' (Leipzig, 1907-50; reprinted 1964-6).

Miscellaneous texts of significance include E. Müntz, 'Les collections des Medicis au XVe siècle' (Paris, 1888), an inventory of works in the Medici Palace at the death of Lorenzo the Magnificent; G. Perosa, 'Giovanni Rucellai ed il suo zibaldone', i (London, 1960), the memoranda of a private Florentine collector; Neri di Bicci's 'Ricordanze', recording all this minor painter's commissions from 1454 to 1472, partly edited by G. Poggi in 'Il Vasari', i, iii, iv (Arezzo, 1927-31) extracts from the text are given by G. Milanesi, 'Le opere di Giorgio Vasari' (Florence, 1878-82) ii 71-9; the short biographies of many fifteenth-century patrons by the Florentine bookseller Vespasiano di Bisticci, 'Vite di uomini illustri', edited by P. d'Ancona and E. Aeschlimann (Milan, 1951), and translated by W. G. and E. Waters as 'The Vespasiano Memoirs' (London, 1926); the MS. known as the 'Anonimo Morelliano', containing inventories of private collections in Venice and elsewhere in the sixteenth century, edited by T. Frimmel in 'Quellenschriften fur Kunstgeschichte', n.f. i (1888) and translated by G. C. Williamson as 'The Anonimo' (London, 1903).

English translations are included as well as the original texts in many of the works listed above which have English or American editors. A few non-'literary' documents are included in E. G. Holt, 'The Literary Sources of Art

History' (Princeton, 1947), reprinted as 'A Documentary History of Art' (New York, 1957); the work of translation by E. H. Ramsden, 'The Letters of Michelangelo' (London, 1963) must also be mentioned.

Index

216

217

219